"Speaking of the Parisian surrealists that s̶ Paris during their visit in 1965–66, Penε ing with poetry, beauty, humor, excitement and life.' Every word applies to this book, a fascinating collection of essays, diary notes, and surrealist reflections. When writing about André Breton and his friends, or about the marvelous surrealist women artists Toyen, Mimi Parent, Leonora Carrington, or Jayne Cortez, Rosemont is not delivering dry abstractions, as so many academic 'specialists,' but telling us about warm and exciting human encounters, illuminated by the subversive spirit of Permanent Enchantment."—**Michael Löwy**, author of *Ecosocialism*

"This compelling and well-drawn book lets us see the adventures, inspirations, and relationships that have shaped Penelope Rosemont's art and rebellion."—**David Roediger**, author of *Class, Race, and Marxism*

"Anyone seeking to understand contemporary surrealism or the history of surrealism in America and beyond should make their way at once to this book. Penelope Rosemont's remarkable life and legendary body of work lies centrally at the crossroads of surrealism then and now. The broad sampling of essays included here offer a compelling entry point for curious readers and an essential compendium for surrealist practitioners."—**Abigail Susik**, professor of art history, Willamette University

"Reading Rosemont is like being led by an enchanted guide through the wild fields of Surrealism. Around her neck must be a double lens made out of telescope and magnifying glass through which she studies this glowing, breathless landscape. Artist, historian, and social activist, Rosemont writes from the inside out. Like a rare, hybrid flower growing out of the earth, she complicates, expands, and opens the strange and beautiful meadow where Surrealism continues to live and thrive."—**Sabrina Orah Mark**, author of *Wild Milk*

"In this wide-ranging collection of essays, Penelope Rosemont, long a keeper of surrealism's revolutionary flame, shows how a penetrating look into the past can liberate the future. With humor and passion, Rosemont tells the story both of her own engagement with surrealism and of surrealism's relevance to the struggle for social and psychic transformation. Whether addressed to feminism, anarchism, the black power movement, or visual art and poetry, Rosemont's writing, like surrealism itself, sets fire to everything it touches."—**Andrew Joron**, author of *The Absolute Letter*

"The looming centenary of Surrealism will be greeted by a boatload of publications, but few will be as heartfelt, spirited, and teeming with the atmosphere conjured by Penelope Rosemont. Her welcome memoir has a double virtue, as testament to the enduring radiance of Surrealism, and as a memento to the sixties, revealing a sweetly beating wonderment at the heart of that absurdly maligned decade."—**Jed Rasula**, author of *Destruction Was My Beatrice: Dada and the Unmaking of the Twentieth Century*

"Written with the quickness, candor, and delight of encounter, Penelope Rosemont's *Surrealism: Inside the Magnetic Fields* brings surrealism's central figures, Leonora Carrington, Man Ray, Toyen, Andre Breton et al. into our field of experience, and out of the stasis of photography and film, where most of us have glimpsed them. Most thrilling, perhaps, is the '60s mimeo-magazine-making coterie of Rosemont and her friends, seeking revolution, disorientation, anything but the banality of the American Midwestern plains. Quite naturally possessing what she calls 'remnants of my healthy beatnik hedonism,' Rosemont recreates the feverish antics and immediate reception her close-knit, sleep-deprived, beat-attired squad find in the established, mores-breaking Parisian and international surrealists. Revolution is here, between the covers. Anyone who opens this book is invited to the journey, the party, the radicalism that 'must not be grim but a liberation, an increase of pleasure. Otherwise what is the point of it?'"
—**Gillian Conoley**, author of *A Little More Red Sun on the Human: New and Selected Poems* and translator of *Thousand Times Broken: Three Books* by Henri Michaux

"Penelope Rosemont recounts her chance encounters with surrealists in Paris, leading her to a lifelong adventure in surrealist praxes. These included (and still do!) sharing poetry, stories, art, and games of objective chance with kindred spirits around the globe, some of which she shares with us in these magical pages. As surrealists, we live our lives not as today's external world demands but as our own inner dreams, desires, and imaginations lead. We demand nothing less than the impossible not in some distant utopian future but right here, right now."—**Gale Ahrens**, author of *Lucy Parsons: Freedom, Equality & Solidarity*

SURREALISM
Inside the Magnetic Fields

SURREALISM

Inside the Magnetic Fields

PENELOPE ROSEMONT

City Lights Books | San Francisco

Cover art: Leonora Carrington, *Ikon* (1988)
Copyright © 2019 Estate of Leonora Carrington/
Artists Rights Society (ARS), New York

Library of Congress Cataloging-in-Publication Data

Names: Rosemont, Penelope, author.
Title: Surrealism : inside the magnetic fields / Penelope Rosemont.
Description: San Francisco : City Lights Books, [2019] | Includes
 bibliographical references. | Summary: "A series of personal and
 historical encounters with surrealism from one of its foremost
 practitioners in the United States"— Provided by publisher.
Identifiers: LCCN 2019026917 (print) | LCCN 2019026918 (ebook) | ISBN
 9780872867680 (paperback) | ISBN 9780872868267 (ebook)
Subjects: LCSH: Rosemont, Penelope. | Surrealist artists—United
 States—Biography. | Women artists—United States—Biography. | Women
 authors, American—Biography. | Surrealism.
Classification: LCC NX512.R67 A2 2019 (print) | LCC NX512.R67 (ebook) |
 DDC 700/.41163—dc23
LC record available at https://lccn.loc.gov/2019026917
LC ebook record available at https://lccn.loc.gov/2019026918

City Lights Books are published at the City Lights Bookstore
261 Columbus Avenue, San Francisco, CA 94133
www.citylights.com

Contents

one

The Magnetic Fields, Cinema, and the Penetrating Light of the Total Eclipse

"Surrealism."

"What did you say?"

"I said, Surrealism."

"And what does that mean?"

"Nothing Everything."

"But what is it?"

"Nothing . . . And yet, it is something."

"And what does this something do?"

"Spreads spreads monsters of consciousness."

Surrealism has spread its images and poetic spell everywhere. Newly invented, in 1919, its first step, the text *Magnetic Fields* is a mental experiment . . . Yet it has always existed, but was understood only subliminally. It could be called the language of the Unconscious. André Breton and Philippe Soupault working together produced its first text. They did this collectively from pieces of dreams and ragtag realities, from murdered moments and twilight streets, from anything and everything that flashed into their minds. Breton later expressed this new idea as "Beauty must be convulsive or it will not be." Surrealism sought to rescue the Verb and refresh language, and thus, refresh thought itself. The image in the mind is provoked by language. Thus new images are created, loosed upon an unsuspecting world, the possibilities swell. The very idea of beauty is challenged and overthrown. Secrets of the Unconscious laid bare.

Surrealism evolved with cinema. André Breton, Jacques Vaché, other Dadaists, and soon-to-be surrealists were thrilled by the cinema. Its darkness, its dream-like quality, its promise of power, its satisfying Wish Fulfilment. They chose to experience it in their own way. They would spend a few minutes at one theater and then go

onto another and then onto the next. Producing a surrealist game of it, a type of mental Exquisite Corpse.

Breton and Vaché had both been mobilized for WWI. They saw together *Les Vampires*, a serial by Louis Feuillade made in 1915. In the film, a Parisian gang of criminals led by a beautiful woman dressed in a skintight black leotard terrorizes Paris. Probably inspired by a group that was part of popular consciousness: the Bonnot Gang, anarchists, known as the "Auto Bandits" of 1912. They escaped capture at high speed in autos, being among the first to take advantage of the new motor car. Somehow Feuillade *twists our morals* and puts us on the side of the outlaws. Breton wrote, "It is in *Les Vampires* that one must look for the great reality of this century." In his preface to Vaché's *War Letters* he writes, "the playbill: They are back—Who?—The Vampires, and in the dark auditorium, those red letters *that very night.*"

The series of books *Fantômas* began in 1911, and ran to 32 volumes. Fantômas is the Master Criminal. "Nothing is impossible for Fantômas!" These novels were written using an automatic method, dictated at high speed. Pierre Souvestre would write one chapter, Marcel Allain the next after seeing only the last page. Every chapter was a cliffhanger. A 300-page novel would take them five days to write.

Soupault commented in *La Révolution surréaliste* that these were written at such a high speed that they must reveal the inner workings of the mind. "I challenge any author anywhere in the world to write, or even more to dictate, fourteen hours a day, day after day, without finding himself under the total control of absolute automatism."

Breton's closest friend, Jacques Vaché, who shared Breton's hopes and dreams, in a letter from the WWI field of battle wrote, "What a film I shall make!—with crazy motor-cars, you know, crumbling bridges, and enormous hands crawling all over the screen toward some document! . . . Useless and inappreciable! . . . With colloquies so tragic, in formal attire, behind the listening palm-tree!—And Charlie Chaplin of course, with frozen smile, his eyes deadly. The Policeman forgotten in the trunk!!!"

And what to do: "I shall also be a trapper, or thief, or a prospector, or a hunter or a miner, or a welder. . . An Arizona Tavern (*Whisky —Gin and mixed?*) and beautiful forests to explore, and you know

those fine riding-breeches and some machine-guns, and well-tended, beautiful hands with diamonds rings—All this will end in conflagration, I tell you, or in a salon, Fortune made—Well . . ."

Speaking frankly to Breton, "How am I, my poor friend, going to put up with these last months in uniform? . . . (I'm told the war is over) . . . I am truly tired out. . . and THEY are suspicious . . . They suspect something—As long as THEY don't debrain me while THEY still have me in their grip! . . . I read the article on cinema. . . There will be some amusing things to do, when unleashed and free."

But Vaché died, a suicide, an accident perhaps, on January 6, 1919, after having been demobilized. Breton, who knew him best, commented that Vaché loved life too much to kill himself.

Breton wrote to Tristan Tzara in Geneva on the 22nd of January 1919 enthusiastic about Tzara's 1916 Dada Manifesto, mentioning Vaché, who had died two weeks earlier, would also have wanted to be part of Dada. Mid-January, an ill-fated Spartacist uprising was put down in Berlin. In March, the first issue of Breton's anti-culture magazine *Littérature* appeared. In Munich, April 1919, some radical Bohemians and Gustav Landauer took over the state. This lasted five days and was called the Munich Soviet Republic. It ended tragically with most killed. Eclipse: May 29, one of the great history-making scientific events. Headlines blared as the total eclipse observed by Arthur Eddington proved Einstein's General Theory of Relativity and truly ushered in a new world. In April, May, Breton and Aragon published the *Poésies* by Lautréamont. They had discovered the only existing copy in the National Library. Earlier, Soupault had discovered Lautréamont's *Maldoror* in the mathematics section of a bookstore in 1917. A letter by Vaché was published in *Littérature* in July. August saw the publication as a book of Vaché's *War Letters*. In 1920, when *Magnetic Fields* appeared, it was dedicated to Vaché.

Considering the war, Vaché's death, the influenza epidemic, it is not surprising what *Magnetic Fields* expresses. The mind struggles there, and all of the outpouring of emotions, long pent up, are expressed . . . meaningless, fraught with meaning . . . the beginning text of surrealism, an intermix of Chance, Play, Intuition. They called it "pure psychic automatism."

What does it provoke? For me, the great experiments of animal

magnetism in Paris. Mesmerism! Hypnosis. Charcot and Freud's exploration of mind. The Passional Attraction of Charles Fourier that is the sublime motivation. Attractions that are proportional to destinies.

But there is also a do or die attitude, taken seriously, taken casually, dismissed, as soldiers learn to dismiss life. The overwhelming chaos of war and loss and a fierce attempt to choose to live. The collisions of chance by which we live or die. That play with us, that are played with, it's all in play, it's all a game, life itself. . . . We're only players on a vast stage . . . But . . . do we get to pick the stage?

Does Breton wish to create a magnetic field for language: surrealism?

"Prisoners in a drop of water, we are everlastingly still animals."

"All of us laugh, all of us sing, but no one feels his heart beat anymore."

"The immense smile of the whole Earth has not been enough for us:

we have to have more deserts, more suburban cities, more dead seas."

"Each transit is saluted by the departure of giant birds."

"Those charming codes of polite behavior are far away."

"No one knows how to despise us." (*Magnetic Fields*)

And myself, as a disaffected teenager I discovered the phrase, "Elephants are contagious!" A slogan penned by Paul Éluard. I laughed for a week. And passed it on, whispered it to friends. In 1964, when I was 22 years old, I encountered the surrealist-oriented militants of the Anti-Poetry Club at Chicago's Roosevelt University. It was the first group I encountered I felt I belonged in. Sometimes I call us, with good reason, "anthropology students run amok." We were anthropology students, studying with St. Clair Drake but with ideas of changing the world, and we were planning to do it from our obscure bookstore on Armitage Avenue. The initial group was Franklin Rosemont, Bernard Marszalek, Tor Faegre, Robert Green, and myself. Soon joined by Joan Smith, Simone Collier, Lester Doré, Lionel Bottari, Larry DeCoster, and Dotty DeCoster. Then, in 1965 rather abruptly, we headed for London and Paris driven by a dream of finding the electricity created inside the Magnetic Fields.

two

My Days in the Mimeo Revolution

All of us around the _Rebel Worker_, a mimeoed mag in Chicago, were fascinated by the printed word. We saw it as a joyous means of expression, vital to the development of ideas, key to changing the world and perhaps even history itself. It seems that actually, we choose our past, just as we choose our future. The past serves as guide though the dark forest of the Present.

Our proto-surrealist _Rebel Worker_ group met each other first at Roosevelt University, then a hotbed of political ideas. Basically, we were "anthropology students run amok." We decided, having read from Emma Goldman to Lenin, that we needed a journal and a place. So we got an old storefront at 713 Armitage Avenue in Lincoln Park. Not too far away were taverns where Haymarket anarchists used to hang out. After finding the place, we moved in books from family, from Maxwell Street, from City Lights, and from London's Freedom Press. We did have some access to the newspaper _Industrial Worker_. (They printed a piece on bookshop folks who tried blueberry-picking in Michigan.) But our youthful ideas, rock 'n' roll, blues, surrealism, went far beyond what they would print and we knew that we needed our own means of expression.

The main group consisted of Tor Faegre, Bernard Marszalek, Robert Green, Franklin Rosemont, Larry DeCoster, Dotty DeCoster, and myself. We were soon joined by Joan Smith, Charlotte Carter, and Simone Collier. We had a small, very difficult mimeo, probably a Rutherford Neostyle, that we used to publish a few leaflets directed to RU and the first _Rebel Worker_. But then, we managed to collect enough money ($150) to get a better one, with a motor, not a hand crank. It was a Gestetner mimeograph and it seemed fantastic after the hand crank—though everything still had to be collated. Typing the stencils was difficult work as mistakes were almost impossible to fix. Thus, misspelled words. We bought our wax stencils by the box from George's Supply on Halsted Street. Later, he introduced

an electric stencil machine that printed the *Rebel Worker* 6 cover. We had to bring him the copy. The need for collating brought us together for collating parties. These sometimes got out of hand because of passionate political discussions. Thus, pages out of order. But a good time, anyways.

Thanks to the IWW we had addresses of many people, friendly bookstores, and alternative spaces. We would send out sample copies or fliers and we'd get actual subscriptions. We were always behind on our issues, but subscribers were patient. Sam and Esther Dolgoff in New York got them around. Gotham Bookshop took some. We sent them to City Lights and Berkeley, CA. Soon we were actually printing 3,000 copies of an issue. We advertised the other mimeoed pamphlets we'd produced. A bestseller was *Mods, Rockers, and the Revolution*. Then *Blackout!* (on the NY electric power failure), and *Revolutionary Consciousness*, and others. Postage was very cheap.

Planning to visit Freedom Press in London, Franklin and I were rejected at Heathrow and ended up in Paris. There, by objective chance of the most wonderful sort, we were stranded with the Surrealist Group and André Breton. But in Easter 1966 we tried again and stayed with Charles Radcliffe and Diana Shelly. This too was a fantastic encounter as it seemed that our minds were on fire with ideas. But we were also down with flu. Charles borrowed a mimeo from Freedom Press and we got to work writing and typing stencils. I got mine finished first. Charles typed in the sun on some scaffolding on the front of his Redcliffe Road place. I huddled around the paraffin stove. Somehow we produced the London *Rebel Worker* in days. The mimeo had to go back to Freedom Press for their use. Diana kept reminding us that "it was impossible and we were all crazy." Perfectly, true. And definitely feverish. She had the burden of going to a day job. We got *Rebel Worker* together in time for the big May Day parade in Hyde Park. We sold practically every one of them. I remember the marches and their banners emerging from the fog. Later in the day, there was good weather and Spring! We went home . . . still sick.

Charles and Chris Grey got together and mimeoed their small mag *Heatwave*. This has to be some of the most passionate English prose ever. They built a connection to the Situationists in France but

found them on the stuffy side. This they certainly were but I always thought there was a black humor in it all. Paul Garon, living in Louisville, KY, corresponded on the blues with Radcliffe, who let him know that his "Journal of Addiction" had been published in *Heatwave*. Paul came to our bookshop in Chicago to see if he could find a copy of *Heatwave* and meet us. We were pretty suspicious of Paul at first. But then he mentioned Peetie Wheatstraw and I knew who he was. So Paul, who had just written a book on Peetie published in London called *Devil's Son-in-Law*, became one of our good friends through this mimeo small mag connection. The celebration of the blues became an important aspect of surrealism in the U.S.

One of my favorite mimeo stories: Some of the kids from the grade school across the street came over and asked if they could use our mimeo. They were maybe nine years old. They said they wanted to do an anti-war leaflet. So Bernard helped them do the stencil and printing. They distributed it at the school, calling for an anti-war demonstration in the schoolyard at lunch the next day. And they did it! There was a large demonstration of kids; they even made their own protest signs, organized completely by themselves. (I knew the war was doomed.)

Why did it change? Some of us went different ways. By the '70s, Bernard Marszalek had learned how to run an actual printing press and bought a Multilith. He printed my first book, poems called *Athanor*, and went on to open a co-op printshop in Berkeley.

Franklin and I tried hard to get his first book, *The Morning of a Machine Gun*, offset printed without success. It was poems but contained a manifesto we had written in Paris. Most Chicago printers had no use for radicals. Finally, we went to Liberation Press, the SDS printshop. They had a press. It was an offset press Chief 10. It was pretty old. I joined the printshop staff (my grandfather was a printer) and worked in the SDS national office from 1967 to 1969. The book came out in spring '68, just as we were shaking up the world a little. Heady day to be there. Never will forget it.

three

Paris Days – Winter to Spring

Our counterculture bookshop group in general had been thinking more and more about a cultural critique, about the synthesis of anthropology, Freud, and Marxism that for us centered around surrealism. Herbert Marcuse's work *Eros and Civilization* and its discussion of Freud was important to us, especially his concept of surplus repression. There has been a concerted attack on Freud, an attempt to discredit Freud and especially discredit the idea of the repressiveness of civilization. The Right sees this not altogether incorrectly as the basis of the '60s radicalism. After all aren't we the freest people imaginable? We have the freedom to buy anything we want. What else is freedom? The entire concept of the repressiveness of society has been dismissed. A mistake.

By December 1965, Franklin and I thought IWW efforts were slowing down and were eager to go to Paris. Robert Green and Lester Doré were already traveling there and sending back reports. Lester sent Provo and Revo literature from Amsterdam and wrote that there was a tremendous youth scene. Maurice Nadeau's *History of Surrealism* had just come out in English and we read with enthusiasm, "the surrealist state of mind or, better still surrealist activity is eternal. Understood as a certain tendency, not to transcend but to penetrate reality, to 'arrive at an ever more precise and at the same time ever more passionate apprehension of the tangible world.'" I read *Nadja*: a mysterious and sensuous tribute to a free-spirited woman. "Who am I? . . . perhaps everything amounts to knowing who or what I 'haunt,'" Breton had written. Fascinated by the idea of wandering the streets of Paris directed by chance alone. What would André Breton be like, I wondered?

First, we planned to go to London and visit the anarchist Freedom Press there. We expected to be gone six months or more, spending most of the time in London, maybe a week in Paris. Only a week in Paris because we didn't know anyone in Paris that we could stay with and felt our French needed a lot of work. Further, we were shy

about meeting André Breton. We were just kids; we hadn't really done anything we considered significant yet. But drawn to surrealism, we wanted to go and see for ourselves what was happening. What would the surrealists be doing, thinking, would we be able to meet them? Would we be able to meet Breton? He was nearly seventy, but still living at 42 rue Fontaine where he had lived when he wrote *Nadja*. We wondered, would we be able to see the famous 42 rue Fontaine?

When we left it was indeed dismal days for the bookshop; Solidarity Bookshop was in storage, driven out of 713 Armitage by irate neighbors, the school board, police, red squad, etc. Our tolerant landlord, Jerry the hairdresser, was visited by the FBI and he worried his beauty shop business would suffer. We were determined, however, not to give up. Tor Faegre and Bernard Marszalek were going to search for a new storefront. Larry and Dotty DeCoster would soon arrive on the scene. At Union Station we boarded the train for New York. From there our plane left for London.

New York, December 1965
During our brief stop in New York we met Nicolas Calas at his apartment. Probably the tallest surrealist, Calas was close to seven feet. From his coffee table I picked up a copy of the surrealist journal *La Brèche*; in it I found the names Franklin Rosemont and Larry DeCoster. Their friend Claude Tarnaud had sent a letter to Robert Benayoun in Paris, describing his meeting with them. The letter had been published two years ago, in 1963. What a surprise, we were astonished, it seemed a remarkable sign.

We left and strolled randomly through the streets of New York unmindful of the raging blizzard about us. We came upon a man standing on a corner in the snow near Rockefeller Center, but standing there so rigid and so tall, I thought he was a statue, wearing a long cape that flowed in the wind, a Viking helmet, shoulders and beard frosted over with snow. Even up close I couldn't tell if he was alive. So I said, "Who are you?"

"I am God!" came a deep, booming voice with long pauses between words. I had to smile; I was not expecting to run into a god standing on a street corner in a Manhattan snowstorm, "but people call me Moondog."

"What's that you're carrying?" said I.

"Music, music that I wrote. Do you want to buy some?" Well, it turns out this was Moondog, a remnant of the old beat scene gone practically catatonic on a street corner.

Then to the airport and on to our BOAC plane; this was our first flight, first time up in the air, but I wasn't frightened, I was elated because of my desire to see the Earth from the air, because of my excitement of going, going across the ocean, going to England, going to France, going on a great adventure, doing it together with my lover.

Leaving just before Christmas, the plane was not crowded. It was a long flight, perhaps eight hours; the plane was so empty we stretched out, lying down over three seats, and slept a bit. Mostly we enjoyed being in cloudland and staring down at the gray endless ocean and dreaming of what could be awaiting us on the other side of the vast wilderness of water.

Our Adventures at Heathrow Airport

At Heathrow Airport in London, we got in line, we were dressed in simple beatnik style, black turtleneck shirts and jeans. Franklin was wearing his black leather jacket; I was wearing a fringed black tweed shawl Franklin's mother made for me; it made me look spectacularly countercultural. We waited in line impatiently to get through customs. Finally, it was our turn; the agent asked us, "How long are you planning to stay?"

"Three to six months."

"How much luggage have you got?"

"Four pieces."

"Rather a lot of luggage, don't you think?" he commented and asked, "How much money have you got?"

"A thousand dollars."

"What are your occupations?"

Franklin answered, "Musician."

"Mmm," said the agent, our first clear indication of hostility. "We've rather enough musicians here already! What about the draft?"

Franklin answered, "I've got a student deferment."

Agent, "Well, you can't very well be a student and be here at the

same time, can you? You can't do it in this country at least. I think you are trying to avoid the draft, trying to emigrate to our country."
We insisted this was not the case. It didn't work.
"We're going to send you back on the next plane."
"Wait," I interrupted, "I want to appeal, I want to see someone else about this."
"Well, there's no one else to see tonight, we're going to keep you in detention overnight and then back you go."

Very dejected, we were shunted off to overnight detention in some cement-block rooms that looked like motel rooms but with no windows, and were locked in for the night. We weren't the only ones; there were quite a few people from Pakistan who were likewise enjoying the hospitality of Heathrow.

In the morning, however, we were ready with our arguments; these would probably have fallen on deaf ears except we had purchased only a one-way ticket and had come on BOAC, the British state-owned airline. Therefore, because of international agreements, they would have to return us at their own expense. We were escorted around the airport from bureaucrat to bureaucrat accompanied by an entourage of two guards (so we wouldn't escape) and two luggage carriers. This situation attracted plenty of attention from other travelers who thought we must be bank robbers or at least rock stars. In retrospect it has provided us with a lot of amusement.

After arguing with three different sets of officials I finally said, "How about if we purchase a ticket to Paris; you can ship us on to Paris and you'll be rid of us!" This definitely appealed to them, passing this bureaucratic problem on to the French; we put out the cash and bought the tickets and they made arrangements for us to be on the very next plane to Paris, and I do mean the very next.

Most humorous of all was our departure. In fact, they called over to the airfield and held a plane, then piled us and all our luggage and all our guards into a large, black limousine and drove us out onto the airfield right up to the plane. The boarding ramp had already been removed and had to be brought back for us; I could see faces gawking out the plane's windows; planes wait for no one; we were hurried up the stairs accompanied by our guards and escorted to our seats in the crowded plane. The last words from the chief guard

to the stewardess were: "Here is their passport, don't give it to them until you are off the ground!" (This was so we didn't bolt and jump off the plane in a daring last second escape, I suppose?) It made us seem really desperate and dangerous; heads turned, everyone had to get a look at us, but no one said anything. International spies, jewel thieves at least! And I thought it only happened in movies.

This short flight was fraught with anxieties; would we get into France? There was a large black X on our passport and a message: "refused entrance to U.K." After landing, we got in line with all the other tourists; there were lots; French Customs was just waving people through as they held up their passports. We walked by but just didn't believe it for a while, didn't believe we had actually gotten through customs and were in France. Then we were jubilant, elated . . . but, what next? Somehow we had to figure out what to do now.

Christmas in Paris!
Our trip began with an amazing demonstration of objective chance. We started for London but here we were in Paris. Little did we realize how fortunate this was. The Surrealist Group had several special events going on.

When we arrived in France at Le Bourget Airport on December 22, we had no plans, no place to stay, and no one had been informed of our arrival; suddenly we were just there, disoriented but ecstatic! All our careful plans demolished. Our relatives back in the U.S. didn't have a clue as to where we were. At last report, the day before, I had called my mother and told her we were being held in detention in London; the relatives wouldn't know where we were for days.

As soon as we could find a phone at Le Bourget, we tried to call Robert Benayoun, the member of the Surrealist Group with whom we'd been corresponding. We looked up his number in the Paris phone directory and dialed anxiously; a woman answered, she didn't speak English. Then she informed us that M. Benayoun was very ill. Too ill, in fact, to come to the phone. What to do? I explained we were friends of his from Chicago. She was astonished; she didn't know that M. Benayoun had any friends in Chicago. When Franklin said, "Is this the home of Robert Benayoun, *Surréaliste?*" She hung up.

We just couldn't stand airports or their atmosphere for one more minute. We moved our luggage to a locker and, equipped with *Europe on $5.00 A Day*, caught a bus for Paris.

Outside the window a curious world passed by, new and modern buildings were rising next door to tiny one-room cottages hardly large enough for a bed and chair, and barely high enough to stand up in, but surrounded by neatly kept tiny gardens.

We arrived at Les Invalides air terminal somewhere in central Paris. We didn't have a map yet, so we had no idea where we were, but left and wandered instinctively down toward the Seine and across a bridge, just soaking in wonderful new sensations on all sides. Not believing it, everything seemed so different, we just wandered and looked at the people, the buildings, the traffic. Finally, we woke up to the fact that we had to find a place to stay and much of the day had already passed. I'm not sure if Hôtel des Acacias was in *Europe on $5.00 A Day*, but I think it was. It was already towards evening then, the day after the shortest day of the year, and around 4:00 p.m. when we wandered there. It was snowing lightly and beautifully against the dark Paris stones. The rue des Acacias bent gracefully. We went into the hotel and I practiced my phrase-book French, "Avez-vous un chambre pour deux? Combien?"

The room was about $5.00 and that seemed exceedingly expensive to us, but we were just exhausted; I was too exhausted to walk another step, so we agreed on it. It was quite a lovely hotel and room; I remember going to the casement window, opening it wide and looking out over the chimneys and rooftops with Paris all lit up and glowing and beautiful snow falling, somehow not really still believing it: we were actually in Paris. The view out the window was so beautiful, I would have been satisfied if we had done nothing else for our trip.

For a moment we thought about going out for food, but we were exhausted and just lay down, fell asleep, and didn't awaken until late the next morning.

Amazingly, when we awoke, we discovered we were still in Paris; it hadn't been a dream, so here we were, two kids in our early twenties having grown up with the corn of the vast Midwest. Franklin had at least been to Mexico; I had never really been anywhere outside

the country except to Canada for a day. But suddenly the boring sameness of everyday life had vanished; everything seemed different, unexpected, sensuous, new, its routine peeled away. Just being there standing on the street was an adventure.

Well, according to our infallible guide, *Europe on $5.00 A Day*, we could find a cheaper hotel on the Left Bank so we headed for St. Germain des Pres near the Sorbonne, and thus a student center in Paris. We walked down the steps into the Metro, after first admiring and running our hands over the beautiful turn-of-the-century art nouveau entrances designed by Hector Guimard, purchased two second-class tickets, and consulted the Metro machine for finding our route. You pressed a button indicating where you wanted to go, and the entire route with transfer points lit up on a glass map of the whole system in red, yellow, or green lights. The Metro had a substantial tunnel system for getting passengers to their trains, and iron gates near the boarding platform closed automatically as the train pulled out of the station to keep frantic riders from mobbing the train and not letting it leave the station. Metro riders were usually frantic.

The first hotel we checked out on the Left Bank was awful, a closet with a bed in it that slanted severely downhill. But, then, at 52 rue Dauphine we found Le Hôtel du Grand Balcon. This time, more cautious, we asked to see the room, it was a beautiful light room with French windows that looking down on rue Dauphine from the fourth floor, by U.S. ideas of floors, at $2.22 per day.

In our room was a sink and bidet, down the hall was the toilet, the halls and stairs were lit by a lumière (a timed light), which we never timed correctly; consequently we were always running down the stairs in the dark. There was not a lot of heat, so we spent much of our time in bed, reading with all of our clothes on, including extra sweaters. We had to wear all of our clothes outside, also, so instead of presenting a fashionable lean Parisian appearance, we looked more like Russian bears.

People asked us if we were from Marseilles, a more working class, tougher place than Paris. When they found we spoke English, they asked if we were from Canada; we thought about this, why Canada, and decided they were hoping against hope they hadn't run into more awful American tourists. We replied we were from Chicago;

that was all right. They would laugh and do a machine gun imitation, "Rat-tat-tat! Capone!" Being from Chicago made us okay; it made us human. Often people would ask, "Why are you in Vietnam?" and, of course, we would explain we opposed the war. The walls in Paris had "U.S. out of Vietnam" graffiti all over the place.

Our room was a long walk up; only one other floor above us; all the rooms on this top floor were already rented by students. That first day, we parked our bags in our room, paid up, and rushed back outside, hungry to experience Paris, by this time, actually very hungry for food. The last time we had eaten was when BOAC had fed us on the plane crossing the Atlantic close to two days ago. We went to a very small French bistro down a couple of stairs, with three tables, and ordered bread and cheese and wolfed it down. We felt better with each bite.

Our hotel was located at the remarkable intersection of rue Mazarine, rue Dauphine, rue Buci, rue St.-André-des-Arts, and rue de l'Ancienne-Comedie. This last was a very short street, but the name was such a wonder, evoking for me a whole array of images.

There was still a slight touch of snow on the ground. Parisians didn't seem equipped to deal with it; no shovels were used, only brooms, but it melted quickly. It stayed cold, though, and damp; colder than we had anticipated. It proved to be the coldest winter in France in fifteen years.

We were not dressed very warmly as we had expected it to be milder than Chicago. Franklin had only his black leather jacket, purchased from Sears, Roebuck & Co., and a white silk scarf with a letter "H" embroidered on it; it was his brother Hank's; I had only the fringed wool shawl Franklin's mother had made for me, not very warm, but very elegant and bohemian; we had to walk very fast to keep warm.

Incredibly eager to see everything in Paris after a total life experience of American Midwestern sameness; a processed and canned version of daily existence that somehow presented itself as the only real possibility of life in the '50s and '60s. Our desire for something more had already caused us to be fascinated with anthropology and surrealism, the idea of the reinvention of daily life. In Paris, we felt suddenly wide awake and alert in a newly discovered world.

The smell was different, a crazy brew of onion soup, crêpes, and diesel fuel; the sounds were new, a delirious French language, often stripped of its meaning because it was too fast for us and appreciated for its pure sound and music, combined with horns of frantic French drivers seemingly engaged in honking competitions, tires on cobblestones. And the darkness: Paris is actually farther north than Chicago and thus has less winter daytime.

To compensate, there are lights and mirrors everywhere, highly polished. Plenty of things to do. Commenting on the Left Bank, I wrote in a letter home, "There are more than two bookstores per block." They all had *Le Surréalisme et la peinture* by André Breton prominently displayed in the center of their windows. It had just come out in a new edition. Posters announced there was being held, at this very moment, the 11th International Surrealist Exhibition, right here on the Left Bank at the Galerie l'Oeil at 3 rue Séguier, just a few blocks from our hotel. We couldn't believe our good fortune and immediately walked over. This was December 24, Christmas Eve.

Absolute Divergence

The exhibition was called *L'Écart absolu*, absolute divergence; its poster and the cover of the catalog featured a portrait of Charles Fourier, the French utopian socialist; but the portrait was redone in the spirit of absolute divergence in a harmonic variation, creating an unusual pattern and compelling image; the face became a geometric form in its infinite variations, refracted as is light by a prism. Several other of these harmonic portraits invented by Pierre Faucheux were in the exhibition and catalog.

Inside, near the entrance, was a shimmering bead work by Max Walter Svanberg and an intensely dark ink drawing by Adrien Dax; standing nearby, a glass case that contained a small army of amusing bread dough figures by Reinhoud. Along the wall was the control panel of a machine, a collective object of the Surrealist Group called the "Disordinator," perhaps the opposite of coordinator. When one pressed a button or two on the panel, special glass windows would light up containing surrealist objects; it bore a humorous analogical resemblance to the ingenious Metro machine meant to give

passengers their coordinates and get them from one place to another. It was made up of ten windows or cases; some of the captions were "Critique of the Machine," "The Conquest of Space," "Disordination of Work," "Disordination of Leisure."

The exhibition contained many classic works of surrealism, Marcel Duchamp's *Why Not Sneeze?* a ready-made from 1921, a small white cage filled with white marble cubes and a cuttlebone, a Max Ernst frottage from 1926, *L'Jole*, a Man Ray work, *L'Impossibilité* from 1920, even a precursor of surrealism, Gustave Moreau, with *Le Sphinx vainqueur*. I laughed merrily at Wolfgang Paalen's *Nuage articulé*, an umbrella made of sponges.

An object by André Breton from 1931 consisted of found objects arranged in a manner that indeed fulfilled its name, *Objet à fonctionnement symbolique*, an exotic fetish of erotism.

The antipatriotic object, the *Arc of Defeat*, the famous Arc de Triomph redone with a wooden leg suggested by Mimi Parent and assembled so it filled the center of the room and stood perhaps eight feet tall.

Then in the next room, we found a huge pink robot sprouting police sirens, while the walls around it lit up with little white lights, BIP!-BIP!-BIP!, this monster, a collective surrealist object called *The Consumer!* Its body consisted of a pink overstuffed mattress with upholstered arms and square head encircled by cone-shaped police sirens; its one staring eye, a TV set; its stomach was a washing machine filled with daily newspapers; its back contained a refrigerator that opened revealing a bridal gown and veil, truly a fine piece, wonderful; so savagely accurate in its humorous appraisal of the "modern human," reduced to the role of "consumer."

In the same room was a large Alechinsky called *Central Park* done in 1965; years later I came across it in a book I was reading at Northwestern University and said to myself, "What a wonderful thing!" Then, I remembered where I had first seen it; it was like recognizing an old friend.

Standing motionlessly in a quiet room, looking at first glance like a suit of armor, stood *The Necrophile*, a work by Jean Benoît, a man's form clothed in light gray from head to foot; its cloak and suit were gray blocks of stone, its face half mask, its mouth opened to

reveal a flame-red tongue, its collar a field of tombstones. At its waist a chain hung with hammer, knife, and other tools, in its right hand was held a staff, on top of which a gray devil held a white angel, from the crotch hung a long, gray, segmented penis-tail that looped, nearly touching the floor. On its face an odd expression, ready to laugh.

Leonora Carrington was represented by a painting, *El Ravarok*, filled with marvelous people and animals, a carriage drawn by a woman-horse with prominent female breasts.

A painting by Toyen glowed from its dark canvas, a shell, a dark flying bat, a purse with glowing red tongue, luminous white evening gloves, a dark phantom woman's face with golden eyelids. A work done in wood burning technique by Mimi Parent, *En Veilleuse*, a proud woman glowed with surrealist passion.

On a dark wall hung a cabinet by Jorge Camacho *La Souriceir d'amour* (1965), a cutout painting by Jean-Claude Silbermann, *Au plaises des demoiselles* (1964), a Konrad Klapheck sensuous machine painting, *Le Visage de La Terreur*, a wonderful Robert Legarde object box, *Maison close sur la cour, en visite le jardin* (1965).

The surrealists in the show were from all over the world; surrealism had always attracted an international following, people from everywhere joined together by their "passional attraction" for the surrealist project. "Passional attraction" was a concept of Charles Fourier, through which human society would be linked together by its desires, loves, and interests rather than the chains of nationality and religion, ghosts of a blood-soaked past.

After we went through the exhibition twice very thoroughly, we talked with the gallery managers, telling them we had come to Paris in hopes of meeting the surrealists, but that our correspondent, Robert Benayoun, seemed to be very ill when we phoned. No, they insisted, Benayoun was not ill, he had been seen very recently. They gave us Benayoun's correct phone number.

When we got back to our hotel, we called him, rather our hotelkeeper called him, and then we talked (French phones remained difficult); he invited us over to his place at 179 rue de la Pompe.

We went over as soon as we could. My first impression was that he had a lot of books; Benayoun's large apartment had books stacked up everywhere, on the floor, between the furniture, behind

the drapes, very appealing to us book lovers; we had to suppress the desire to browse. Fortunately for us, Benayoun spoke a flawless English. Initially we talked about *Positif,* the film journal he was editing, and he gave us the names of several bookstores. I liked him at once. He was delightful company, we had a very fine time. A Surrealist New Year's Eve party was being planned for December 31 at the Théâtre Ranelagh; he invited us and gave us the address. About our phone call to the Robert Benayoun who was ill, he said, "I'll have to call and see how I'm doing."

For us Paris was an absolute divergence, *l'écart absolu* from our lives up to that point. Sometimes I think about the amazing chance of it; the certainty that if we hadn't been rejected from England, we would not have seen this international surrealist exhibition, or visited 42 rue Fontaine, and would have missed entirely so many of our other experiences in Paris. We might not have met André Breton and the Surrealist Group. But circumstance or desire or fate or all combined together into objective chance conspired to get us to Paris to see this exhibition, the last that André Breton himself inspired and organized.

New Year's Eve, 1965

The Surrealist New Year's Eve party was held at the Théâtre Ranelagh near the Bois de Boulogne across Paris from our hotel. This was the first time we would meet the surrealists. I wore my light-gray wool dress with a red paisley pattern and suede boots, felt hopelessly out of fashion by Paris standards, where every woman working in every shop looked like a fashion model; I felt rather nervous and anxious.

We arrived around nine or ten at the Ranelagh, a very romantic-looking place, even more so, as the outside was entirely dark. Benayoun told us the antique theater was one of the oldest in Paris and, indeed, guidebooks tell of Marie Antoinette's masked balls there. It was now owned by a friend of the surrealists, Henri Ginet, who was thus our host for the evening and who had contributed a work to the *L'Ecart absolu* exhibition.

We met no one as we entered and followed the lights downward into the theater. I was impressed by the tiers of broad stairs carpeted in red, with huge crystal chandeliers on every landing; after the

darkness outside, the effect of these blazing chandeliers was dazzling; the carpeted stairs and chandeliers seemed endless as we walked down from level to level, lower and lower into the depths of the building, certainly a dramatic setting for a grand entrance. (Were we off to see the Wizard?)

Then the huge dark theater, we walked down a long, long center aisle, me wanting to turn back and perhaps reconsider all this; Franklin nervous, too, we held hands to encourage each other. From the stage we heard Jean-Claude Silbermann say, "Chicago!" Benayoun had told everyone to expect us.

On the stage, a buffet dinner was set on a long table. We came up, all eyes on us, nervous as could be but then we were given a marvelous welcome by all in the surrealist tradition: kissed twice, once on each cheek, and greeted warmly. I felt incredibly awkward at all of this, but it made me feel so good, so welcome; I bumped noses with Jean Benoît while trying to get my kisses exchanged.

Benoît bounded up with some champagne and gave me a couple more kisses. He said to Franklin, "I like you, Chicago!" and grabbed a chunk of Franklin's face, announcing to all, "I like him. Yes, I like him, he is *trés sympatique*. Yes, I like you, Chicago, but I like your wife better." Mimi Parent, his companion, laughed. "Just ignore him," she said. Not easy, as he was good sized, stocky, wearing a short pink dress with puffy sleeves and using two balloons as false breasts which he kept shifting around "to see where they looked best." Big legs with heavy black hair glared out from under the short pink skirt. Further, Benoît had the habit of grabbing me by the arm and dragging me off to say hello to someone on the other side of the stage.

Several years earlier Benoît, I knew, had branded himself using a hot iron with the letter *S* for Sade during a ritual in celebration of the Marquis de Sade. He had performed this ritual at the time of the last surrealist exhibition; I asked if I could see the scar. Obligingly, he pulled down the front of his pink dress and showed a now faint *S* among the hairs on his chest. Then he related the great tale of how he prepared for a long, long time, preparing both his costume and his mind, spending days and nights obsessed with the idea, working himself into a frenzy of anticipation and desire. Those in the group

who witnessed his ritual found it profoundly hypnotic and symbolic. After the dramatic moment in which Benoît burned the *S* into his chest, a much-inspired Matta jumped up to join him, seized the hot iron, and pressed it against his naked chest also, Mimi added. But Matta hadn't prepared for it, was badly burned, let out a horrible scream, and fainted.

Benoît told us he and Mimi had come to Paris from Canada to meet André Breton and join the Surrealist Group, but while they stayed in Paris for ten years, he was too shy to contact Breton and the group. Finally he met André through his daughter Aube. I certainly understood this suffering. Now, however, Benoît was madly overthrowing his inhibitions. He arranged one balloon in back, one in front, and sat down in Mimi's lap. Bang, One of the balloons exploded.

There were perhaps forty people present, surrealists and their close friends. We did our best to meet and greet everyone. Radovan Ivsic was there with a camera, taking pictures all evening, tall, extremely thin, pale, and quiet, with a disconcerting way of standing absolutely still and motionless, Radovan had come from Yugoslavia. We met Alain Joubert, Nicole Espagnol, and Giovanna and Jean-Michael Goutier who had done a mysterious dance performance together at the opening of the surrealist exhibition. Benayoun arrived quite late and Breton did not come at all; Benayoun said André wasn't well and didn't care for parties.

Franklin and I both gave the impression that we were shy and retiring types in part because we had not yet realized that the normal speaking distance in France is much closer than in the U.S., so as people stepped toward us to speak, we stepped back. I remember being disconcerted at finding myself backed up against the table or in a corner by various French surrealists talking animatedly about group plans, not really intending to be particularly forward; they danced their conversations more beautifully and animatedly than we in the English-speaking world dance ours, with a wealth of gesture, using hands and head and generally more of the body.

The great Czech painter Toyen was there, with her wonderful warm but quiet ways, not dressed up at all, but wearing a white shirt and dark slacks, the same simple, practical outfit she wore to group

meetings and everywhere. José Pierre and Jean-Claude Silbermann held glasses of champagne and talked animatedly.

Franklin and I had more champagne, not much, as we weren't used to the taste, and ate some food, or tried to. It was a cold buffet, with rye bread spread with cream cheese and caviar. I distinctly remember the caviar because I recall trying to very discreetly scrape it off onto the neighboring piece with a huge knife, the only one I could find. We were both quite hungry and had to repeat this performance several times so our subtlety was observed to the amusement of all.

There was a grand piano and Franklin played boogie-woogie and rhythm and blues tunes that echoed through the hall, spicing up the end of dinner.

At midnight, everyone kissed one another again with excitement and enthusiasm and wished each other *Bonne Année*, 1966 had begun. What a year it was to be! After that, the table was removed, and the stage readied for the entertainment that had been planned and rehearsed. It proved to be both lavish and funny. Various surrealists from the group got up and did skits, charades, or told stories; there was plenty of riotous laughter. We, of course, were in trouble; humor and songs of another language are something that really need to be pondered by anyone who is not a native speaker. But it was enjoyable just to watch, seeing the expressions and gestures, bold and flamboyant. Jean Schuster did a charade performance based on the *Communicating Vessels*, a work of Breton's; it was the "non-communicating vessels."

A particularly lively chorus-line dance was performed by some of the women of the Surrealist Group, five of them dressed in black tuxedo chorus-girl costumes, legs in black fishnet stockings, long tuxedo tails in back, high silk hats, white dickeys with bow ties and slim black canes. The tall, slim Mimi Parent was at the center, with her long, spectacular legs. It was funny and extremely well done.

Then more skits and songs. At one point, an inspired woman in the audience, slim, tiny, and blonde, who had not been part of any of the performances, got up on the grand piano and began a charming and provocative striptease. Gracefully she removed her garments one by one, down to her bikini panties; by this time, she

had everyone's attention. Suddenly, she became self-conscious and refused to go on, resulting in moans and loud protests. "What a silly time to become shy. Take the rest off!" someone in her audience called out. It was her husband.

More skits and performances were coming up, but we were tired out, hadn't realized the party was planned to go on until dawn; also we were exhausted from trying so very hard to follow the French, not used to saturation levels at all. It was also difficult to remain because, in some ways, we suffered from a puritanism of youth and thought of ourselves as very serious revolutionaries; it was hard to just relax, have fun, and be deliriously silly. A year of frustrating jobs had made me grim. I felt a heavy burden of desperation; I was much older and more serious then than I am now, having realized at last that one can't be desperately serious every moment, one must be desperately happy now and then. A favorite line of Spinoza comes to mind, "Pleasure in itself is always good." Because of remnants of my healthy beatnik hedonism, I was able to enjoy the spirit of the evening without analyzing it to death. So it is with pleasure. Sometimes I had to remind myself that revolution must not be grim but a liberation, an increase of pleasure. Otherwise what is the point of it?

That night was not particularly cold, and it was especially pleasant to be so excited and walking through the calm night after the intense experience of the surrealists' New Year's Eve party; a relief to have the time to think about it, talk about it with each other, piece things together, go over the skits, the jokes in the French language, and to understand and laugh. We walked and walked, and Paris seemed to be there for us alone; we didn't meet another soul and soon discovered that the Metro was closed and buses weren't running. One reason the party went all night.

As we walked through the dark streets, we turned a corner, and there lit up in a blaze of light stood the Eiffel Tower. We laughed and laughed; it had taken us by surprise. At around 5:30 a.m., we noticed people beginning to queue up at the entrances of the Metro, mostly working-class Algerians. Soon it was dawn and we were climbing the stairs to our room just as Paris was beginning to stretch and wake up, and I fell asleep dreaming mad dreams of surrealist skits that became more and more fantastic.

Jean Benoît strode onto the stage in his Necrophile outfit, his tail-penis beating softly on the stage as it coiled and uncoiled, looked around the Ranelagh, and laughed a low, evil laugh; slowly he raised his arms, and his costume peeled off like a lizard's skin. He was left wearing the little pink dress with the short skirt and puffed sleeves; he did a little dance in imitation of a child ballerina. Then, gradually, his skin turned gray, became transparent, brittle. Suddenly, he writhed in horrible pain; his face grew a bony mask; his nails lengthened; breathing heavily, he ripped away the dress, his penis-tail springing out and beginning to slither, cobra fashion. He roared, a deep echoing boom, "The Necrophile lives again!" But then, in this moment of mad triumph, he raised his arms; his costume, his very skin, peeled off, and the transformation repeated itself, again and again and again. Agony!

Then Mimi gracefully strolled onto stage; she was ten feet tall, dressed in a skintight costume of glittering red that changed from moment to moment like flowing blood. The Necrophile took a deep breath, screaming with joy as he grew tall, to the same size. They danced together Javanese-style, with many complex postures and hand movements. Benayoun entered on roller skates, carrying a book which he opened and began reading: *Maldoror*. The words formed in the air, "*Je te salue . . .* " then one by one the letters dropped to the floor and became cartoon characters.

A huge, beautiful blue fox carrying long evening gloves in its teeth and wearing golden eye shadow came on stage—I recognized at once that it was Toyen. Alain was a trumpet; Nicole, a silver harp. Mimi and the Necrophile laughed, stamped their feet; the old Ranelagh theater shook.

There was a distant rumbling, then very close, a grinding and rumbling, the giant Consumer monster from the exhibition had arrived, with its pink mattress-stuffed body; it rolled on stage, bursting in with its voice of blaring sirens and its TV eye projecting a glaring red beam; it was two feet taller than Mimi and much more powerful than the Necrophile. I worried. But they cast powerful enchantments at it in the form of poems; the most glorious words I had ever heard flowed from them, words that could create new universes.

Suddenly the Consumer began to shrink; it shrunk until it was

only a foot and a half tall, became gentle as a puppy, and frolicked around them in circles spinning like a delighted dervish. Round-faced Benayoun was now doing disappearing tricks like the Cheshire cat, always smiling; often only his smile was left. The stage was becoming more and more crowded with surrealists performing wonderful feats of magic and poetry. I realized the Necrophile and Mimi were still growing; the others too were growing, the old theater would soon burst at its seams! Any moment giant surrealists armed with the magic of their imaginations and the powerful laser of their humor would be loosed on the streets of Paris. I woke up with a start. Laughing!

During our first weeks in Paris, we were visited in our room at Le Hôtel du Grand Balcon by Jacques Brunius; it was a tiny room; we all sat on the bed, but this didn't prevent us from having a good conversation. Brunius, who was living in London and had just married, was happy and full of enthusiasm; he didn't have the manner of someone who was in his sixties. Although he didn't look young, he had an engaging and vital spirit. In Paris to do a radio program on *Alice in Wonderland*, on which he was an expert, he had to leave the next day for London.

We were also visited by Andrew Leake who pounded on our door demanding, "Any anarchists here?" He was in Paris with his mother who we ran into in front of *The Necrophile*, Jean Benoît's piece at the exhibition. Late one night at 2 a.m., the police came by and asked us and everyone else in the hotel to see their papers (passports). I have no idea whether this was routine or not.

The neighborhood where we lived was very old, the most ancient stones of Paris. Right around the corner from rue Dauphine on rue Buci was a wonderful Parisian market; the shopkeepers would open their doors, rolling them up like garage doors; their shops would be open to the air and heavy foot traffic of the area. All sorts of fruits and vegetables and meats were displayed, hawked, and sold.

My efforts to shop were humorous; I was not prepared for an entire shop full of bread, bread alone, smelling like heaven. I went in and lined up with all the smartly dressed Parisian women. There were stacks of beautiful breads behind the counter everywhere, long breads standing on end, round breads facing out. I realized with a sinking feeling that my textbook French, "*Un pain,*" was not going

to get me far with this large a variety. Listening with careful attention to the person in front of me who confidently said, "*Un baguette.*" I pronounced the same words and was handed a beautiful, long bread, no bag. Magic. I handed over my money and was given change. I was thrilled, both with getting the bread and not having made a spectacle of myself, and ran up the four flights of stairs to our room, where we enjoyed the bread while it was still soft and warm. This became our usual breakfast-lunch, but we later added butter, milk which came in a triangular container, and oranges from Algeria, the best-tasting in the entire world and flecked with red spots inside like glittering tiny drops of blood.

Since no bags were given, one of my first purchases was a net bag of the sort that people there carried in their pockets, blue with tiny pearls.

The market was closed for a few hours in the middle of every day, seemingly disappearing often just before I got there and then, surprisingly, back in full force an hour later. It seemed very mysterious to me, expecting stores open nine to six. But all of Paris still lived a very sociable life, taking a two-hour break for lunch, two hours for everyone to have coffee, eat lunch, make love, talk, walk around, and then return to work until 6:30.

Our neighborhood also had a charcuterie, a boulangerie, and a pâtisserie. I mistook the pâtisserie for a jewelry store at first, it was so deluxe. Each fancy little cake sat on a mirror in front of a mirrored wall. Ah, and when you purchased one of those little cakes, and they weren't cheap, they would be packed very carefully in a little box tied with string with true Parisian precision. One felt as if one had just purchased a diamond necklace. I remember my mother making these cakes occasionally at home and the hours she lavished on them.

On rue Dauphine, on the way to Pont Neuf, there was a wonderful antique toy shop with gaily colored paper theaters and marionettes, most made of printed colored paper. Punch and Judy, harlequins, fine ladies in ball gowns, chevaliers, all quaint and old. The owner would always demonstrate these wonderful things for us with perfect skill and drama. He kept up his demonstrations and performances long after it became obvious we were not buyers and were just in for a visit. It was plain that he loved these things. Perhaps,

like the reluctant bookseller, he would not have been entirely pleased to part with them. It seemed that in matters large and small, and in careful attention to detail, Parisians had long ago discovered the necessity of luxury.

On the corner of rue Le Buci and Dauphine, right next to our hotel, was the Café Buci where I occasionally had a *café au lait*. Later I learned it was quite the center for drug traffic on the Left Bank. Out front one day, we ran into Lester Doré, our friend from the Beatnik Café in Chicago; Lester was selling the *New York Times* on the street. He said it was just about the only job Americans could get in Paris. He added that Green had been through Paris not long before, but hadn't liked the cold weather and headed down to Tangiers where he had found a good place, a house, and lots of good, cheap hashish. Lester was trying to get together enough money to go and join him. We talked with Lester about the Provos and their activity in Amsterdam. Lester had lived with them for a while and thought they had a fine community going, building an alternative culture and society with great success. We didn't see Lester again; he was gone, off to Tangiers. We didn't hear from either him or Green until we got back to Chicago. By then, Green had been deported from Lebanon to the U.S., madly carrying hash while handcuffed to his guard. Apparently, since he was already under arrest, they didn't search him.

The Surrealist Café, Le Promenade de Vénus
At this time, the Surrealist Group met at Le Promenade de Vénus, just outside the Les Halles district at the corner of rue de Louvre and rue de Coquillière. Surrealists began to arrive about 5:30 and went to the rear of the café, partitioned off from the front by a booth that wrapped around the outside wall.

It was a great walk. To get there Franklin and I passed the ever-busy Les Halles market. Once we walked to Les Halles at 4:00 a.m. and found an incredible beehive of activity. Huge floodlights converted the darkness into daytime, men carrying sides of beef across their backs and rolling huge round cheeses down the street on little carts. You really had to take care and watch your step or be run down by one of hundreds of people pushing, pulling, or carrying the stubborn produce to the huge market called the belly of Paris.

The Promenade itself stood out with a certain élan and the smell of onion soup gratinée that pervaded the entire neighborhood. With its many paneled mirrors and booths, the café looked as if it had survived from the turn of the century untouched. Surrealists arrived individually and in groups as they finished work for the day. Everyone shook hands with everyone present while exchanging greetings. This worked well early on when those present were small in number, but as the group built up to 15 to 20 people, new arrivals caused incredible commotion and completely disrupted conversations being carried on. This, however, didn't seem to trouble anyone. We came and met all of the surrealists in Paris at that time who attended meetings. Among them, those most prominently active were Jean Schuster, Gérard Legrand, Vincent Bounoure, Jean Benoît, Mimi Parent, Robert Benayoun, Claude Courtot, Konrad Klapheck, and Joyce Mansour. Younger members were Nicole Espagnol and Alain Joubert, who was a poet and champion kickboxer. Joubert put together the best book on those days *Le Mouvement des surréalists ou le fin de l'histoire*. Georges Sebbag, now a noted scholar, was our age.

Among other members were Michel Zimbacca, Jehan Mayoux, Toyen, and Elisa Breton. The group was largely made up of people in their thirties or forties, most of whom had been in the group for seven to ten years and had been active in writing for *La Brèche*, painting, and doing surrealist research. They were diverse in their interests and opinions but held together by their love of surrealism and enormous respect for the genius of André Breton.

They were full to overflowing with poetry, beauty, humor, excitement, and life. All enthusiasts for the surrealist adventure, they would all talk at once, reminding me of home and my unrestrainable relatives. This unstoppable enthusiasm, however, gave my college French a fatal attack. I went through several degrees of panic as I realized I probably never would be able to keep up with what was being said. My French endured only one person speaking slowly and distinctly. Occasionally Benayoun would translate for us, but he often came late. Then Mimi Parent, a French Canadian who realized our dilemma, came to our rescue and very sympathetically took the time to let us know what was being said in that hubbub of conversation. Benayoun reminded us not to miss seeing Breton's studio before we

left Paris. He said the place was "full of wonderful treasures." Also, he told us about the Théâtre Universel which was entirely devoted to animated cartoons. We went there whenever the program changed, saw lots of Bugs Bunny, Daffy Duck, Tom and Jerry. This theater was wonderful; every city should have one.

Schuster and Legrand often talked about their projects. Plans for publications, correspondence, and articles were regularly brought in and read and discussed. They wondered about how surrealism was viewed in the U.S. and what was happening there in terms of surrealism. "Was Rosenquist a surrealist?" Konrad Klapheck asked. A few of the surrealists thought he was, but Franklin and I argued fairly convincingly that he was not.

We discussed pop art and surrealism, especially, since Nicolas Calas, who identified with surrealism, had come out with a book, *Pop Art*, and was now one of its promoters. We couldn't see anything revolutionary or even imaginative in copying commercial art and further glorifying the almost deified commodities. Was there humor in the confrontation with an enlarged soup can?

For me, there was hardly any humor and no confrontation. Everyone was able to experience a painting of a large can of soup quite comfortably while preserving, without challenge, their bourgeois ideas. To me, pop art seemed a pasteurized and commercialized art, a justification and glorification of a reprehensible system, the commodity economy.

The surrealists we met in Paris in 1965–66 proved to be close and lasting friends and correspondents as well as enthusiastic supporters of the Chicago Surrealist Group. André Breton's warm encouragement, his friendly questions, and his evident interest and hopes for the beginnings of a new surrealist group in the New World were very important to Franklin and me.

It showed that despite our youth and our difficulty with French, we were accepted into the surrealist movement that meant so much to us. Several of the younger surrealists, as well as Breton's wife Elisa, were fluent in English, and helped us understand and participate in the discussions at the group's daily meetings. I think that André also understood English a little but did not wish to speak it. Either that or he was a good mind reader.

Only a few of the new surrealist generation in Paris were well

known outside of France at that time, but most of them had already made major contributions to surrealism. Individually and collectively they were recognized for their originality and innovation, and increasingly were regarded as equals of the surrealists of earlier years.

Gérard Legrand, for example, often called Breton's "right-hand man," had distinguished himself as a significant surrealist theorist. In addition to collaborating with Breton on the very large and comprehensive book, *L'Art magique* (1957; revised/expanded 1991), he also published *Puissances du jazz* (*The Powers of Jazz*, 1955) and an important philosophical treatise, *Preface au système de l'eternité* (1971), as well as many articles in surrealist journals.

Other surrealist theorists in those years included Vincent Bounoure, later co-author of *La Civilisation surréaliste* with the Czech Vratislav Effenberger. And the old-timers, Jehan Mayoux, and his wife, also well known for their long involvement in French anarcho-syndicalism. In the realms of humor and popular culture, Robert Benayoun published numerous excellent studies of cinema, nonsense literature and animated cartoons (especially the work of Tex Avery).

Painters: Toyen, Mimi Parent, Jean Benoît, Pierre Alechinsky, Jorge Camacho, Konrad Klapheck, Marianne van Hirtum, and Jean-Claude Silbermann were all very active.

Joyce Mansour was not only an outstanding poet in the group, but also, according to Benayoun, a champion runner. Later, in the *Bulletin de liaison surréaliste*, Mansour made it a point to celebrate the Chicago surrealists' activities and publications. Annie Le Brun became a noted writer (her *Castles of Subversion* is a classic study of Gothic novels) and effective spokesperson for surrealism.

Georges Sebbag, one of the few in the group close to our own age, was quiet at meetings, but clearly had a lively intelligence and a good sense of humor. Some years later he published a whole series of large and important books on André Breton and Jacques Vaché—a friend of Breton's during WWI who was extreme in his hatred for the war and the civilization that created it.

André and Elisa Breton

Franklin and I met André Breton on Monday, January 10, 1966. He already knew we were in town from Benayoun and perhaps Jean

Schuster. I was sitting on the left when he came in and began greeting the friends. I was about to shake hands when, with a very elegant gesture, he lifted my hand and kissed it. "Ah, *anarchiste!*" he smiled at the political button I was wearing which read, "I am an Enemy of the State" and asked if we had been to the surrealist exhibition. We replied we had already been there several times. He smiled, pleased. He asked if we had come from the U.S. to see the exhibition, but we replied that we had not yet heard about it in the U.S., that we had come by chance—the surrealist method.

Elisa Breton was with him. She spoke excellent English and was graceful and gracious, with sparkling eyes that laughed beneath her bangs as she greeted us. Breton didn't come to the café very often, especially since the arrival of snow and cold weather, as he was bothered by asthma. At this time, Breton was "a magnificent old lion" as Benayoun had called him. He looked like the photos I had seen, but was even more grand and inspiring. We went over and sat near him so we could hear what he was saying. There was plenty of room, as most of the surrealists hadn't arrived yet. In fact, Benayoun, who had hoped to introduce us and help translate, arrived late that day and sat at the far end of the room, occasionally smiling with amusement at our predicament.

That day, Breton had come to go over the plans with surrealist friends for making a movie of the *L'Écart absolu* exhibition. We were able to follow his elegant and careful French and listened with pleasure to the animated discussion.

When Benayoun had arrived, he had handed us a letter from Chicago. It was from Franklin's mother. She enclosed a review of the *L'Écart absolu* Exhibition from the *New York Times*. No one in the group had seen it yet, but they were all very interested, and so we were glad to be able to pass it around and talk about it.

Elisa often asked us how we were and what we were doing. When we mentioned we visited the zoo, she said it was the first place she and André usually visited in every city. Once she asked us, "Are there surrealists in the U.S.?" "Well," Franklin replied, "there's the two of us and several of our friends. We plan to form a group when we get back."

I asked if she had ever been to Chicago. She said she and André

had been in Chicago on their way to Reno to get married and they had stayed at a hotel that had doors like a bank vault, six inches thick of steel, from the "gangster period." For all that, they had forgotten to lock the door, and someone employed by the hotel came by in the evening and admonished them. (I concluded it was Al Capone's old hotel near Roosevelt Road.) They stayed for a couple of days and told us they found Chicago much more interesting than New York.

They saw the Field Museum and especially admired its fine New Guinea and Oceania art works, particularly two masks from the Sepik River, for decades hidden in a corner of the basement. They were still there in the same place when we got back to Chicago. I must admit I liked the old Field Museum the way it was. There was something good about being able to find the objects that I loved as old friends, year after year in their same place. The new concept of museum as "sideshow" is a failure as far as I'm concerned.

Elisa gave me their phone number and said we should get together. As we had no phone I would call her a couple of times a week, to talk, to tell her about what we were doing and to see if it was a good time to get together.

One day, we came into the café when André was already seated precisely with his back to the door. Astonishingly, he got up just at the right instant to turn and greet us! We were both surprised, a bit confused. Wondering how he did it; it was only later we realized he had seen us enter in the mirror he faced.

Another time, perhaps a month later, Breton was at the café. The group was discussing the new magazine they were planning. They still hadn't completely settled on a name for the journal that would be *L'Archibras*. I managed to get so excited by the discussion, I pitched in my suggestion. I said in modest French, "How about *Tamanoir* (Great Anteater)? It would be good to have a journal named after an animal." Well, of course, I thought no one had heard me. The discussion went on as full high-speed French. But André had heard me, so he quieted everyone and said, "What did you say? What was your suggestion?" I repeated it, probably blushing at the sudden quiet. André smiled and said, "Yes, it's a good suggestion. It's one of the ones we will consider." The group finally settled on *L'Archibras*, a wonderful word image that I, of course, had never heard of; they

LE SURREALISME
en octobre 1967

Issue two (October 1967) of the Paris Surrealist Group's magazine L'Archibras, *in which Penelope and Franklin Rosemont's essay "The Situation of Surrealism in the U.S." appeared.*

had to explain it. That was a very funny discussion. It was very hard to explain. It was a Fourierist term, an eye on a prehensile tail, or *a prehensile eye.*

Franklin recalls my commenting after meeting Breton, "You almost never get to meet the people who write the books you love!" Things like that are truly a life-changing experience. And besides this André had warmly welcomed us into his circle of friends, a circle like Freud's, one that included some of the most brilliant minds of the 20th century. A circle that had transformed modern concepts of beauty and freedom forever, expanding them, overthrowing them, seeking to discover the true nature of creativity and freedom. A circle of friends that could truly be called magical. So you see magic circles do exist. And their effects are lasting.

I'm not quite sure where I acquired my obsession with the mystery of the printed word, but I am a worshipper of its delights,

fascinated by books, bookstores, and the ability to put thoughts, feelings, and scenes into words that will be meaningful to oneself and remarkably, even to others. As a child, it seemed an impossible dream to meet someone who had actually mastered the arcane science of making poems and books, an idea that seemed as remote as taking a journey to Uranus. No one I knew had known anyone who had done such a thing. Not only do you meet the great minds of history when you read their words, but you carry on a dialogue with them and their thinking.

Even now I'm amazed at the ability of the word to conjure up images, images leading to thoughts, to ideas, to states of mind, to a whole psychic chain of perception that, in fact, is capable of renewing the world. Thoughts that were created and written down 7,000 years ago can enter our minds today and we can experience their meaning. Perhaps in a way that is historically bound, but this exists actually as a window in time, a time machine. Words spin webs of connections that persist, create anger and joy, set worlds into motion, conjure futures, waterfalls of words cascade around us, we exist in a whirlpool of words. The vortex becomes a vertigo, a vast luminous ocean of words.

The next time we saw Benayoun after the New Year's Eve party, he asked how we got home. We described our walk through Paris and of seeing working people queuing up at the Metro entrances before dawn. He said it was not very long ago when the paramilitary groups would go to those Metro entrances, pull the Algerians out of line, take them away, beat them, shoot them, and throw their bodies in the Seine; there many were found floating. I had read about the Algerian war, its horrors and tortures, but hadn't realized the extent of this fascist activity in Paris.

Benayoun, who was Moroccan himself, told us at length about the "Declaration of the 121," an important document signed by the leading French intellectuals denouncing the war and the government's fascist policies. The Surrealist Group, he explained, had a leading role in initiating, proposing, writing, and gathering signatures

for this document. The role of the surrealists was certainly not well known in the U.S., although the declaration did appear in *Evergreen Review*, and was noted in the *Industrial Worker*. Oddly in the U.S. this document became associated with Sartre and the Existentialists.

Benayoun told us that André Breton liked to be called André, not Monsieur Breton, and that he didn't like to autograph books, that his asthma was bothering him very much, and that he generally was moody around the time of his birthday on February 18 and rarely came to meetings at that time. We wondered what he must think of us; but what could he possibly think? We were so young, had so few accomplishments, and barely spoke French.

I talked with Elisa often but the cold weather kept them in. It didn't seem the best time to visit. There was cold and rain and flu everywhere.

Our communication problems affected almost the entire group; they all must have wondered about us. Why had we come? Why had we continued to attend meetings? What did we want to do? There was no way to explain it. Even to those who spoke English it was hard to express our deeply felt commitment to surrealism.

One day, after we had been in Paris perhaps two and a half months, depressed, thinking my French would never be adequate, I suggested to Franklin that we must write something and have it translated into French to be read at a meeting. Then our friends would understand and comment. We must do it. Jean-Claude Silbermann, Benayoun and others agreed.

I celebrated my 24th birthday in Paris on January 22. It was a gray but bright day; we spent the morning at the St. Ouen flea market in Montmartre. The market stalls were built permanently into a row of small garages; people were stamping and moving about in a lively way because of the cold; there was furniture, silver, bizarre stuff, and very few books. We went largely for the experience, not to purchase anything, but to enjoy the bizarre juxtaposition of stuff, to imagine Fanny Beznos at her stand, dressed warmly against the damp cold, the days of surrealism before World War II sandwiched into an odd period of history, the less than twenty years between the two great wars, a time of vast transformations. And now, 1965, was just twenty years after World War II ended.

Back in the Latin Quarter, Franklin purchased a book for me on the Jardin des Plants with many engravings. In the evening, we went to the "Échaudé," a restaurant downstairs in the rue de l'Échaudé; it served the finest onion soup gratinée imaginable. The restaurant was always packed with young people, the tables so close together it was a miracle the waiter could get through; then the rest of the evening we walked through the nearby streets glistening in the darkness.

One morning, through our forwarded mail, Franklin received a letter from his draft board; he replied that he was on his way to Tangiers for his health and could be reached there care of American Express. For more humor, the state of Illinois wrote suspending my driver's license for six months and Peoples Gas sent a bill for $600.00, then a fabulous amount of money for a gas bill.

Bernard wrote they had found a new location for Solidarity Bookshop at 1941 North Larabee for $30 per month and he added that Students for a Democratic Society, SDS, was now putting out a newspaper called *New Left Notes*. He commented, "I've seen a copy and, my god, it *is* notes!" Further, he thought all the names in the paper looked like a roster of the ruling class. A few friends had an anarchist group meeting; John White had suggested they call themselves the "Anarchist Horde."

Maureen wrote from Lake Forest College that Mayor Daley and Dick Gregory had apparently been invited to the college on the same day at the same time, but confrontation was avoided when the college asked Daley to cancel. Later she wrote to mention that she had been propositioned by a multimillionaire catalog heir, when she called about her loan for the semester's tuition. Maureen, sick of being pushed around, became assertive and raised a storm of protest.

Meanwhile, in quest of more and warmer clothes, I purchased a brown turtleneck sweater at a classy nearby boutique called Gudule on St.-André-des-Arts for the incredible price of $35. Also, turquoise velour slacks, a fabulous luxury. The new clothes were a huge improvement.

Franklin came down with a bad case of *la grippe* in January. He spent weeks sick, getting better, and then sick again. A neighborhood doctor, Dr. Robert-Henri Polge, who had his office on rue Mazarine, came and gave Franklin a going-over in a charming Sherlock Holmes

manner. He spoke excellent English, prescribed some medicine, and recommended that Franklin might try to stay in bed long enough to get well. While Franklin was ill, I got Vietnamese food to go on an oval china plate with a metal cover, this place was the Hanoi, decorated with metal sculpture made from wrecked airplanes, across the street was the Saigon. We were aware that Paris was not a "to go" city. Although the phrase book plainly said "à porté," when we tried to get a Coke "à porté," we were ignored. Finally, the exasperated bartender said in perfect English, "How are you going to carry it, in your hands? This isn't the U.S., we don't have paper cups."

The Situation of Surrealism in the U.S.

Franklin sat scribbling in his bed, as Marat had in his tub, and we began the task of getting together our document for the Surrealist Group. We now had plenty to think about and talk about. What should we say? The document, finished only a week or so before we left Paris, was called "The Situation of Surrealism in the U.S." It began: "The splendid Watts Insurrection of 1965 should be seen not as an isolated fragment of revolt but as part of a deeper, more complex pattern woven on the other side of the 'American dream,'" and it pointed out that "as Herbert Marcuse has shown in his important work *Eros and Civilization*, the material conditions in the world today are historically ready for a revolution greater in scope than ever conceived by parties and groups of the traditional Left, a revolution aiming at the total liberation of man or, in Marcuse's words, 'a non-repressive civilization.'"

"Everywhere one sees the formation of associations of resistance and combat (by American Indians, by gypsies, by Mexican Americans, by individuals opposing war, etc.)."

Meanwhile, capitalism was "tending toward the manipulation and control not only of the means of production, the machinery of the state, the military, the press, the trade unions and organized religion, but also of the sciences, of art, of every aspect of everyday life, state and ruling-class power . . . becoming more and more totalitarian."

Revolution was necessary; "all true art, all poetry, every human action worthy of the name must be directed . . . toward the earliest

possible realization of this revolution. . . . We recognize in Surrealism . . . a potent weapon of offense and a means of research, invention and discovery which can admirably serve to discredit, deface, dismantle and ultimately destroy the limitations imposed on man by immediate reality, expose the extreme precariousness of the human condition, and thus lend invaluable assistance to the realization of the fundamental tasks of the entire revolutionary movement."

We recognized that the situation of surrealism in the U.S. was in many ways different from that in France, that we were involved in a new period of "*une vague des rêves*" and "pure psychic automatism."

We planned to do a journal, a surrealist exhibition, an international bulletin, and vowed "we shall disturb ceaselessly and without pity the complacency of the American people." We concluded: "Elements of a new mythology are everywhere around us. It is up to us to give them a reality. More than ever, we can say with certainty: *Surrealism is what will be.*"

We gave our text to Jean-Claude, and he undertook the task of getting it translated and passing it around the group. A slightly abridged version appeared in October 1967 in the second issue of the new surrealist journal, *L'Archibras.*

It was a delight to realize that we had been there when *L'Archibras* was still a dream, when it was being named. I like to think that perhaps the students of the Sorbonne read our statement in *L'Archibras* and found there a confirmation of their own aspirations, ideas that expressed themselves in the uprising of May '68. In Chicago, we printed the "The Situation of Surrealism in the U.S." in our wallposter *Surrealist Insurrection* in January 1968 and in the first Black Swan book, *The Morning of a Machine Gun* that came running off the press by chance in May '68 as we heard and followed breathlessly the events of May in Paris, hoping that our friends in France would have the pleasure of being part of a successful revolution.

The threads of choice and chance flew back and forth across time and space, making these exhilarating days and delirious nights.

On our tiny radio we listened to Radio Luxembourg and an illegal station from England that was broadcasting from a ship in the middle of the English Channel. In every café, we heard the Rolling Stones on the radio or jukebox, "I can't get no satisfaction!"

Sometimes they played it when we walked in, a comment on our long hair and Franklin's leather jacket. There was no doubt, however, that the Stones were popular. A kid working in the Italian restaurant downstairs asked us what "Hey, hey, hey, that's what I say" meant in French. I translated. Something was definitely lost in translation. He walked out looking bewildered, convinced that English was indeed a strange language.

In turn, we felt the same about French. Reading French Bugs Bunny comics, Sylvester Pussycat was always saying "*Saperlipopette!*" We asked quite a few people what "*Saperlipopette*" meant and were told sort of "smash the doll," hardly funny in English, but certainly not the "sufferin' succotash" that Sylvester was famous for in English. In this we didn't "get no satisfaction."

In Paris I first saw homeless people; I didn't believe it. Late one night walking home, light, fluffy snow in the air, we saw an old man and an old woman stretched out in the middle of the sidewalk. Were they victims of some bizarre crime, murdered and laid out neatly next to one another, the woman's arm around the man? But it seemed impossible that any killer would be so careful. From closer, it was clear that their gentle faces and gray heads showed no sign of agony or violence. I stared down and noticed a tin cup near them with a franc in it; they were lying on a warm subway grate, sleeping. Sleeping an exhausted sleep on the winter streets, being murdered slowly. This had to be one of the worst crimes I could imagine, that the French state would abandon these helpless old people who looked like lost grandparents. We left all the money we had, not much, and went on, feeling torn apart by rage and guilt: rage that we couldn't do anything and guilt that we had a warm room to go to.

Later I saw others, some young people sleeping in doorways now and then. Never did I even consider that in a few years this tremendous shame would be found here in the U.S., too, with its vast riches. A society that forces people into homelessness violates the very premise upon which society is founded, mutual aid. A society that abandons its own people has lost its reason for existence.

So-called "primitive society" has no homelessness, the people them-
selves with the help of their neighbors build homes out of what is
available. Homelessness is an invention of "modern" society.

Enjoying the Riviera

Toward the end of January, we decided to go to the French Riviera
in hopes of shaking the flu and maybe catching a glimpse of the sun
and feeling warm for a while. In fact, it was not warm there, just a
little less cold and just a little more sunny. We hitchhiked down,
starting in Paris at Autoroute du Sud, and got a ride all the way to
Avignon, where we were dropped off in the middle of the night in
the cold pouring rain. The worst possible situation. I really thought
we were in trouble, sure we would both have pneumonia by the next
morning and would next be checking into a French hospital. But
as luck would have it, we were standing there in confusion for less
than five minutes when a large van driven by a woman stopped and
picked us up. She had us sit all the way in the back. Then she called
to us in several languages, in German, Spanish, French; she wasn't
getting through.

I said to Franklin, "I'm not sure what she's saying . . . ," when
she interrupted with a charming British "You speak English!" We
all laughed. She invited us to have some peanut-butter-and-jelly
sandwiches. Middle-aged, she was off adventuring on her own; we
enjoyed talking with her. She drove us almost to Nice, where we got
out of her van early in the morning and were soon picked up by a
Frenchman, who spoke only French, driving a truck full of vegeta-
bles to market. We squeezed in front with him and enjoyed the sights
as the high, old truck rattled along. Then we took a city bus and
arrived in downtown Nice, exhausted but amused by the adventure.
We checked into a hotel and slept.

I was charmed to touch the Mediterranean Sea at last, the sea of
the *Odyssey*, the sea around which great civilizations had developed
and decayed, but the sea was asleep. Winter lethargy. We enjoyed
Nice's old town, the flower market, the hills, climbing up to the ru-
ined chateau, but in no time, we were lonesome for Paris and on our
way back.

On February 2, we were in Marseilles. One of the first things
we saw was a Chuck Berry poster, ten feet tall. We got a distant view

of Château d'If where Dumas had set the first part of his Count of Monte Cristo, the world's greatest novel of revenge, dearly loved by both Franklin and me. We visited the hilltop zoo; there we first heard the noon sirens tick off a concert of wolves, hyenas, siamangs, monkeys, etc., in one grand howl! The hair on the back of my neck stood up.

Hitchhiking

We arrived in Marseilles by hitchhiking and later we got a ride with a maniac Frenchman whose job was selling religious junk. His classy sports car was full to overflowing with plastic Madonnas, St. Christophers, and crucified Christs on the seats and floor and in the back window; I pushed a pile over and climbed in back. He drove his car at top speed over the curving roads, taking them as straight as possible by ignoring the center line, which he crossed and recrossed as if he were the only driver in the world. Perhaps he thought the 800 white plastic statues of St. Christopher would protect him. He couldn't seem to understand why we were only too happy to get out once he finally pulled to a stop.

We were stranded for hours holding our "Paris" sign in Aix at a star-shaped intersection that had probably been there since the days of ancient Rome. Just couldn't get a ride in any direction, so we walked to the train station and took the next train leaving for Paris. So much for "the cure;" when we arrived, Franklin was sicker than when we left.

We got a different room at our same hotel, Le Grand Balcon, when we came back from Nice. The romance between the hotel keeper's son and a beautiful young woman was still hot, and we often found them sitting holding hands dreamily behind the counter. (There is a photo of two lovers on the Paris barricades that reminds me of them.) He welcomed us and added, "We have a different rate for long-term guests. You can pay by the week. It's cheaper." He talked us into taking a room on the second floor; the first floor of the hotel began a floor above street level. It was a nice, large room at the same rate we had paid for a tiny one.

I think they were probably quite tired of the noise we made bounding up and down the stairs 25 times per day. In a letter, I wrote, "Much nicer than our last mainly because it is larger with two

windows framed by red drapes. The room itself is gray with a large bed, a good-sized round table with three chairs, a chest of drawers which doesn't open, a bookshelf/cabinet with doors that fall off when you open them, an extra bed covered by a black-and-white shawl, and a closet closed with a drape of the same pattern.

"A small sink and a very sensual little blue lamp with a blue bubble of glass that seems as though it might have once burned alcohol. Though the furniture has a feeble quality, it looks all right which means we can invite people to visit us. I am forgetting the large gold thing which looks like it could be a lamp from a church."

For a special outing we went to the Théâtre Universel with Benayoun and saw a Woody Woodpecker festival of cartoons. We also saw Jerry Lewis movies, which were very popular in Paris and very popular with Benayoun. We were puzzled as to why old Jerry Lewis movies should be so popular in France. Benayoun thought it was because the French enjoyed seeing Americans as the *big baby* that Jerry Lewis represented so well on screen. And, indeed, Americans, with their large size, arrogance, lack of language skills, and confusion, must certainly have appeared this way to many French people.

We saw a Marx Brothers movie, also extremely popular in France. For this one, *Love Happy*, the small theater was packed to capacity. Marilyn Monroe had a walk-on role after which Groucho commented, "If this were a French movie, this scene would have been longer!" The whole audience erupted with laughter that wiped out the next three lines. The joke about "why a duck" and "viaduct" didn't make it though. I read with pleasure the Ado Kyrou book on cinema.

Around the corner on rue de Seine we discovered an Italian deli. It was in a beautiful storefront that apparently had once been a *poissonerie*, as it was embellished with colorful seascape tiles featuring fish and shells. The owner personally made all the pasta in an odd machine resembling my mother's mangle, and also waited on customers. A large order of spaghetti with sauce was 30 cents. He also sold small pizza. I convinced Franklin to sample one, his first. He had been under the impression that pizza was a dull stewed-tomato pie, and so this was his first sample. He found it excellent.

In spite of the fact that our diet consisted of French bread and butter, french fries, and plenty of butter-soaked crêpes bought rolled-

in-paper from grandmother-operated, on-the-street crêpe stands, we lost weight. Constant walking and running up and down stairs did it.

In the Passage du Commerce on St.-André-des-Arts, there was a family-style restaurant. It served the meal of the day at long tables. There we ate quietly with many seemingly retiring souls that lived their bachelor lives in Paris hotels. The food was good, plain, a sort of stew.

The passage itself was a romantic yet melancholy place with a huge iron gate with large key, archway, cobblestones. Very ancient, it had seemingly been bypassed by time. The shops not of the boutique sort were often not even open. There was a bookstore with surrealist books in the window that we must have passed by a hundred times before we found it open. There we found a copy of *Minotaure*. Yet I found this quiet passage a very attractive place. It was only later that I learned it was here that Marat published *Friend of the People* and Dr. Guillotine pondered his humanitarian invention.

Down St.-Germain a few blocks was the Church of St.-Germain-des-Prés and the noted café, the Deux Magots, and across from that was the Café de Flore. Nearby was the Gallerie 1900 where we saw a wonderful Victor Brauner show. We were sitting down and enjoying a café au lait at the Deux Magots when Micheline Bounoure appeared walking down the boulevard. Slim and striking, her arms thickly covered with Navaho and Hopi silver-and-turquoise bracelets, Micheline said bonjour and joined us for a while at the café. She was an exciting person to be with. She sparkled. I talked about the Brauner show in my Chicago-French. She laughed and laughed. Then she was on her way again. Sidewalk cafés were made for wonderful chance encounters.

I longed to be able to communicate. I ached with frustration; I had finally found some people who shared my deepest desires, my dreams and yet there remained a barrier resembling thick glass between us; we were able to see each other, but we couldn't hear each other. I was desperately pounding and waving on my side. I knew my time in Paris was limited. They saw me, they smiled; we gestured, we signaled and grew fond of each other in spite of all.

I called Elisa; we worried about André and wondered if we would ever be able to see his magical studio.

Diogenes and *The Lantern*
One evening I attended a meeting at the café alone and let some of
the friends know that Franklin was ill with the flu and confined to
his bed for a while. Jean-Claude Silbermann decided to come to the
Hôtel du Grand Balcon and pay us a visit.

Jean-Claude, then in his thirties, was strikingly good looking.
He was more casual than many in Paris and wore plaid shirts with a
crew sweater. He had been a student of philosophy at the Sorbonne.
His English was good, and he was trying to polish and perfect it. He
sat down and made himself comfortable on a chair next to our little
round table and related what he had been reading and thinking lately
while Franklin sat in bed propped up with several pillows. Franklin
hadn't been out for several days and had spent plenty of time reading
the many books we had stacked all over our room, feeling confined
and irritated at the inconvenience of being ill while in Paris, partic-
ularly at the extravagant expense of "$5.00 A Day." "I could just as
well be sick in Chicago at a cheaper rate," he mused.

Jean-Claude had an excellent sense of humor, and he related
stories about ancient Greek philosopher Diogenes the Cynic from
a book he was currently reading. Of course, Diogenes was loved by
both Franklin and me for the famous story of carrying a lantern
through Athens "looking for an honest man." And when Franklin
and his friends had put together and printed (mimeoed) a protest
newspaper at the Proviso High School in 1959, an underground
newspaper before there were underground papers, they called their
paper *The Lantern*, after Diogenes.

It is impossible not to love the mad and inspired Greek philos-
opher who lived in a barrel so that he could lead a bold and uncom-
promising life.

Jean-Claude related the story of Diogenes sold into slavery:
The slave dealer asked Diogenes what work he could do. Diogenes
thought for a moment and replied, "I'm good at being a master!" So
it was announced, "Whoever needs a good master should buy this
man." A wealthy man purchased him and never regretted it. Then the
story of Diogenes and Alexander and of Diogenes at Plato's school.
This was the first I had heard of other stories besides Diogenes and
the lamp. I was charmed that his brilliance and wit still sparkled after

over a thousand years. Jean-Claude mentioned Jacques Vaché as a modern character similar to Diogenes.

Jean-Claude wanted to put some of the provocativeness of these ideas into practice; so he equipped himself with a tape recorder and a series of questions and took surrealism to the streets of Paris in the form of three questions. He hoped to glean from this what ordinary people were thinking and dreaming. It would be a surrealist intervention in daily life.

Setting himself up as an on-the-street interviewer, as much like an official news reporter as he could, he asked passersby three questions, meant to be somewhat ambiguous: 1) Do you cross the street between the lines? 2) Who is above you? 3) If someone came to the door and said the police were after them, would you let them in? The answers were interesting. Working-class people answered in the most non-conformist ways. And, surprisingly, many elderly women of the working class were willing to hide anyone from the police, no questions asked. And so we had a very jolly afternoon as Jean-Claude related the results of his experiments and thought about their implications.

Jean-Claude later brought some of the tapes he made to Le Promenade de Vénus so the group could enjoy the responses firsthand. On another inspiration, he went over to the Paris Metro "lost and found department" and delved into what sorts of things were lost and what sorts of things were found, and tried to speculate on the psychological mechanism of "lost and found." He wrote up his study for *L'Archibras*.

José Corti and the Hopi Way

We spent an afternoon visiting Jean-Claude and his wife at their home in a Paris suburb and enjoyed the paintings that Jean-Claude displayed for us. Humorous and sensual, they very much reflected his personality, his strong love of life and surrealism. We rode back to Paris on the Metro together and went to another meeting at Le Promenade de Vénus.

An important discovery was made at an English language bookstore; I found a copy of *Sun Chief* by Don Talayesva. The book had been saluted in *Bief* by Breton and the entire Surrealist Group.

Franklin and I read it eagerly in bed at the hotel, sharing incidents of Hopi life, discovering part of our continent and its most ancient city, in Paris so far away. Perhaps distance and a different perspective are remarkable stimulants for discovery and the critique of one's native land. Talayesva's picture of the *Hopi way* was splendid, filled with wondrous stories, Katchinas, Spider women, a salt journey, rediscovery of self, showing that everyday life was not of necessity dull and lifeless, but it was and should be much more. Native Americans carried an invaluable portion of the store of poetry and inspiration for us.

There is reason to believe that the Pueblo cities are actually the long sought after Seven Cities of Cibola. There never was any gold; it was either a trick to deceive the gold-obsessed Spanish or a tale based on the perfection of their societies. The cities portrayed by Carl Barks are certainly some of the Pueblo cities of the Southwest.

Our favorite place for surrealist books was the Minotaure Bookshop located at 2 rue de Beaux-Arts and run by Roger Corneille, a young man who admired surrealism and thought his contribution to the idea could be to make available to the public both rare and new surrealist books. The symbol of the shop was a smiling minotaur drawn by Maurice Henry.

The store consisted of a couple of tiny rooms lined with books, magazines, and journals reasonably priced; obviously he was familiar with surrealism, Dada, etc. We purchased books in quantity for Solidarity Bookshop. Some of our first purchases were Benayoun's *Erotique du surréalisme* and Joyce Mansour's poems, which I began reading as soon as we reached the hotel.

We met Benayoun at Le Terrain Vague Bookshop and he introduced us to Eric Losfeld, its owner and publisher. Losfeld was involved in publishing many surrealist books at that time. Tall, straight, and graceful, he seemed more like an actor or an athlete than a publisher. It was and may still be the fashion in Paris for each publishing company to have a bookstore that stocked and sold its own books. Losfeld was selling *Positif* and *La Brèche* and also among other titles *Barbarella*, a sex comic book, made into a movie starring Jane Fonda.

Losfeld himself had written scores of mysteries set in the U.S.,

these had been fabulously popular after World War II. They were set in places all over the U.S.; places Losfeld had never been. The exchange of mysteries between the U.S. and France has been an ongoing phenomenon since Edgar Allan Poe's Monsieur Dupin. Apparently, we consider Paris a mysterious and sinister location; the French consider the U.S. tough and wild, an opinion not changed by our prohibition-gangster era. Losfeld was prospering. In later years, he had financial troubles caused by lawsuits against his publishing company.

Another bookstore, Le Soleil dans la Tête, run by a French woman, was very expensive. Other specialty stores, Nicaise and Lollier's, were even more expensive, dealing in surrealist books only as rare commodities with no particular love or enthusiasm for them. We were lucky to find *Free Unions*, an English surrealist magazine reasonably priced. We also went to Présence Africaine bookstore. It was there on our second trip to Paris that we met Aimé Césaire and talked with him about Etienne Lero, *Légitime Défense,* and *Tropiques.*

In the block north of rue Dauphine, there was a wonderful, old, dusty bookshop, actually very dusty and very disorderly, with stacks of ancient books all over the place. This bookshop, in a neat and polished neighborhood, stood out looking like it had been leftover from another century; perhaps it had. The bookshelves, stretched from floor to ceiling, were double-lined with books in crumbling leather bindings, some tied together with string.

Run by an elderly Frenchman, it didn't seem open: incredible disarray, few lights, no hours posted on the door. But, being devoted book enthusiasts, we managed to get in and look around. We were surprised to find that the vast number of books were on or related to the French Revolution of 1789, including Marat's *L'Ami du peuple,* and the Paris Commune of 1871, a superb collection. We picked out a small stack of books. All of the books were unpriced, and the owner never could decide what price to sell anything for or even if he wanted to sell it at all; it took forever to purchase a book. Our stack was honed down to one book on Flora Tristan that we did manage to purchase, but the owner seemed to have regrets about even that. So we left hurriedly before he had the chance to change his mind.

Years later, the director of the Rare Book Room at Northwestern University told me that the library had purchased a whole store,

a marvelous collection on the Commune. Included with the books were many original photos and posters of the Commune. The old man apparently had managed to hold that collection together for years and years. Finally, he or his estate sold it as a whole. Perhaps all along he had in mind to sell it as a collection, and that was why he was the most reluctant bookseller I've ever encountered. So the mysterious bookstore's collection is near us again, having followed us to the shores of Lake Michigan.

Shakespeare and Company Bookshop existed as a dark, rambling storefront near the Seine, punctuated with raggedy couches and cats; we browsed but didn't find anything. Still, it was an unhurried place where patrons felt they would never be asked to leave; they even slept on the couches and stayed for weeks.

Down near the Seine just off boulevard St.-Michel was Le Joie de Lire bookshop, the street, most likely St. Severin. Le Joie de Lire was actually two stores opposite each other, both run by the publisher Maspero, a company owned and run by Trotskyists associated with Ernest Mandel, the United Secretariat, part of the Fourth International and, at that time, close to the U.S. Socialist Workers Party.

Open until late in the evening, 1:00 a.m. and packed with young people it had one of the finest selections of new books available in Paris, plenty of Left books, surrealist titles, psychoanalytic journals and magazines of all kinds. In a glass case of old books I even found *Les Chants de Maldoror*, Éditions GLM from the 1930s.

Further down the crooked street were two more bookshops. Not far was the house where alchemist Nicolas Flamel lived with his wife Pernelle. Hard to say how many times my feet felt the glistening paved stones on the way between our hotel and that spot; so often, I know I consider that path part of myself wherever I walk now.

Eventually, we'd wind our way back to Rue Dauphine along St.-André-des-Arts, or occasionally St. Germain, passing the dim windows of a scientific supply store with preserved animals including, unhappily, a stuffed baby penguin; you could find absolutely anything in Paris.

We were astonished to find the Librairie José Corti still there and thriving, with José Corti himself still at work in the store almost every day. From 1929, José Corti had been a leading publisher of surrealist books. His store was now located on rue des Medicis, which

led diagonally away from rue Dauphine and up a hill by the Palais du Luxembourg and Jardin du Luxembourg. There, opposite the Jardin, was the bookstore of José Corti. With its large, bright windows and tables in the center stacked with the books that Corti published, it had an open spacious look. José and often his wife too would be behind the desks just opposite the door.

We would walk in and pull out a long list of surrealist books we were searching for. José, a wonderfully handsome and elegant white-haired gentleman, would laugh. Then he would tell us in excellent, if somewhat hesitant, English, "They are *epuisé*, how do you say it, out of print. But I will try. I know someone who has one but doesn't need it anymore." Then he would say, "But you must speak French."

One day I stopped by alone, as Franklin was ill. When José saw me he immediately jumped up and gestured, saying in English, "I have something to show you!" Then he pushed me into a nearby small closet. I was slightly reluctant, somewhat confused and bewildered, but I could see Mrs. Corti smiling from behind the desk. José then closed the door tightly and carefully locked it, *and turned out the light!* I was indeed mystified and considering panic, but then the words "*Le Surréalisme au service de la révolution*" flashed before me in a wonderfully lurid-green luminous type. José had uncovered an issue of a rare surrealist magazine from the 1930s, with glow-in-the-dark type on the cover. I admired it, as it glowed phosphorescently, beautifully. I thought perhaps he was just showing it to me, but, no, he had found it for us. And, indeed, it was very special. I can't imagine what I would rather have had. I left treasure in hand, walking on air.

On days when it was not raining and fairly pleasant, bookstalls would open along the Seine. There were millions more books for sale in Paris than in Chicago, and they were found everywhere at every price, from flea markets and bookstalls all the way to super-deluxe art bookshops on the main boulevards.

At one of the bookstalls along the quai, we found a complete set of *Medium*, a surrealist magazine from the 1950s, for 15F. Nearby hung pages from medieval manuscripts hand-lettered by scribes, botanic prints, and steel-cut engravings of just about everything. Elated, we spent the next couple of days poring over the pages of *Medium*.

Several of the surrealists had told us that old surrealist books and journals were impossible to find. This usually meant that by some quirk of fate, we would find something in the next few days.

Fire-eaters on the Left Bank

The Left Bank always had something going on. Once, coming out of the Odéon Metro station, we saw a crowd of people, so we walked over. It was a fire-eater-sword-swallower doing a spectacular act.

One morning, in our room on rue Dauphine, I was awakened by the noise of someone beating a drum. It seemed right outside our window. I jumped out of bed, pulled back the red curtain, and looked outside; there in the middle of the street was a gypsy with a performing goat. The small black-and-white goat was wearing an elegant red headdress and climbing a ladder to the beat of the drum, mounting all the way to the very top. There the goat stood on its hind legs and turned. A most unusual way to start the day.

During the entire time Franklin and I spent in Paris, the city itself was in turmoil. It was just about the end of the road for the Gaullists. Daily life was constantly disrupted by wildcat strikes by public workers, often one or two a week and, of course, you never could predict when or where.

First, the bus drivers would go on strike and there would be no buses. Then, when you decided the next day to take the Metro instead of the bus, the Metro workers would be on strike, but the buses would be running and everyone in Paris would be trying to get on a bus. The Parisians themselves didn't complain. They seemed good humored and in support of the workers. Well, okay, you would assure yourself, it's good. I support the workers; every strike is a rehearsal for revolution; I hope the workers win. I can live with it. Then, the next day, the electrical workers would go on strike, although the buses and Metro would be working. Surrealism in daily life!

It is thanks to this surrealist activity of the working class, orchestrated no doubt in secret by Luis Buñuel, movie-making master of black humor, that we were treated to the rare spectacle of a Prisunic Super Marché, an American-style supermarket, in near total darkness; a candle propped up here and there. I felt my way through, past others also feeling their way about in the dark, to the back of the

store and got some milk in a triangular carton and purchased it from a cashier standing with a candle dripping wax into the cash register. I didn't even steal anything. It seemed like it would be taking unfair advantage. All Paris shopkeepers I ran into were scrupulously honest and never took advantage of the money confusion. I always bought the soap we used in this Prisunic, an inexpensive French soap called Le Chat, perhaps it was for washing cats, I don't know, but it was a clear green and had a wonderful smell. The lights would come on after dark, but perhaps tomorrow there would be no phones.

This surrealist rehearsal by the French workers should have been seen as a clear prelude to May '68, when workers joined forces with the Sorbonne students. Somehow the students hammed it up enough so that they got most of the credit. But in 1966, there was definitely a militant working class making its demands known to one and all. If they had all struck on the same day, the government would have collapsed.

In the true spirit of objective chance, we met Ted Joans one afternoon while we were walking up rue de l'Ancienne-Comédie towards St.-Germain, and he was walking down the street toward the Seine. We hadn't met before, but Franklin recognized him from his photo in *La Brèche*. There he was, a tall, handsome Afro-American man wearing a trench coat, beret, and sunglasses, the height of beatnik style. Indeed, he used to have a "Rent-a-Beatnik" service in New York, "guaranteed to spice up dull parties."

I had my fortune told sitting in Le Procope by a gypsy woman who walked in and came directly over to me, insisting she must tell my fortune. She was very persistent and didn't demand much, so I finally agreed. She took a look at my palm and seemed shocked, as though she had picked up the hand of Lucrezia Borgia. Then she quickly said, "You will lead a remarkable life." She closed my hand and rushed out. Perhaps it was all part of the routine of palm reading, but it left me wondering, disaster, tragedy, wealth, happiness? It has been all that.

We had the address of Lutte de Classe, a small Marxist group, and looked up their group, met with them around a large table in one of their apartments. There were eight to ten people present, their entire group.

While discussing *Rebel Worker* and our political ideas one of them said, "Are you the group that has an article in *I.C.O.* (short for *Information Corréspondence Ouvrier*)?" No, we thought not. What article? They replied something about mods, rock 'n' roll, and revolution. So we were surprised and elated to learn that Solidarity Bookshop Pamphlet #1 by Franklin, *Mods, Rockers, and the Revolution*, had been translated into French and published just recently. Our hosts, traditional Marxists, a split from Pouvoir Ouvrier, were not entirely pleased, not interested in anything beyond economics and class struggle. Still they remained friendly; they thought we might stay in the room where they kept their mimeograph, but it never worked out.

We tried to set up a meeting with I.C.O., since they had just published *Mods, Rockers, and Revolution*, but they seemed rather paranoid; in any case, they never showed up. Perhaps they didn't believe it was really us; too much of a coincidence to publish an article from far away Chicago and then have the Chicago author turn up within days.

On one of my walks, I discovered La Vieille Taupe bookshop, which reminded me of Solidarity back in Chicago. I took one of their cards that gave their address, 11 rue des Fossés Saint-Jacques. Also, I bought the Situationists' "Address to Revolutionaries of All Countries . . . " Franklin was writing, but when I showed him the card, he was eager to visit the store on the next day, February 15th.

Le Vieille Taupe was run by the Pouvoir Ouvier group who we never did meet except for visiting the store. Their group was to the Left of Lutte des Classes and stood for the organization of autonomous workers' groups; it had members and an influence in the Renault plant; it was there the most radical sections of the French working class existed. A split from "Socialisme ou Barbarie," the Paul Cardan group. Solidarity Bookshop carried their magazine *Socialisme ou Barbarie*. We were surprised to hear about a split, the news hadn't yet reached Chicago.

Guy Debord & the Situationists

La Vieille Taupe bookshop had a picture of Gaston Bachelard on the wall and quite a few old Fourierist pamphlets, still available in quantity in Paris. (Fourierism had been a huge movement.)

On the front door was a sign that read, "We don't carry any

books by Tailhard de Chardin." De Chardin was a reactionary French Catholic that Breton and the surrealists had denounced. When Breton died, La Vieille Taupe issued a card reading, "André Breton is dead, Louis Aragon is still alive, a double tragedy!"

There was a shelf of Situationist International journals, faced out with their glossy mirror covers that attracted attention. We bought several and took them back to rue Dauphine and pored over them.

On walls everywhere in Paris were the words "*Défense d'afficher*," meaning "Post no bills." The Left Bank, however, was covered with posters, mostly music, movie and political posters. The huge "*Défense d'afficher*" was uglier than any posters could have been. The students altered the official "*Défense d'afficher*" during the May Days in '68. They changed it to "*Défense d'interdire*"—"it is forbidden to forbid!" A splendid détournement by surrealist Gérard Legrand of those obnoxious notices.

We set up a meeting with the Situationists by the pneumatic mail system. (See "Surrealism and Situationism," later in this book.) Debord claimed there were no new developments in surrealism, that in the '20s, '30s, and '40s, one important book after another appeared. But after that, what? Breton had written nothing major after *Arcane 17*, and no one else in the group had either. It was now an art group, in his opinion. Further, he thought that surrealism had been studied, dissected and categorized, and as a consequence was reified, it was related to it as a category, an object, something one studied in school, not a force for liberation. So Debord said it was necessary to abandon it.

While the Situationists rejected art and poetry they were a hyperpolitical development stemming directly from surrealism; they insisted on a revolution that would transform everyday life. Which is precisely what Franklin and I wanted and believed was possible with the combination of technological development and the discoveries of Marxism, psychoanalysis, anthropology and surrealism. It seemed to us that surrealism was necessary to this development. Surrealism had a tremendous creative contribution to make to revolutionary thinking and action; it was necessary now to abolish the authoritarian models.

None of us had any idea then that in less than two years Paris would come close to revolution, the largest general strike in world

history, surrealist and Situationist slogans everywhere that summed up in a few words the hopes and aspirations of millions of young people around the world, May '68. The suddenness of this blossoming was a shock even to the participants; the last revolution in France had been in 1871.

The Situationist critique of architecture and its relationship to daily life was a splendid insight they developed from their observation of Paris, gradually being devoured by stark modernism. Their critique of the spectacular commodity economy was a witty and brilliant clarification of what daily life had become under capitalism, conspicuous consumption, a commodification of life itself.

Debord and Frantz Fanon were two of Europe's most important revolutionary thinkers in the '60s. Michael Löwy described Debord as "a twentieth-century adventurer." Debord himself described an adventurer as "someone who makes adventures happen, not someone who simply happens to have adventures."

Debord was interested in our activity in Chicago and asked how many of the SI pamphlets we could use; Franklin estimated several hundred. Debord was impressed. That was a lot by French standards.

We liked Debord and were impressed by SI publications, the seriousness and originality of their critique; we might have joined the SI right then. Later, however, we met Mustapha Khayati, who laid down the line on surrealism; that was, no surrealism or surrealists in the SI; no dual loyalties. Surrealist art was just a commodity among the other commodities, to make art was wrong. He regarded surrealism as a commodity itself, part of the spectacle. He seemed inflexible where Debord had seemed so open to discussion and interested in our ideas, so Franklin and I, disappointed, never willing to submit to a political line, backed away from the SI. We did, however, bring plenty of the SI publications to Solidarity Bookshop so their important critique could become more widely known in the U.S.

They must have been disappointed, resentful too, and worried that a revived surrealist movement would be competitive with Situationism because their journal not long afterward referred to us hostilely. They were an important step in a new revolutionary critique of this pathological society that converts everything to a commodity, not simply art, but water, air . . . situationism . . . Salvation, even.

Man Ray and the Musée de Cluny

The boulevard St.-Michel was the place everyone on the Left Bank flocked to at night. We went there, too, strolling back and forth on sidewalks, past many places, people sitting outside and inside the glass-fronted cafés, just strolling or buying nuts from the vendor who sold all kinds of nuts, peanuts, almonds, cashews, even coconuts, enjoying the sweet smell of pralines cooking, crêpe stands, vendors of ice cream and frozen yogurt, lottery tickets on sale everywhere.

Often there would be an old man and his trained white mice, very tiny, pretty white mice with pink ears and long pink tails. The old man was dressed with care in a somewhat tattered suit and carrying a fancy cane. He would put his hand into his coat pocket and bring out the mice, five or six of them, and put them on his sleeve. Quick as a flash, the mice would race up his sleeve, over his coat, down his other sleeve, and onto the cane he held out, all the way out to the very tip, and then back around and into his hand. It was startling and funny. I never tired of it. He always did it with an air of drama, showmanship, and elegance that made it seem like this was a privileged performance just for you.

More and more people came out to stroll as spring unfolded; around April, women began to sell bouquets of violets with their heart-shaped leaves. Walking home on the midnight streets, buildings dark but not entirely, high up on the top floor a light would be burning brightly, a sign of a poor poet or student at work late poring over papers and books in a garret room under the roof; wide awake while everyone else slept, driven by an unaccountable passion for the printed word.

A place we frequented was the student cafeteria at the corner of boulevards St.-Michel and St.-Germain, not because of the restaurant (I often ate the raw carrots and raisin salad), but because its tables looked out across boulevard St.-Germain at the Musée de Cluny surrounded by a black cast-iron fence, wildly romantic, a ruin with crumbling arches and untrimmed trees.

The Romans built a bath on the site in 197 A.D., a stream flowed then. The mansion dated from the Middle Ages, now a medieval museum housing carved wooden virgins whose bodies were

hinged doors revealing Christ crucified. There also were the marvelous unicorn tapestries, a reminder that poetry survived in the age of religion in spite of everything.

Before I knew Cluny was an ancient ruin, the place attracted me for its wildness, its otherness, its magic, a place where my homesickness would vanish. Why? What dreams lingered there? Historically there have been many. We arrived at 4:15 as the winter's sun peeked from its endless gray blanket of clouds for a brief glimpse at Paris before setting at 4:30 p.m. An incredibly gray winter, heavy and close, with a gray sky near enough to touch, very different from Chicago winter. An uncrowded time, I'd watch the sunlight flood the ancient ruin, creating long shadows. Odd, I missed the sunlight, but also the shadows. No, even more the shadows. The season changed from winter to spring, the bones of the trees and the leaves on the ground began to breathe a bright green. How many dreams and birds have nested here?

Our footsteps often traced a path along the Seine to the Jardin des Plants to visit the zoological gardens. Small and graceful, trees scattered randomly, walkways curving among the compounds, the animals had thatched huts of quaint types. The sight of some non-human beings was refreshing. I've always felt that I'm a non-human being in disguise; no, more like trapped in a human form.

Our social structure leaves little room for animals. The beauty of the gazelle must be kept in a cage, there is no place for a free gazelle. Likewise, there is less and less room for human freedom. We simply get a choice of cages.

On Sunday, lines of French people filed through the reptile house, tapping on the glass to get the animal's attention, calling out, "Bonjour, M. Chaméléon." In the U.S. we file by in silence or with comments as "What an ugly animal!" Perhaps, the reptiles prefer quiet but who knows? Maybe they spend the week bored, waiting for their Sunday greetings of "Bonjour, M. Chaméléon!"

One evening Franklin and I visited Man Ray; we had passed the wall on the rue Férou often; the wall, high, stark, windowless with its lone door, was odd, almost eerie. I was surprised when we found it

was Man Ray who lived there. Juliette Gréco answered the door and invited us in. Their combination studio and apartment was large by Paris standards, no windows but a skylight; it was a courtyard that had been converted to living space. Franklin and I sat on the couch; facing us was Man Ray's painting of the famous red lips floating in a blue sky, much larger than I had expected. They reminded me of the lips of Marilyn Monroe. On our right was the famous photo of Kiki's back with the bass fiddle strings added. Man Ray's place was filled with his own mad objects and photos; it had a temporary, camp-like feel to it. This made it exciting, as though, if Man Ray wished, he could pack it up and leave anytime, tomorrow, in a couple of hours. Leave mysteriously without a trace.

Just around the corner from rue Dauphine was the Jane Ascher Gallery at 18 rue de Seine, specializing in African, American Indian, and Oceanic art. Jane Ascher had advertised her gallery in *La Révolution surréaliste* in 1926, and later advertised this very location at 18 Rue de Seine in *Le Surréalisme au service de la révolution* in 1930. Déjà vu, a shock of recognition to see the name. She had wonderful pieces of the quality more often found in museums than galleries; we purchased a Bambara Gazelle from Mali. Jane gave me a string of "African trade beads." She was an active woman in her sixties. Just around the corner, at 16 rue Jacques-Callot, had been the location of the original Surrealist Gallery in 1926.

Walking one rainy day, we took refuge in a scientific shop specializing in antique scientific equipment near the church of St.-Germain-des-Pres; the room was dominated by an orrey, a model of the solar system done in polished brass and semiprecious stones. The earth was formed of the bluest Lapis Luzi, designed to move. One could observe the gears that moved the planets, a masterpiece. Besides this, there were scores of brass astrolabes of intricate design and variety done with exquisite workmanship, even was a dark globe of the heavens portraying the positions of the stars and including the outlined constellations. We stayed a long time, fascinated. What hands had touched these instruments, I wondered, what dreams moved them? What worlds did they discover?

Disturbed by the big black X on our passport and hoping to get into England, we went to the U.S. Embassy and told them we lost our passport. With indifference, the bureaucrat in charge told us we must find a U.S. citizen with a passport who had known us since childhood and thus could vouch for us. "A Frenchman," he said, "will not do, we know what their word is worth." (If you think the U.S. Embassy will be of any help to you whatsoever overseas, I suggest you abandon the illusion.)

I had the privilege of crying bitter tears into the rushing black waters of the Seine from Pont Neuf near midnight one Paris night, next to me Henri IV on horseback, saying to myself that my life was a shambles, a ridiculous ruin, a failure at age 24. Worse, I was homesick. Homesick for Fox Lake, for the countryside, my mother, my dog. Only three years since I swam in Fox Lake. Only two since I climbed the Lake Forest bluffs and wandered the ravines.

An elegantly dressed elderly Frenchman who look liked he might be returning from the Opera, top hat, cloak, gloves and cane, stopped and asked me what was wrong. Hearing me out, he insisted, "You must not be sad. After all, you're young. You're in Paris!" Leaving unsaid, but implied, "the greatest place in the world!" He had expressed such a passion for Paris, it made me smile. I had to admit to myself that it was a wonderful privilege to be there. Then, he offered me his arm politely and insisted on walking me back to my hotel. What an unusual couple we made, him in his formal suit, me in my flowing countercultural poncho and long hair.

On Pont Neuf I had noticed I was sitting next to a Henri on horseback, Henri IV. Then, I had no idea who he was. Since then I have become quite fond of him; he lived in troubled times as bad or worse than our own; he was courageous and fair-minded. In times of civil war and religious persecution he put forward a program of tolerance, the Edict of Nantes. He was assassinated in 1610.

Pont Neuf, Henri IV on horseback, the Seine slithering in the dark, and the glittering Paris night all around me is still strong in my memory. It was Henri who dedicated the bridge 400 years ago. His efforts were a major step forward in tolerance and freedom of thought.

A Visit to 42 rue Fontaine, Breton's Studio

André and Elisa Breton were living at 42 rue Fontaine in Montmartre. André had lived there when he met Nadja in 1926. He returned to the loft after his WW2 exile in the U.S. It was near a seedy strip that resembled Rush Street in Chicago. The Moulin Rouge club was there; it was a neighborhood of nightlife and nightwalkers, a subterranean culture that blended with the working class. This Montmartre district, made famous by Toulouse-Lautrec, Van Gogh, and Gauguin, was not high rent. It was famous also for its stubborn rebellion of 1871, the Paris Commune, which inspired Karl Marx. The women of the commune erected their own barricade at Place Blanche just steps from Breton's door.

Franklin and I had enjoyed our conversations with André at the café, but we hoped to meet André and have a long conversation with him about everything we had been thinking and planning. At the same time, we were anxious about it. On the day he invited us to his studio, André had an asthma attack and was not well enough to meet with us. Elisa, however, insisted that we come in so she could show us his studio, a place we had come to Paris hoping to see.

The room, while not particularly large, had an eighteen-foot ceiling. One wall was entirely windows; bookshelves and books ran up another wall all the way to the ceiling, accessible by a ladder. Very familiar and splendid surrealist paintings filled up another wall.

Collections of minerals, insects, cabinets of objects, and more paintings filled the fourth wall. A heavy oak writing table stood in the middle of the room, to the right was the window, to the left, under the paintings, was a daybed covered with a colorful Mexican blanket.

It was a strikingly beautiful room, simple and comfortable, a room full of objects created by the genius of mankind and nature; in every facet it reflected that it had been assembled by a bold and adventurous spirit; it mirrored that spirit wonderfully, magically. A glimpse of inner-self manifested, almost a violation of privacy, so intimate, the exact opposite of modern functional simplicity and interchangeability: the sterile idea sold to the consumers of the '50s.

It was a quiet place. Since André was not standing there, I was

not distracted by his presence. His objects, his life and persona were scattered about the room in an organized but also haphazard way, the room had such intensity it would have been possible to spend days looking at the different objects and paintings. A lifetime would not be long enough to read the books. I wanted with all my heart to sit down at that desk and write and write, never leaving that enchanted place, letting my life's blood flow out of me through my pen onto the paper as I created magic spells that would transform the world the way Breton had.

In the grip of my waking dream, I had to force myself back to reality, out of my reverie, my compulsion, get a grip on myself and leave. I felt I belonged there. I hadn't said much. I wondered what Elisa thought of our visit. If I stayed any longer, I felt I wouldn't be able to leave. Already I didn't want to, the spell of the place held me. Now out in the hall, Franklin and I didn't talk. We were both overcome by our thoughts and reveries.

I was beginning to blend in on the Left Bank; standing on a corner I was mistaken for French by two English tourists; this was an experience. First, they addressed me in tourist French; then they chattered to each other in English, assuming I didn't understand a word they were saying. A disembodying experience, like being a mind-reading street sign. Spring signaled the invasion of robot tourists with their robot French.

I visited the Bon Marché department store that I'd read about in my French textbook back at Lake Forest College. There I purchased a cheap suitcase; we needed it to pack the extra things we had acquired. While poking around, I found a table full of long winter underwear, long sleeves, long legs, flaps that unbuttoned in the rear; they looked exactly like my grandfather's union suit, though they came also in pink. The table was dominated by a large sign that proclaimed "ON SALE! Underwear, American style." That's what Parisians think we wear in Chicago.

In midday, while walking through the Jardin du Luxembourg near José Corti's Bookshop, I had an odd experience, sweet in

remembrance, though then it frightened me. I often felt a slight apprehension, being in such a different place so far from home, now in April and on a lovely day with the freshness of spring in the air; suddenly, out of nowhere, a group of young men, perhaps eight of them, students most likely, surrounded me, then joined arms, closing me inside their circle, and began to dance around me and sing.

At first I stood still. Then, as it seemed to be going on too long, I tried to escape, to push my way out. I tried several times while they circled and sang, but I couldn't get out. Finally, after a while, they ran off. I sat down on the nearest park bench and burst into tears. Why? I really don't know, except it was so strange and unexpected, marvelous and mad. My shyness had got the better of me; thrilled and terrified, my emotions scattered over a whole range of the possible, brain patterns on red alert. Today, I still don't know if this was a French custom or a spring inspiration, but I think their intentions were to flatter me.

I awakened with a start, sweating. I had been dreaming in French again. The seemingly impossible had begun to happen, I no longer needed to translate English into French when I thought and spoke. Another identity, a French-speaking identity, had begun to share my mind, a shock, not altogether pleasant, even quite strange. The French identity was less shy, bolder. But it was too late.

April 10, 1966, our last morning in Paris, back in our old room on the fifth floor, I looked out our window across rue Dauphine with confusion, opened it wide, and breathed in the fresh spring air. I missed friends in Chicago, Solidarity Bookshop, my mother, Lake Michigan. And yet could I really leave, I didn't want to leave, I was no longer homesick. I felt divided. Young enough so that five months was a long time; I felt at home here now as much as Chicago. I knew I wouldn't be back soon. Money would be scarce, it was already, one of the reasons we had to leave.

Another was that we felt it was only in our own language and in the U.S. that we would have an influence on coming events and the Vietnam War was an ever-escalating tragedy.

And yet, these streets had become the rivers of my thoughts, intricate and winding, always bending to my desire, taking me just where I wanted to be. Perhaps because any place is special when young and in love and in Paris. Paris was special for me; I knew I would miss Paris.

I ran down the stairs and into the street and back and forth on rue Dauphine, I didn't know why. I decided I was looking for something, looking for something of Paris that I could take with me, a pebble, a rock, anything might do, but there was nothing. Then in Passage du Commerce I found a key. A big key, perhaps to a gate.

Later, when reading Éliphas Lévi, the great 19th-century occultist, I discovered that he was born there, the same streets. One of his major books was *The Key of the Mysteries*. A random piece of his advice, "The will develops itself and increases itself by its own activity. In order to will truly, one must act."

In Paris we hadn't sought historic places, too sterile and rigid a tourism; we had let them find us. But everywhere in the streets the spirits whispered; you didn't need to seek them. Rimbaud and Diderot wandered here. Marat and Danton passed this way. Thomas Paine sat writing *The Age of Reason*, and Mary Wollstonecraft pondered *The Rights of Women*. Ben Franklin came here to negotiate a loan for the revolutionaries of the thirteen colonies, and it took years for him to tear himself away and return to Philadelphia. Karl Marx and Babeuf dreamed here. Isidore Ducasse discovered an entire new concept of beauty. The air of Paris must have some odd ingredient. Now André Breton, Mimi Parent, Jean-Claude Silbermann, Toyen, Jean Benoît, Joyce Mansour, Vincent Bounoure, Claude Courtot, Alain Joubert, Nicole Espagnol, Jorge Camacho, Annie Le Brun and others, friends of my waking dream, the magic circle of surrealism that holds my hopes and my heart, spin their convulsively beautiful visions, here.

In a couple of years, in 1968, the "old mole" will come up and look around to see if the Situationists have found that "point of no return." And if the surrealists have achieved that synthesis, that point in history in which the Enlightenment liberation of the Mind and the Romantic magic of the Imagination have ceased to be perceived as contradictions.

CODA

August 1966: André Breton died at age 70. We knew this would be a serious problem for the group, all admired and respected André, but did they have confidence in one another? We kept up a correspondence with Elisa and with her help Franklin put together a book of Breton's writings translated into English. It was the first collection of Breton's writings in English and called *What Is Surrealism? Selected Writings of André Breton* and is still in print today, thirty years later, an amazing indication of the lasting interest in Breton and surrealism.

Earlier in 1966 we had come out with a mimeo'd collection called *Surrealism & Revolution* that was so popular we had to reprint it within months. In December 1966 we came out with *Rebel Worker* 7, the most surrealist of its issues. It printed "The Colors of Freedom" by Breton, "Liberty does not consent to caress this earth except in taking into account those who have known how to live . . . because they have loved her to the point of madness."

four
Chicago: Maxwell Street in the Sixties

For the nascent Chicago Surrealist Group—the *Rebel Worker* staff—a favorite outing was Maxwell Street on Sunday mornings. Tor and Green would go very early, around six a.m., to get the best bargains on tools and materials. Franklin and I, and sometimes Bernard, usually arrived around ten, in time to take in the sights, pick up a few things, and then listen to the blues.

In those years blues was a kind of international language and free-floating community, and we were all part of it. (A couple of years later, it was our common interest in blues that sparked our friendship with Paul Garon when he wandered into Solidarity Bookshop one day and in no time at all was telling us about bluesman Peetie Wheatstraw, known as the Devil's Son-in-Law and the High Sheriff of Hell.) The whole world knew that Maxwell Street was the best place to hear the blues in Chicago.

To really enjoy Maxwell Street you had to get there in the morning. After a quick cup of coffee, we'd walk a couple of blocks over to Halsted Street and get on the No. 8 bus. The bus at that hour was driven by a big, handsome and exuberant Black man who was also a part-time preacher. He'd give every person the warmest greeting imaginable, and he knew everybody who took the bus—many by name. "Good morning, all you lovely, lovely people!" he would say as he opened the door. Then, as some ancient lady hobbled up to drop in her fifty cents, he'd say, "Well, Mrs. Jones, I'm certainly glad to see you today on this lovely, lovely morning!"

This deluxe treatment put everyone in a merry mood, and as passengers continued to board the bus, he continued his greetings, never tiring. Standing room only, the bus bumped happily all the way: over pothole-filled streets, under viaducts, past the projects, over the old iron bridge that crossed the Chicago River at Goose Island, past Montgomery Ward's warehouse, under the Lake Street el, past the T.N.T. Lounge, through Greek Town, over the Eisenhower

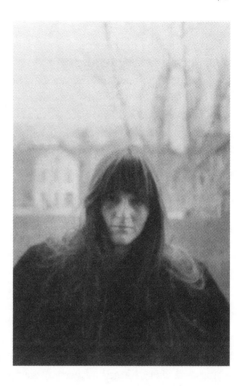

Penelope Rosemont,
Chicago 1967

Expressway, past the then-new (but already hated) University of Illinois Circle Campus, across Roosevelt Road, and you were there—Maxwell Street! All of a sudden traffic completely snarled the streets; the bus stalled in traffic with hundreds of beat-up old cars and a few new Cadillacs, and it seemed to take forever for it to finally get through that last intersection.

Everybody poured out at the stop—Maxwell and Halsted: a jubilant mix of young, old, Black, white, brown, tan, in Sunday clothes, in rags, in cowboy hats, sombreros, felt hats with huge flowers, and some in outfits too bizarre to describe.

On Sunday, even in winter, Maxwell Street was always crowded—no, packed, packed like no other part of Chicago ever was—not even the Loop at Christmas. I remember going there in the fifties, as a child with my mother, to a Mexican store on the east side of Halsted where she purchased chili powder by the five-pound bag. It was

still there in the sixties; I bought five-pound bags there myself. My grandmother had grown up around Maxwell Street and used to talk about going to the Twelfth Street Store as if it were a trip to heaven. She claimed she had sold matches in the street at age five. She'd pretend to be ashamed of this—ashamed of having been so poor—but really she was proud of it (she was in fact the toughest and proudest person I've ever known).

In the sixties the Twelfth Street Store was still going strong—a good place to get bargains in sheets and bedding. Indeed, a lot of the old buildings were still standing, and still occupied. It was a poor area, but it didn't look like a bombed-out city as it has in recent years.

We'd usually stop at what we called the Voodoo Drugstore (on the southwest corner of Halsted and Maxwell) just to soak up the atmosphere, scents, and sights: Hex-Removing Floorwash, red candles to burn for happiness and black for revenge, Gypsy Witch Dream Books, fortune-telling cards, John the Conqueror roots, Black Cat Oil, and sometimes even black cat bones, all reasonably priced.

Then we'd wander down Maxwell Street past the large permanent stands that sold hotdogs and Polish sausage, hats and socks, shoes and canes—on to the countless smaller stands that sold anything and everything. Unhurried, we'd stroll through twelve square blocks of weird, fascinating junk, all thrown together, stacked in piles or rows, attractively arranged—or at least as attractive as the seller could get the uncooperative, incongruous stuff to be. The street was a fantastic montage of improbable, sometimes unidentifiable objects and artifacts: old and new, familiar and unknown, intact or with parts missing, ready to use or needing "slight repair." In the carnival-like air of Maxwell Street, many of these incomprehensible things took on a rare, disturbing beauty—a spontaneous exhibition of surrealist objects right there on the street. The whole place was a paradise for photographers.

We still have many of the treasures acquired on these expeditions: an alabaster table lamp, a lamp made entirely of popsicle sticks, a large and elegant stained-glass window, a wonderful and mysterious Mexican lotto game, a nineteenth-century German cookbook with color fold-out plates of cakes that looked more like Gothic castles, a miniature stove that we used for years, a charming old "Liberty"

typewriter (a ready-made homage to Konrad Klapheck), black cast iron pots and pans, a copy of *The Rise and Fall of Anarchy in America*, published in 1888 ("Two bucks! It's old and rare!"), several old volumes published by Charles H. Kerr, a numbered limited edition of René Char's *Le Marteau sans maître* (his surrealist poems), some 78 rpm blues records on the Cobra label, and several hundred Bugs Bunny and other great old comics.

Everything possible, and lots that seemed impossible, was for sale there—cheap: stacks of old used tires and hubcaps, bins of brand-new gaudy prints of *George Washington Crossing the Delaware*, boxing-gloves and fencing masks, old back issues of *Life* and *Look* and *Frank Leslie's Illustrated Weekly*, Chinese fireworks, and yo-yos that glow in the dark. And if you didn't like the price? "Well, make an offer!"

And so we'd walk and walk, crisscrossing paths at Sangamon or Peoria with Tor, Simone, Green, and other friends. Sometimes we'd run into Kenya Eddie (Eddie Lamaka) in his beige cotton army fatigues, pith helmet and mirrored sunglasses, accompanied by his small brown and white dog wearing a sandwich-board sign that read "Free Jomo!" We knew Kenya Eddie from anti-war and civil rights demonstrations. He would always give us a friendly nod, and we'd usually talk with him for a few minutes.

Every week we'd find Bozo Kodl, an old-time Wobbly who we also used to meet at the IWW hall at Halsted and Fullerton. Among other things he was a playwright and actor and had bit parts in several movies (he usually played a bum or a drunken cop). At Maxwell Street he would let us set up a card table next to his stand where he sold Venetian blind parts. On this table we'd put copies of *Rebel Worker* and other IWW and anarchist literature, and start hawking it. We'd take turns minding the table, arguing with people, soapboxing a little, and then resume wandering around.

Sometimes we'd stop and get an Italian sausage from an old Mexican in a huge black and silver decorated sombrero. He fried his sausages right on the street at a charcoal grill. There were plenty of other grills with chicken, hotdogs, Polish sausage. The smell of Maxwell Street's old junk was neutralized by the spicy smells of cooking food: an authentic "Taste of Chicago."

At Maxwell Street we also bought our fruit and vegetables for the week. Sometimes several of us would buy fifty pounds of potatoes ($1.50) and split them up.

Best of all, around 11 a.m. the blues musicians would begin to tune up. From way off you could hear them play a few riffs on their guitars as they warmed up. They often played in the back yard of a dilapidated house—hard mud, the grass long gone or maybe never there. They'd run a fifty-foot extension cord up the back stairs into the kitchen, plug in their amplifiers, and they were in business!

Long, tall, one-armed John Wrencher was one of our favorites with his frenzied harmonica-playing, singing and stomping: "My babe, don't stand no cheatin', my babe!" On Sunday the entire world revolved around that spot—there wasn't anywhere else you'd want to be! John and his band would give their all to the magic of the music, playing to large crowds of Blacks, whites, Latinos, Asians, old-timers and kids—everybody who loved the blues.

Wrencher led a quartet with drummer, bass and rhythm guitar. Of all the Maxwell Street blues people, he was the one we came to know best. We talked with him between sets. John Wrencher was a fine musician with a great, powerful voice, and he should have been better known.

Usually a band at Maxwell Street would attract 60 to 100 people in the warm summer weather, sometimes more. They'd play with only short breaks until one or two in the afternoon when the crowds started melting away. Every now and then, a friend of the band would come through the crowd shaking a cigar box, collecting quarters and dollars for the band.

Crazy as we were about John's music, swaying and stomping from one set to another, drifting with the rhythm, sooner or later we'd tear ourselves away because, just down the street, maybe J. B. Hutto would be playing, and across that lot, Eddie Shaw would be playing. A little further down, Robert Nighthawk would be playing—and behind that bar, Maxwell Street Jimmy would be playing. The man we knew as "Chuck Berry, Jr." would be doing extravagant stunts with his guitar. Old, blind Arvella Gray would be wandering the streets with his steel guitar and tin cup singing "John Henry" with all the dignity and pride of an African prince sauntering through Timbuktu greeting the admiring throng.

They were all great, great musicians! And unforgettable! Maxwell Street was always Chicago's greatest Blues Fest.

One time when John Wrencher was playing near a cross-street, we were standing in the street swaying to his music when a beautiful Black woman in a tight red dress walked up to the singer and, with flair and drama, reached into the bosom of her low-cut dress and pulled out a derringer. "I'm going to kill you, you low-down bastard!" she announced. Hardly anything ever interrupted a Maxwell Street blues band, but this time they all stopped playing immediately; the entire audience, as if they had been well practiced, took cover or threw themselves on the ground in one quick motion.

John said, "Now, darling, I'm real sorry. Please don't shoot!" Well, she didn't, but she was still pointing the gun at him. Apparently, if someone doesn't shoot in the first couple of minutes it's not likely to happen, because people began getting up from the ground and brushing off their clothes. The irate lady, ruffled feathers soothed, put her gun away and stalked off, and the band went back to playing.

There weren't many women blues musicians at Maxwell Street, but there were some, and wonderful they were. The only woman with her own group was a blues gospel singer, Carrie Robinson, who also played guitar. Dressed in white—a nurse's white dress, white stockings, white shoes—and very tall, very thin, very dark, she looked like an exotic stork and had graceful but angular stork-like movements.

Once when we were standing in the midst of the crowd on a deliriously hot summer day, the sun was pouring down and she was belting out a song in vibrant rhythmic breaths while stomping around in a circle in her frantic stork-like way, flapping her elbows, calling and chanting, "Oh, Je-sus, oh, Je-sus," and a few seconds later, "Oh, free-dom, oh, free-dom!" Suddenly, a man in the front of the crowd went rigid. He dropped his bag of groceries and stomped right through them. His eyes were shut—he was in a trance. The band kept playing; people picked up his groceries and held them for him. The marvelous stork-lady took his hand and led him to the front of the band. There he followed behind the singer, hopping with both feet together in a sort of spin—hopping with the throbbing rhythm. She returned to singing that frantic song, putting all her wild heart and soul into it. Finally the song stopped—another moment and I probably would have been up there hopping too, the magnetism was

so great. And then the man in a trance stopped hopping and opened his eyes. He was astonished—and embarrassed to find himself up front with the singer, facing the audience. Disoriented, he asked, "Where's my groceries?" A couple of people came forward and handed him the trampled bag. Really stunned and confused, he left hurriedly. What had happened? Still shaken myself, I didn't know, but it seemed as if my very spirit had grown tired of my body and wanted to slip out and dance, dance, dance and be free.

If you stayed late enough at Maxwell Street, you could get great bargains as the vendors packed up. Then, wandering back through the debris-strewn streets, you knew it wouldn't happen again until the next Sunday. You knew you'd have to work and wait all week, pretend to be interested in the job, put on a show for the boss, but all the time you'd be thinking: I hope it doesn't rain on Sunday. I hope the weather will be warm on Sunday. I'm going to get up early; I'm not going to be late; I'm going to be there when John is tuning up—I don't want to miss a note!

five
Toyen and *The Sleeping Girl*

I felt a great affinity for Toyen from the moment I met her. It was like meeting a dear friend again after a long separation. Warm, wise, witty, independent, with a deep inner power, a charisma clearly indicating the presence of someone special—one who "KNOWS," as Jacques Vaché put it, in capital letters—and who radiated confidence in her knowledge: That was Toyen, a most unconventional woman, who knew what she wanted from life, and who gave the world infinitely more than she took from it.

A picture of her taken in Paris in 1926—during the heyday of the pearl-bedecked flapper with short skirt and silk fringe—shows Toyen wearing what looks like mechanic's overalls; her dark hair is slicked back, her eyes very dark with Kohl, like Musidora in *Les Vampires*. Above all she looks determined, passionate. Toyen always believed in living simply so that she could devote herself to what really mattered: her surrealist inspiration. When we first met at a Surrealist Group party on New Year's Eve, 1965, she was wearing a white blouse and dark slacks—and that was her wardrobe for all occasions. Then in her sixties, she had been a surrealist for over thirty years. She was a splendidly accomplished artist and a thoroughly wonderful person whose surrealist enthusiasm, sense of humor and love transcended all language barriers.

As a militant member of the Surrealist Group in France, Toyen, like Mimi Parent, Nicole Espagnol, Joyce Mansour and Micheline Bounoure, attended practically every meeting of the group, which met each evening from six to eight. Mimi and most of the others often sat in the center of the group, in the thick of the discussions and arguments, while Toyen tended to sit off to the side, listening, laughing, making an occasional comment filled with humor and wisdom.

Born in Prague in 1902, Toyen in her teens took part in the wave of social and cultural radical activity that blossomed all over Europe after the First World War. She broke with her family and took the name Toyen from the French *citoyen*, the greeting of the French Revolution, leaving the word with its root meaning, dweller. Thus she stripped away the conventional masculine/feminine properties of a first name, and did away entirely with the family name, to become her own person, a rebel who questioned everything.

As a young woman she frequented the anarchist milieu, while a brief flirtation with Cubism started her life as a painter. Soon, however, she turned to the lush imagery of the carnival, the circus, and dreams of strange, faraway places, often painted in pastels. In 1920, with the theorist/collagist Karel Teige, painter/writer Jindrich Styrsky and poet Viteslav Nezval she founded the group Devetsil, the most forward-looking current in a broad, flourishing Czech avant-garde that also included Franz Kafka and Jiroslav Hasek. A loose Marxist-oriented coalition of diverse tendencies in the arts, Devetsil maintained that Social Revolution necessitated revolution also in the areas of human expression, consciousness and behavior.

Around 1926 Toyen and her friend Styrsky, without breaking with Devetzil, started their own art movement which, stressing their indifference to Naturalistic rendering, they called Artificialism. The Artificialist canvases they showed in Paris in 1927 were largely the result of splashes and stains, prefiguring the so-called abstract expressionism of the 1940s. During the same period Teige promoted what he called Poetism, which dispensed with all forms of aestheticism and identified painting with poetry. The Poetist tendency in Devetzil evolved steadily toward surrealism, and in 1934 Toyen was one of the founders of the Czech Surrealist Group. With an unbroken history spanning nearly seven decades, this group has never abandoned its surrealist perspectives, its research and agitation. One of the largest and most active groups in the international surrealist movement today, the Czech Surrealist Group is animated by a dedicated core of young people resolutely devoted to the freedom of the imagination, a cause they have courageously defended against all oppression.

From the beginning the Czech Surrealists were in close contact with the group in Paris, and Toyen was immediately recognized as

one of international surrealism's outstanding painters. Until 1947 she took part in all surrealist activity in Czechoslovakia—much of it necessarily underground because of the Nazi invasion, the Second World War, and postwar Stalinization. In 1947 Toyen moved to Paris and joined the Surrealist Group there, in which she was an active and inspiring presence until the unfortunate split of 1969. Her fidelity to surrealism's aims and principles remained absolute up to her death in 1980.

I was delighted but not surprised to learn that Toyen loved to roam the shores of streams and oceans seeking pebbles and to search the forests for mushrooms—lifelong passions of mine. Toyen often enjoyed such adventures in the company of André Breton, Benjamin Péret, Adrien Dax, Guy Flandre and other surrealist friends—what a time they must have had! I like to imagine their discusssions of poetry, love, and surrealism—suddenly interrupted by outbursts of enthusiasm provoked by discoveries of the moment.

Pebbles are miniature worlds unto themselves, and agates the congealed alchemical eggs of the Earth. Stones and minerals, which seem so alienated from the living, were themselves in many cases once alive, and are now the residue of eons of living creatures. The abyss here is unbridgeable, except by imagination; the layer of infinity so different it makes philosophers of those who ponder it. Remarkably, however, rocks and minerals—to whom we humans are nothing, the merest ephemera—nonetheless speak to us. What Breton called "the language of stones" is a vital element in the life of many "primitive" cultures, as well as of alchemists, magicians and poets.

Stones and pebbles figure in many of Toyen's works: pebbles scattered on a plain in one of the drawings in *Specters of the Desert* (1936–37); a single pebble juxtaposed with a marble in *The Origin of Truth* (1952); rock crystals in *The Vertiginous Woman Visitor* (1957).

Mushrooms, too, loom large in the poetic rites of tribal societies, in occultism as well as folklore, and in the personal mythology of Toyen. Many of her seemingly abstract forms are funguslike. This

life-form so ancient that it flourished before the continents divided has long been sought by seekers of wisdom for its special powers, and to this day "magic mushrooms" are part of the pharmacopoeia of dreams and revelation. Their sudden, mysterious apparition and fantastic shapes and colors made them staples of witchcraft, demonology, and fairy tales.

Mushroom hunting is an especially important component of Czech and Czech-American culture. At least once a year my mother, grandmother and I would pack a lunch and set off for an entire day. We knew the trees of the woods very well—knew them as individuals since we visited them often, and therefore knew which trees were most likely to have mushrooms around them. On these pleasant, exciting expeditions we would always find mushrooms in uncountable variety: from minute, delicate Umbrellas almost lost in beds of moss, to giant Puffballs and an occasional Hen of the Woods weighing many pounds.

Mushrooms made the headlines a few years ago—a rare occurrence!—when a scientist announced that in Minnesota a life-form had been found that measured ten acres square and was 30,000 years old, making it the world's oldest living creature. Although people had been picking what they considered "individual" mushrooms there for centuries, genetic testing revealed that this huge underground life-form was in fact itself one big individual. The discovery of this ancient and gigantic fungus immediately raised the philosophical question: "What is an individual?" Mushrooms are still widely and wrongly believed to be destroyers of trees, but are now recognized as an integral part of the ecological balance of the forest.

Toyen featured a particular mushroom in her painting titled *Château La Coste*, the residence of the Marquis de Sade. The picture's central image is a gloriously beautiful but menacing fox, whose silent tread one can feel with each anxious beat of the heart, but never hear, no matter how clever one's ears may be. The fox appears to be drawn on a stone wall, but his head and a front paw emerge from the stone, the paw on the neck of a beautiful bird lying on its back—dead or hypnotized. From the fox's shoulder as well as from cracks in the side of the stone wall sprouts a lavish and sensuous growth of mushrooms, like labia. (It is well known that under the right conditions

a mushroom, one of the most delicate things one can imagine, can break through pavement.)

Toyen knew her mushrooms: the one she has portrayed is no ordinary fungus, but the highly prized Oyster Mushroom, cherished by connoisseurs as especially delectable.

In these and many other works Toyen dwells in the midst of an intense sexuality—an eroticism of canyon depths, of the ocean's deepest abysses. Like a lantern fish, equipped with her own instruments of illumination, she moves with utmost naturalness and grace through the darkest depths of human consciousness. At the point where blackness becomes fire, Toyen is completely at ease. A serious student of alchemy, she transforms her rage and pain into "Great Works" of mad love: each one a triumph of desire against death, a marvel of poetic revenge, a crystal goblet filled to the brim with volatilized lightning. How she found such unique ways to reveal her dark truths with a brush and paint remains her own secret, but a part of the secret surely lies in her passionate intimacy with the language and lore of the world of stones and mushrooms. In dampness and decay she discovered the life of shadows, the myth of light, and other enigmas of hope and despair.

All of Toyen's works have a way of making us participate in them. Her early painting *The Sleeping Girl* (1937) pictures a golden-haired Alice-in-Wonderland little girl in a white dress, carrying a butterfly net; her body and face are turned away from us as she looks on a blank horizon, the future. Seen from the back the figure is disquietingly empty—so perfect, but so hollow, as in the tragedy of "roles" that don't fit, but just form a surface. The whole mood of the picture, however, is one of waiting: latent promise and expectation. Like us, the sleeping girl is still dreaming, and in dream as in life, anything can happen.

At the *L'Écart absolu* International Surrealist Exhibition in 1965–66 Toyen showed a splendid dark canvas in which a woman's accoutrements stood out from a grayish-black background: white gloves with ermine tail; a green purse, but with a living, red animal tongue; an emerald necklace displayed on a dressmaker's form,

whose neck is delicately nipped by a flying bat; a seashell; an apple on a plate; a pale golden mask, featureless except for gilded eyelids with dark lashes on the body of an elegant woman; and in an upper corner, the glow of a man's suit. This painting is titled *The One in the Other*, a title full of dialectical implications, and also the name of a popular surrealist game, in which a particular object has to be described exactly in terms of another. A dance of transmutation is about to begin—has already begun—in which the riddle of metamorphosis choreographs its own answers.

Toyen's sharp critical intelligence always cut through the illusions and pretensions of the hypocritical social order we are all still forced to live in. A knife to the bone, her poetic vision goes deep—deeper than any mere x-rays—and straight to the essence. In the painting titled *Eclipse* (1968) one can barely distinguish the black shadows of a man and a woman against a dark background. The man's face is reduced to a cartoon mouth, but his body contains luminous, colored fish; the woman holds her hands behind her: hands with pink claws holding gloves and the face of a fish. Two fish swim away from each other but they are joined by a golden cord. It is said that you can't look within the human heart, that motivations go unknown, but Toyen's oceanic eyes always penetrated beyond all surfaces, through every armor, to see deep inside of people, places, things, and their myriad configurations.

Toyen's subversive imagination also manifested itself in drawing; indeed, she has left us some of the finest, most moving drawings of all time. Her great graphic work *War, Hide Yourself!* (a title taken from Lautréamont's *Poésies*, and signifying that war should get lost) leaps immediately to mind. No one has ever demonstrated more powerfully or more precisely the mental and physical devastation of war in all its profound and eerie horror, than Toyen has in this unforgettable album of images accompanying a poem by Jindrich Heisler. The incredible strength of these drawings, which pose the inescapably direct question, "Why war?" in the starkest terms, lies in the artist's ability to confront the viewer with poetic evidence that wins all arguments.

Her drawings from *Shooting Gallery* and the *Specters of the Desert* have also continued, and will always continue, to haunt and provoke those who refuse to run away from the risks that poetry implies. For example, the magnificent drawing in *Specters* of a lion cracked like china, its black mane framing an empty hole where the face should be, is a vision which, once seen, can never be tossed aside. First printed in 1939 as Europe was once again starting to tear itself to pieces, it was also reproduced on the cover of the Surrealist Issue of the SDS journal *Radical America* during the Vietnam War. Such images are permanent landmarks for the ever-wandering inner eye.

The work of Toyen demonstrates that surrealism is not only "the collective pursuit of individualism," as André Masson once called it; it is also the collective exploration and reinvention of individual passions. It enables each of us, following through our desires in playful association with others, to become free, and in turn to help free others through the medium of the marvels we reveal together. Surrealism gives voice to desire's telepathy: It is oxygen, the weightless weight of thought, perpendicular flight, a wheel of black fire, the true alchemy of our time. Toyen herself considered surrealism "a community of ethical views," thereby suggesting its supersession of aesthetics, but emphasizing especially its emancipatory solidarity and mutual aid.

Among the gentlest of the surrealists, Toyen is also among the angriest. Perhaps because of her gentleness, she had none of that cynical, emotionless detachment which living in this death-oriented society seems to demand. Her entire work resounds with the urgency, generosity and passion of the most extreme poetic imperatives. Enraged, intransigent, direct and forceful, Toyen is a rigorous philosopher who has reflected critically on life, its seeming mysteries and its potentialities, and is more than willing to communicate to us the lessons she has learned. Above all, however, she is a wonderful seer, who shares with us the things she has seen.

For Toyen, the universal solvent sought by the alchemists of old was always right at hand: the universal shock of self-recognition

provoked by the unsettling apparitions of surrealism's automatic messages. Toyen's magic art, crepuscular, ivory and blue, remains forever aglow in an all-night festival on Prague's Street of the Alchemists. Her implacable poetic vision has given revolutionary consciousness a new dimension, and leaves a brightly burning path toward the renewal of the world.

The Hermetic Windows of Joseph Cornell

Joseph Cornell, who was born in 1903 and lived in Flushing, New York, is one of the few U.S.-born persons who have been associated with the surrealist movement. He was attracted to surrealism at the age of twenty-six when he discovered Max Ernst's album of collages, *La Femme 100 têtes*. Examples of Cornell's work were included in a Surrealist Exhibition at the Julien Levy Gallery in 1932. He has never ventured from the U.S. except in his imagination, nor has he become particularly well-known here. He participated in several surrealist exhibitions and, in the 1940s, collaborated on the publication of the surrealist-oriented *View* magazine in which several of his collages, pictures of his boxes, and several of his texts may be found.

One of my favorite of his works—a little collage of ship, rose and spider web—draws together and expresses very subtly both cultural and dream symbols that are very compelling. It seems almost possible to grasp it immediately and yet it lingers mysteriously in one's thoughts—like a dream which one is sure is filled with hidden meanings. Ships have always been considered feminine. This vessel displays her sails proudly like a beautiful and independent woman; nested at her stern is a huge rose in all the beauty and maturity of its bloom, lending its symbol of female sexuality to that of the ship: inside the rose is stretched a spider's web, the pattern of which perfectly reflects the pattern of the ship's rigging, implying that the petals of the rose can be controlled by the spider's web as precisely as the sails of the ship can be controlled by the rigging. But the web is not empty: in its center dwells a spider who controls the web and sets it out for its own purpose, for the satisfaction of its desires, even as the flower sets out its petals, and the ship sets out its sails.

The small boat behind the ship could very well be a child who follows his mother whom he both respects and desires. The ship itself, a woman essentially desirable and beautiful, is also purposeful and intelligent—a ship with the gracefulness and stillness of a dream.

Cornell is best known for his object-boxes of which he has made hundreds. *The Soap Bubble Set*—one of his earliest boxes (1936)—is dominated by a large chart of the moon labeled in French. Before the moon, on a low shelf, is placed a white clay bubble pipe; below this are three circular mirrors. To the right on a high pedestal is a child's head of white china; to the left is a goblet in which an egg is suspended. Near the top of the box four rounded containers are suspended: on the left one is a collage of an astrological horse and rider, Saturn replacing the horse's head. On the right Saturn rises above the ruins of an ancient city.

In this particular box Cornell's work is remarkably analogous with the imagery of alchemy. Alchemy itself, to preserve its secrecy, used a cloak of analogy involving traditional symbols. Thus the *Magnum Opus* is often represented as the head of a child or, to follow its reflection on the other side of Cornell's box, the "egg of the philosophers," meaning either crucible or retort but also symbolizing the perfection of their work, the roundness of the universe, eternity. The egg has also been called the "stone which causes the moon to turn." In *The Garden of Earthly Delights* by Hieronymus Bosch the egg is carried aloft in the parade about the Fountain of Life (its position is the exact center of the central panel). In Brueghel a broken or cracked egg represented corruptness, and the cracked and broken head the corruptness of the state. (All the king's horses and all the king's men couldn't put Humpty Dumpty together again.) The child's face is itself an egg: one finds there the beginning of an adult and hope for the transformation of the world.

The four containers suspended above the shelf can be seen to represent the four elements of the alchemists (fire, water, earth, air); the three mirrors on the floor of the box, the three alchemical realms (animal, vegetable, mineral) or perhaps the three planes of being (corporeal, subtle, spiritual). Alchemically, Lead is represented by Saturn, a winged horse (the volatile principle), and the ancient city perhaps becomes the ancient art.

The glass goblet is a recurring element in Cornell's boxes: one thinks of china cabinets and the mothers who cherished, polished and protected them. (But why should cups have stems? Are they imitating flowers?) The moon in this box seems to be the *Magnum Opus*

of the child, his great alchemical triumph which has been created from the goblet and egg by means of the bubble pipe. The moon and bubbles participate in the same luminousness and evoke the same fancy. Is it possible that soap bubbles which escape and drift very high become moons?

Cornell's boxes hearken to that magical time in childhood when thought was the same as deed, when one suffered the pangs of conscience for dangerous thoughts against one's parents, when one carefully avoided the cracks of sidewalks, occasionally running all the way home just to be sure that one's mother was safe. It was this period of life, or perhaps earlier, that I remember being fascinated by the jars on my mother's dressing table. One of Cornell's boxes, *L'Égypte de Mlle. Cléo de Mérode: Cours Elementaire de l'Histoire Naturelle*" evokes the same feelings. It is filled with lovely jars containing fascinating specimens. Once, playing by myself, I carefully inspected all the jars and bottles on my mother's table, picking them up one after another, reading their labels and examining their contents. At this time I recall that I came upon one which made my heart beat faster with wonder and fear, for the label read quite clearly—there was no mistaking it: VANISHING CREAM. There was not a doubt in my mind that one vanished when one applied this cream, or that my mother applied it and vanished on occasion. The instructions for application were quite clear, and I longed to be initiated into this secret rite, to apply the cream and vanish. How glorious to have the omnipotence of one's parents! But there were absolutely no instructions regarding how to reappear. I was afraid that in my vanished state, although I would be able to learn all secrets, I might not be able to communicate with anyone, and thus be destined to remain vanished and lost forever. Worried that I might be discovered, I replaced the lid, being careful not to get any cream on myself lest I vanish in part, and thus reveal to all what I had discovered, leading to some punishment.

Cornell's boxes appeal to that time when we first learned to wonder, when the sun still followed us wherever we went, when dream and reality were not understood as being separate: a time of alchemists when the mind triumphed over matter and base metals could certainly be transmuted into gold through the correct process

of thought and combined action; when one had the power to bring on the night by making a shadow with one's hand. The alchemists sought to transform matter; Cornell transforms matter into dreams by the creation of perfect worlds in miniature, entirely self-contained. A rational order with a seemingly incomprehensible end, Cornell's worlds appear remote—as remote as distant galaxies—but they are in fact the reflection of the forgotten and forbidden secrets of one's own mind.

seven

Citizen Train Defends
the Haymarket Anarchists

Of all the men and women who came to the defense of the Haymarket anarchists, none was more unusual or more colorful than George Francis Train (1829–1904). Renowned in his own lifetime as America's greatest eccentric, he led a life of unparalleled diversity and adventure, and had an extraordinary effect on his time.

Orphaned at four, the Boston-born Train enjoyed a real-life "rags-to-riches" career, although he added many unique touches of his own that never figured in any Horatio Alger tale. Arguably the nineteenth century's foremost transportation genius, he revolutionized several branches of the industry and more or less single-handedly invented others. His clipper ships, most notably the famous *Flying Cloud*, were the fastest and most beautiful of all time. Second to none in developing the transcontinental railroad, he initiated the Crédit Mobilier which financed it, and later he went on to build street-railways in Britain. A prolific journalist, he wrote some twenty-five books and pamphlets on a wide range of subjects. He was a major promoter of Irish immigration to the U.S., the founder of Omaha, Nebraska, and the inventor of the pencil with attached eraser as well as of the perforated stamp. He was also a great traveler: His 1870 voyage around the world in eighty days inspired Jules Verne's celebrated novel on that theme.

Largely as a result of the California gold rush, and the later gold rush in Australia, Train, with his extensive shipping interests, became a millionaire. He went to live for a time in Australia, where revolutionary miners offered him the presidency of the republic they hoped to establish in what turned out to be an ill-fated effort to declare their independence from England. Although Train declined the honor, it was clear that he was already recognized as a man of progressive and even radical views.

His wealth notwithstanding, Train grew more radical as the years went by. An atheist in his childhood ("I could not see the necessity of God . . . religion never appealed to my intelligence or to my emotions"), as an adult he rejected the conservatism of his business associates. Although his wife was a close relative of Jefferson Davis, Train—in England during the Civil War—was a vigorous supporter of the Union cause; his speeches and publications were an important factor in educating British workers on the war issues, and in blocking British government support for the Confederacy. His abilities as an agitator did not go unnoticed by those in power. For years, he wrote later, "five or six governments kept their spies shadowing me in Europe and America."

After the war, Train's radicalism blossomed in all directions. Seeing no reason why ideas—or indeed, life itself—should lag behind technology, he took up virtually all the advanced ideas of his day. He funded the feminist paper *Revolution*, edited by Susan B. Anthony and Elizabeth Cady Stanton; identified himself with the First International; took an active part in the Marseilles Commune; supported the independence of Ireland; became a vegetarian; and, in 1872, went to jail for defending free-love advocate Victoria Woodhull against "obscenity" charges leveled against her by that bookburning Puritan, Anthony Comstock. This was neither Train's first time behind bars, nor his last; he later boasted that he had been imprisoned fifteen times without ever having committed a crime.

Train's eccentricities, already in evidence in earlier years, became pronounced in the 1870s. Styling himself the "Great American Crank" and even "the greatest man in the world," he went about in a bright red sash (indicating his passion for communism), and sported a green umbrella and lavender gloves (no doubt indicating his passion for flamboyance). After running for president in 1872, he declared himself a candidate for dictator, intending to establish "a pure autocracy of love." Asked by a reporter if, as dictator, he would occupy the White House, he replied that he preferred to rule the universe from the park bench that he regarded as his headquarters.

Eventually, his fabulous wealth long since exhausted, he withdrew from public life altogether. Believing that contact with adults

was injurious to evolutionary development, he spoke only with children, birds and squirrels, with whom he shared the peanuts which were his principal food.

What brought Train out of his self-imposed seclusion from adult society was the Haymarket affair. In a lecture on the trial on September 18, 1887, he declared that if seven men had to hang, the American people would do much better to hang the seven judges of the Illinois Supreme Court rather than the anarchists. He sent a wire to the imprisoned men, expressing his willingness to lecture on their behalf and asking them if they thought his doing so would help the cause. When Parsons and his comrades said yes, Train left immediately for Chicago.

Speaking in the city's Princess Skating Rink, Train threatened: "You hang those seven men if you dare, and I will head twenty million workingmen to cut the throats of everybody in Chicago!" He asked: "How can you convict men of being accessories to a crime for which there is no principal?" And again: "What do they want to hang these men for? Are they afraid of them?"

As a result of this address, Train was barred from further speech-making in Chicago, and the paper he had started, *The Psycho-Anarchist*, was also suppressed. These latest incidents in a seemingly unending series of violations of fundamental democratic rights prompted Albert Parsons, in Cell 29 at Cook County Jail, to write Train a remarkable letter, dated October 14, 1887. "Despotism of America's money-mongers again demonstrated," wrote Parsons.

They deny the right of the people to assemble to hear you speak to them. Free speech! They will not allow the people to read *The Psycho-Anarchist*. Free press! They interdict the right of the people to assemble and petition for redress of grievances. Right of assembly! . . .

The people clubbed, arrested, imprisoned, shot and hung in violation of law and constitution at behest of America's monopolists.

Parsons concluded his letter with great warmth:

Onward! Citizen Train! Freedom shall not perish! Let the welkin ring, and from land to land labor's innumerable hosts proclaim—Liberty! Fraternity! Equality! Salut!

And when the venerable sage of the *Flying Cloud* sent a basket of

fruit to each of the Haymarket prisoners, he received another notable salutation, this time from Adolph Fischer. Thanking Train for the gift, Fischer went on to say

"I noticed that the daily papers refer to you as the 'champion crank.' Don't mind that! What is a crank, anyway? . . . [A]ll men who are in advance of their age go under the category 'crank.' Socrates, Christ, Huss, Luther, Galileo, Rousseau, Paine, Jefferson, Franklin, Phillips, and last but not least, old John Brown, and many other more or less known apostles of progress have been considered 'cranks' by their contemporaries because they held ideas which were contrary to and in advance of the customary social, political, religious, or scientific arrangements of things. But for these 'cranks,' civilization would be in its infancy yet.

Therefore, long live the 'cranks.'"

In an interview after the execution of the anarchists, Train expressed his belief that Louis Lingg was not a suicide, but had been killed by jail authorities. He also avowed his refusal to live in a country guilty of the judicial murder of the anarchists, and announced that he was leaving for Canada, where he did in fact live for a time.

In 1890 he traveled round the world again ("I go round the world every twenty years, to let it know I am still alive"), and three years later made a splash at the World's Columbian Exposition in Chicago. Radical to the end, he had encouraging words for Coxey's Army and the Populist movement, and denounced U.S. imperialism during the Spanish-American War.

Train's 100,000-word autobiography, published in 1902, is dedicated "To the Children and to the children's children in this and all lands, who love and believe in me because they know I love and believe in them."

eight
Mary MacLane, a Daughter of Butte, MT

"I of Womankind and of nineteen years, will now begin to set down as full and frank a Portrayal as I am able of myself, Mary MacLane, for whom the world contains not a parallel." Thus begins one of the most unusual books in our literature, by one of the most scandalous American writers.

When *The Story of Mary MacLane* was published by the prestigious Chicago firm of Herbert S. Stone and Company in April 1902, its author was skyrocketed to nationwide notoriety. The book was an immediate sensation. Nothing like it had ever been seen before, and the fact that it was the work of a teenage girl—living in Butte, Montana, of all places—made the scandal complete. Every Associated Press affiliate in the country ran a front-page story on it. Here for the first time was a young woman's "inner life shown in its nakedness":

> I have discovered for myself the art that lies in ob-
> scure shadows. I have discovered the art of the day
> of small things . . . I care neither for right nor for
> wrong? my conscience is nil. My brain is a con-
> glomeration of aggressive versatility. I have reached
> a truly wonderful state of miserable morbid un-
> happiness . . . May I never become that abnormal,
> merciless animal, that deformed monstrosity—a
> virtuous woman. . .

Respectable critics roared their disapproval. "Mary MacLane is mad," wrote the *New York Herald*. "She should be put under medical treatment, and pens and paper kept out of her way until she is restored to reason." The *New York Times* urged that she be spanked. Other critics raised the charge of "obscenity." When the Butte Public Library announced that it would not allow the book on its shelves, the *Helena Daily Independent* applauded, arguing that if this book

"should go in, all the self-respecting books in the library would jump out of the window."

The Story of Mary MacLane was an instant bestseller. Some 80,000 copies were sold the first month alone, and the resulting $17,000 in royalties allowed MacLane to fulfill her greatest ambition: to escape Butte. The book went through several printings, and its author remained front-page news for years. Mary MacLane Societies were organized by young women all over the country. The popular vaudeville team of Weber and Fields—remembered today mostly as the introducers of pie-in-the-face gags—did a burlesque of the book. A full-length spoof was published, titled *The Story of Willie Complain.* "Montana's lit'ry lady" found her way into the comics and popular songs. There was even a Mary MacLane Highball, "with or without ice-cream, cooling, refreshing, invigorating, devilish, the up-to-date drink."

The rage for "MacLaneism," against which leading critics from coast to coast declaimed so fervently, also had its more somber aspect. It was reported that a Chicago girl who had organized the local Mary MacLane Society was arrested for stealing a horse. She said she committed the theft because she needed the experience for a novel she was writing. And on 4 May 1902 the *Great Falls Daily Tribune* told of a Michigan 15-year-old who "imagined herself ill-used and misunderstood. The reading of the morbid ravings of the Butte girl convinced her that she was, and a dose of arsenic followed. She died with a copy of the book in her hands." According to some reports, MacLane's book prompted a whole rash of suicides.

Who was Mary MacLane—this Montana girl who drove literary critics to distraction and made moralists furious, and whose book was said to provoke insanity, crime and suicide?

Descended from "a long line of Scotch and Canadian MacLanes," Mary was born in Winnipeg, Manitoba, on May 2, 1881. Throughout her life she was fiercely proud of her father's "Highland Scot" heritage, and she considered her own rebellious genius to be a direct result of it. At age four her family moved to western Minnesota. Her father died when she was eight. A few years later, after her mother had remarried—this time to "a mining man"—they pressed on to Montana, finally settling in Butte in the mid-1890s. Those

who knew Mary MacLane in those years recalled her as a studious, withdrawn and somewhat morbid child; her schoolmates called her "The Centerville Ghost" because she liked to prowl around the local cemetery at night. For two years she edited the Butte High School paper. She graduated in 1899, with proficiency in Latin, Greek and other languages.

She seems to have read whatever came her way—everything from Nick Carter pulp mysteries to *Foxe's Book of Martyrs*. Drawn to the great Romantic poets, Byron and Keats above all, she was also fond of "books for boys." She did not, however, care for "girls' books": "I felt as if I had more in common with the Jews wandering through the wilderness, or with a band of fighting Amazons."

Well versed in the history of the struggle for women's rights, she read and liked the feminist authors—especially Susan B. Anthony, Elizabeth Cady Stanton, and Victoria Woodhull—but took no part in the organized women's movement. Similarly, she admired "the noise and color and morale of the crowds on a Miners' Union Day" (Butte was a stronghold of the militant Western Federation of Miners, and later of the Industrial Workers of the World), but remained outside the ranks of organized labor. "I am always alone," she wrote. "I might mingle with people intimately every hour of my life, still I should be alone."

Outwardly her life remained in many ways as severely restricted as that of most women in the turn-of-the-century United States, crushed beneath the weight of custom and crippled by prejudice. But inwardly her spirit yearned for love, adventure and the marvelous, and teemed with a defiance that found expression in her writing. It was what she did with these yearnings and this defiance that makes her work so unique and important. And what did she do? Simply, brilliantly, rigorously, she revealed the real working of her mind in the various circumscribed situations of daily life.

"The clearest lights on persons," she noted, "are small salient personal facts and items about them and their ways of life." Out of these "small salient personal facts" Mary MacLane elaborated her own myth—a myth of herself. From the seemingly most trivial things that surrounded her, she distilled a pure magic. She wrote, with sensuous detail, on "the art of eating an olive," on her long walks over

Butte's endless "sand and barrenness," on the sexual longings stirred in her by seventeen engraved portraits of Napoleon. Narcissistically, obsessively, playfully, she explored the infinite irrational depths of her recalcitrant subjectivity. "Just to be Mary MacLane—who am first of all my own self, and get by with it!—how I do that I cannot quite make out."

After *The Story of Mary MacLane* she published two more books: *My Friend Annabel Lee* (1903) and *I, Mary MacLane* (1917). She also contributed feature articles to a number of newspapers and magazines. None of her writings fit into the usual literary classifications. They are neither fiction nor non-fiction; they are not "stream-of-consciousness" narratives and should not be confused with "true confessions." Although presented in diary form, they are really something quite different. They are certainly not autobiography, philosophy or psychology, any more than they are stories, essays or poems. Mary MacLane defied existing genres and created her own.

Poetic humor is her hallmark. Much of her work, such as "The Six Toothbrushes" and "The Back of a Magazine," makes us think of Lautréamont and Jarry. There is an "anti-literary" quality about her writing—anti-literary in the sense intended by André Breton and Paul Éluard when they declared that "poetry is the opposite of literature." Although an avid reader she disdained the society of *littérateurs*, and contributed rarely, if at all, to literary reviews. Her eccentric, playful yet radical divergence from the dominant literary tendencies of her time qualify her as an authentic presurrealist.

"I do not write what my thoughts are saying to me," she acknowledged, although "now and again I think I catch some truth by the sweat of its Rhythm." But "something lives, lives muscularly in me that constantly betrays me, destroys me against all my own convictions, against all my own knowledge, against all my own desire." With the same striking candor she recognized the limits of her own self-assigned project: "It is as if I have made a portrait not of Me, but of a Room I have just quitted."

If most critics disparaged her with uncomprehending malice, there were at least a few exceptions. Novelist Gertrude Atherton, who visited her and wrote about her at length, admired not only her writing but also her conversation, "a mixture of slang and prose of an

almost classical purity"; she found, too, that MacLane's "criticisms of current authors were acute, unbiased, and everything she said was worth listening to." Hamlin Garland praised "her crisp, clear, unhesitating use of English." H. L. Mencken admired her sense of "the infinite resilience, the drunken exuberance, the magnificent power and delicacy of the language," and said he knew of no other woman writer who could play on words more magically. In a full-page review in the *Chicago American*, Clarence Darrow pronounced *The Story of Mary MacLane* "little short of a miracle," and went on to say that "No more marvelous book was ever born of a sensitive, precocious brain." Socialist Oscar Lovell Triggs saluted MacLane's courage in portraying "the inner history of her life." And Harriet Monroe, who went on to become founding editor of *Poetry* magazine, likened her to Emily Brontë and elsewhere stated that she had never met anyone with more analytical power.

After *The Story of Mary MacLane* was published, the young author visited Chicago and then went East for a time. Rumor had it that she might enroll in Radcliffe College or Vassar, but nothing came of it. She found life in Boston and Cambridge dull compared to Butte, "where the people are so much more virile and full of imagination." She much preferred New York, especially Greenwich Village, where she kept an apartment for several years. Her New York writings include an affectionate sketch of Coney Island and a strong indictment of Wall Street.

Wherever she went she was sure to confound the philistines with her unconventional behavior. She went out of her way to insult Butte society matrons who staged a literary reception in her honor. A trip to Newport, Rhode Island provoked an article sharply critical of that fashionable resort-town's class pretensions and arrogance. Mary MacLane simply could not be "domesticated." Violating social conventions was the essence of her being. At a time when tolerance of dissident sexuality was virtually non-existent, she openly avowed her Lesbian inclinations. We find her refereeing a prizefight in Thermopolis, Wyoming, and frequenting low-class gambling dives on 42nd Street in New York. In later years she seems to have rejected literary society altogether and, with characteristic defiance of white middle-class propriety, chose to live instead in Chicago's African American community.

Always, everywhere, she freely expounded her controversial views on marriage, the family, sex, religion, literature, morality, the greed and idiocy of the rich, and anything else that came to mind.

Unlike so many authors who enjoy initial success in Chicago and then move to New York to grow old and respectable, in 1917 Mary MacLane came back to the city of her youthful triumph for what turned out to be a second triumph, of sorts—or at least another scandal in the grand MacLane tradition: She made a movie!

An "ardent film fan" herself, when she received an invitation to make a film from producer George K. Spoor of Chicago's renowned Essanay Studios, where Charlie Chaplin made his greatest shorts, she readily accepted. Shortly after her arrival in town, production began on the full-length feature *Men Who Have Made Love to Me*. Not only did MacLane write the script—based on an article of the same title she had published in 1910—she also played the starring role: herself.

Directed by Arthur Berthelet, the seven- or eight-reel *Men Who Have Made Love to Me* was released in January 1918, and was widely reviewed throughout the country. Unfortunately, no print of this film appears to have survived. Most critics didn't care for it, needless to say, although a few begrudged her some ability as an actress, and her director said that the comic vamp reminded him of the young Sarah Bernhardt. Not surprisingly, the film provoked the wrath of puritanical public opinion; it was banned by the Ohio Board of Censors as "harmful to public morality."

And so Mary MacLane, who embodied much of the spirit of the "Jazz Age" two decades early, was still going strong in 1918. Not for nothing has she been called the earliest example of the "New Woman" in literature, and even "the first flapper." But when the Roaring Twenties roared into full swing, she was no longer the constant headliner she had been in her youth. After the furor provoked by her movie died down, she settled in Chicago. Her contract with Essanay called for a series of films, but she made no others. In part this may have been because the first film was not a box-office hit, but MacLane's failing health was surely another and perhaps greater factor. She had been considered frail even as a child, and in 1910 she suffered a severe case of scarlet fever. Sometime in the 1920s, if not earlier, she was diagnosed as having tuberculosis.

She was cared for during her last years by her best friend, the African American photographer and longtime Chicagoan Harriet Williams, whom she had met through New York acquaintances not long after her first book came out in 1902. The two had stayed in touch and were especially close during MacLane's last four years. On August 6, 1929, she died in her room at the Michigan Hotel on South Michigan Avenue, not far from Williams' studio. She was forty-eight years old. Williams, together with Harriet Monroe, arranged her funeral.

For decades after her death Mary MacLane remained largely an unknown. Her books were long out of print and difficult to find, even in libraries. Standard literary histories and anthologies ignored her completely, and until recently even feminist writers rarely referred to her except in passing. Amazingly, she is not profiled in the three-volume reference work *Notable American Women*.

Yet MacLane's is an important voice, rebellious and original, and surely will be listened to again. At a time when most U.S. "women's literature" reeked of genteel sentimentality, moralistic uplift, and other literary sugar-water, she offered readers stronger stuff by far. Scandalously, passionately, she rejected bourgeois Christian notions of "femininity" and scorned the patriotic platitudes about life in the U.S.A. Above all she affirmed her right to a free sexuality, and insisted that the quest for experience and self-realization is too important to allow it to be impeded by stupid, narrow-minded bigots and bureaucrats. After nearly a hundred years, her radical pessimism, her individualist feminism, her refusal to adjust to the misery and hypocrisy of an unjust and exploitative social order have retained and even multiplied their force, and more than ever win our respect and admiration.

"I can shake my life like a hollow gourd," said Mary MacLane, "and hear the eerie rattling sound I make in it." There is a bitter humor in these words, as in so much of her writing. Although she felt that her humor was "far too deep to admit of laughter," she coolly and calmly insisted on keeping the last laugh for herself. "In my black dress and my still room, I say inwardly and willy-nilly, and with all my Heart and relishingly: Ha! ha! ha!"

nine

Surrealist Encounters, Ted Joans, Jayne Cortez, Black Power

You have nothing to fear from the poet but the truth.

—Ted Joans

The surrealist concept of objective chance identifies unforeseen encounters that coincide amazingly with one's own desire. André Breton defined it as "the form of the manifestation of external necessity that finds its way to the unconscious." It is an experience perfectly suited to the city of Paris, and it is no accident, as surrealists are fond of saying, that objective chance was first discovered and named in that place. At least that's the way it seemed to me in 1965–66, when Franklin and I, happily liberated from the workaday world, spent whole days, week after week for months on end, wandering and exploring its labyrinthine avenues, *passages*, and *rues*.

Our hotel, the Grand Balcon, was on the rue Dauphine on the Left Bank. To our continual surprise and joy, we found that its crooked and meandering streets intersect at unexpected angles and come together in unusual ways at odd places. The "city block," as we think of it in the U.S.—a street-pattern based on a square or rectangular grid—is unthinkable in Paris (or, for that matter, in any of the world's great precapitalist cities). In Paris, diagonal, curving and zigzagging streets are the rule, and yet one never gets lost: the streets seem to curve to one's desires—or perhaps, when you are precisely where you want to be, it's impossible to be lost. London streets, in contrast, often turn into dead ends, and no one, not even lifelong residents, seems to know more than a neighborhood or two—which is why Londoners all carry their *A to Zed*.

From the Grand Balcon the path of least resistance naturally led downhill to the Seine, where we enjoyed browsing the bookstalls. The same route, pursued a bit further across Pont Neuf, took us to

the fantastic Les Halles market district, one of the wonders of Paris, long since devastated by "development." There, especially at night, a dizzying profusion of the most astonishing sights commanded one's attention at every turn, as workmen in a hurry wheeled huge round cheeses, six feet in diameter, down the street past immense overflowing bins of oranges from Algeria, truckloads of vegetables from the south of France, and barrel after barrel of nuts and spices from who knows where.

It was in Les Halles, at the café Promenade de Vénus, that the Surrealist Group was meeting every weekday evening in 1966. One day word went round the cafe that Ted Joans, surrealiste *Afro-américain*, was in town. "You'll meet him," our friends told us, and when I asked where, the answer was, "Oh, you'll just run into him." I wasn't so sure; Paris is not what you'd call a small city. We did know what Joans looked like, for his photo had appeared in the same issue of the journal *La Brèche: Action surréaliste* (October 1963) that contained Claude Tarnaud's letter to Robert Benayoun about the beginnings of a Surrealist Group in Chicago.

Not more than a day or two after learning that Ted Joans was in town we indeed ran into him, on the rue de l'Ancienne-Comédie, a hundred feet or so from the Hotel du Grand Balcon. He was strolling breezily along the narrow sidewalk heading toward the Seine, wearing a black beret, sunglasses, and a light brown trench coat right out of Casablanca. He greeted us warmly, and said he had heard that "surrealists from Chicago" were in Paris, which intrigued him mightily. He said he had in fact noticed us earlier but, probably because Franklin was wearing a black leather jacket, decided we were from Marseilles. We walked over to his hotel near the boulevard Saint-Michel, where he blew a few riffs on his trumpet and told us stories of his life and travels. We talked about the International Surrealist Exhibition at the Galerie l'Oeil, about other current doings of the Surrealist Group, about jazz in Paris, about Malcolm X, about *Présence africaine*, about Black politics in the U.S. and France, and of course about his totemic animal, the rhinoceros. As he wrote in his first letter to André Breton in 1960:

"I love rhinoceroses because they are rhinoceroses."

When we left, we agreed to get together again soon, but made

no rendezvous. When he asked how long we were going to be in Paris, we told him "indefinitely"—we had no plans to leave. He said he was taking off in a few days for Timbuktu, but would probably be back in a few weeks.

On that first trip to Paris, we ran into Ted Joans many more times—sometimes at the Promenade de Vénus, but above all in that privileged place reserved for chance encounters: the street.

Born in Cairo, Illinois in 1928, Ted Joans first encountered surrealism as a child in Indianapolis, where an aunt who was employed as a domestic brought him old books and periodicals her wealthy white employer had discarded; among them were copies of *La Révolution surréaliste* and David Gascoyne's *Short Survey of Surrealism*. As a child he also discovered jazz, and eventually became so enamored of it that he called it his "religion." As an art student at the University of Indiana he was drawn toward the Beat scene, and soon gravitated to New York's Greenwich Village. In no time he was a major player in the Beat game, renowned for his poetry readings, imaginative parties, and the hilarious "Rent-a-Beatnik" agency (to liven up square parties). He was also active in the New York bebop scene. A costume party he organized to raise funds for Charlie "Bird" Parker was dedicated to "Surrealism, Dada and the Mau Mau." Joans and Bird were good friends, and even roommates for a while. Joans's writings contain many moving reminiscences of the greatest of all jazz alto saxophonists, and warm tributes to his generous genius.

Unlike most Beat poets, who took their cue from Ezra Pound, Joans found his original inspiration in Black American poets, notably Langston Hughes, and the surrealists André Breton and Benjamin Péret. It did not take him long to discover the Black surrealists as well: poets Étienne Léro, Léon Damas, Aimé Césaire, Clément Magloire-Saint-Aude, and the painter Wifredo Lam. Even in his Beat days Joans often wrote in the language of surrealism and Black Power:

"I saw Mau Mau kicking Santa Claus."

In 1960 he encountered André Breton, and soon began to take part in surrealist activity—at first in France, and later also in

Holland, Germany, and other countries. Since 1968, when his poem, "The Statue of 1713," appeared in the Chicago wallposter *Surrealist Insurrection*, he has collaborated on virtually every collective publication of the Surrealist Movement in the United States. One of the foremost surrealist poets in English today (over twenty volumes of his poems have been published), he is also noted for his paintings and collages, and his own inventions, including the Outagraph (a photo from which the central image, "what everybody is looking for," has been cut out, "leaving only its shape and shadow"), and the film-poem: short, spontaneous documentaries of magic moments and special places. He has contributed numerous articles to surrealist journals throughout the world, ranging from a merciless critique of Salvador Dalí's racism to a lyrical celebration of schizophrenic painter Adolf Wölfli, and also writes inspired jazz commentaries for various music magazines.

In this article I want to concentrate on Joans's overall impact on the surrealist movement, and on certain ideas he has either introduced or developed in new directions. More specifically, I shall focus on his "wild talent"—to use Charles Fort's term—for being both participant in, and stimulator of, highly improbable yet far-reaching chance encounters, and how this relates to the specific contributions he has made to the theory and practice of surrealism.

Even the simplest occurrences of objective chance offer an electrifying insight into "how life works." More powerful examples can bring one to the point of delirium. Much more than mere coincidences, such encounters can and do shape decisive events in our lives. The experience is a little like paranoia, but in a pleasurable form: an acute awareness that more is going on around us than we realized, but that we are actively involved in it all, and that our desire is a crucial factor.

Such glimpses of one's shifting place in the larger sphere of events counter the entrenched positivist belief that we have no vital connection to the things that happen in our midst. (The feeling of disconnectedness is in turn the source of one of the worst curses of contemporary civilization: boredom.) Restoration of our sense of

connectedness, lost since childhood, fosters a consciousness psychologically akin to animism, and allows us to feel the stirrings of newly awakened powers within us, not unlike those of a magician.

Incidences of objective chance, and the "enchanted situations" they tend to create, seem to have the strongest effect on people who are, as it is said, "tuned in to the same wavelength." Indeed, sometimes it appears that poets are alone in recognizing these encounters for what they are, and in trying to follow through on them, to see where they lead.

Since the early 1960s, Ted Joans's surprise comings and goings have had a serendipitous and vivifying effect on his surrealist friends around the world. His unanticipated arrivals have a way of bringing about genuinely playful situations which are conducive to spontaneity and improvisation. What happens next can be poetry, action, humor, or an exchange of ideas, but it is always interesting and somehow fruitful for all concerned.

In "Laughter You've Gone And . . . ," a beautiful salute to his friend and fellow African American poet, Bob Kaufman, he wrote:

> *I benefit the magics. . .*
> *I poem my life to poetry. . .*
> *I visit rubber orchestras. . .*
> *I mistake no incomprehensibles*

Our second trip across the Atlantic, in the fall of 1970, was limited to two weeks, with three days in London. We knew that Joans spent most of his time on the continent, and had no reason at all to expect that he would be in London during our short stay there. Nonetheless, at a place called Better Books, one of the "hip" bookstores of those days, I asked a clerk if she knew Ted Joans.

"Everybody knows Ted Joans," said she, with a smile.

I asked: "Is he in town?"

"I have no idea," she replied. "But if he is, he'll be here!"

Five minutes later—there he was!

Our hectic schedule made this encounter especially important. In a couple of hours he gave us the up-to-the-minute details on

surrealism in France (the Paris group had suffered a catastrophic split the year before). Independent of the competing factions, but still friendly with the individuals involved, Ted Joans was ideally situated to provide us with an overview of the situation in Paris.

In 1978 Franklin and I were in New York for two days, representing the Black Swan Press at a small-press book fair. Ten hours each day we sat behind a table which displayed copies of *Arsenal/Surrealist Subversion* and other surrealist publications. Those two days were full of encounters; we made several new friends and enjoyed reunions with old ones. Early on the first day we had the pleasure of meeting James G. Spady, of the Black History Museum in Philadelphia. A friend of the great Black poet Sterling Brown, and also of the extraordinary musician Sun Ra, Spady was very well-informed about the history and literature of surrealism, and we had an extremely interesting discussion with him concerning surrealism and the Black world, during which he spontaneously mentioned "the fabulous Ted Joans."

This discussion was unfortunately and yes, rudely interrupted by a (white, male) visitor to our table who began denouncing, in a loud voice, Franklin's article, "Black Music and Surrealist Revolution," in *Arsenal* 3. This self-appointed music critic, who said he was a supporter of one of the smaller leftist sects, was especially enraged that Franklin had praised the music of Cecil Taylor and even referred to Taylor as a revolutionary. Franklin had hardly had an opportunity to reply to this tirade when, all of a sudden, who should arrive on the scene but Ted Joans! Smiling at the ignorant, hostile mentions of Taylor, he wordlessly reached into his bag and pulled out an 8" x 10" glossy photo of Taylor and himself, which he just happened to be carrying. Holding it aloft and showing it to the crowd that had gathered, Joans announced, "This is who they're talking about: Cecil Taylor! Everything he does is revolutionary! This man [pointing to Franklin] is correct!"

By this time the crowd had grown to some thirty people (no other exhibit in the place attracted more than two or three at a time) and our fulsome critic was finding it difficult to continue his unsolicited

lesson in "musical politics." To Joans, who was still holding up the photo of Cecil Taylor, he shouted angrily: "You're trying to intimidate me!" Calmly Joans replied: "Nobody's trying to intimidate you. The truth is, you don't know what you're talking about."

"I do so!" shouted our critic. "I say Cecil Taylor and all contemporary jazz are counter-revolutionary!" This outburst provoked much laughter from the still-swelling crowd. And then, as if from nowhere, Joseph Jarman of the Chicago Art Ensemble approached the table and said hello. Franklin and I knew Jarman as one of the major figures in the Association for the Advancement of Creative Musicians (AACM) in Chicago. We had loved his music for a long time, and Franklin had written an enthusiastic piece about him in *Arsenal* 3, but our personal acquaintance with him began only at the 1976 World Surrealist Exhibition, which it so happens none other than Cecil Taylor had urged him to attend.

As we greeted Jarman at the Black Swan table, our poor deluded critic, convinced by now that his cause was hopeless, sputtered that all of us were "crazy," and beat his retreat.

The comedy-like quality of this incident does not detract from its significance. A ludicrous defamation of Cecil Taylor provoked an impressive protest in his defense, led by Ted Joans, who arrived—by chance, of course—at just the right moment.

I should add that we had seen neither Joans nor Jarman for at least a year, and did not know that either of them was in New York.

One good encounter leads to another. That very evening, Ted Joans introduced us to Jayne Cortez, whose powerful firespitting poetry Franklin and I had long admired. She had in fact already collaborated on *Arsenal* and other surrealist publications, but it was a real joy to meet face to face at last with one of the truly outstanding—and most profoundly radical—poets of our time. A voice akin to William Blake.

Spring 1985. Demanding an end to university investment in apartheid South Africa, students all over the country were seizing large areas of their campuses and converting them into symbolic

"shacktowns." One of the largest and longest-lasting of these actions was carried out by students at Northwestern University in Evanston. The Chicago Surrealist Group took part in these actions; we were not students, but we were welcomed as "outside agitators."

The students occupied a spacious outdoor plaza—the showplace of the campus—and renamed it Nelson Mandela Square. Twenty-four hours a day this "shacktown" reverberated with revolutionary speeches, discussions, and songs. Colorful signs reading FREE MANDELA!, END APARTHEID! and DIVEST NOW! were posted everywhere. Many hundreds of students participated. It was the largest surge of student radicalism in the Chicago area since the sixties.

Just as this struggle reached its height, Ted Joans phoned to say he would be in Chicago the next day: "Could we all get together?" He himself had been an anti-apartheid activist for years, but he had not heard of the occupation at Northwestern.

Next day Ted Joans joined the Surrealist Group at Mandela Square. Also present were South African poet-in-exile Dennis Brutus, Guyanese novelist/poet Jan Carew, Africanist Jean Allman, and historian David Roediger—Northwestern faculty members who wholeheartedly supported the student occupation. We talked with students, listened to speeches, distributed surrealist leaflets and condemned stickers ("Having been found absolutely inimical to the poetic spirit, and a menace to the continuation of life on this planet, this building has been CONDEMNED by the Surrealist Movement.") It was a grand day. Enthusiasm ran high, and everyone was determined to see the struggle through.

At this gathering Joans spoke of his efforts to change the name of Lake Victoria, in central Africa, to Lake Satchmo (after Louis Armstrong). "Why," he asked, "at this incredibly late date, should the largest lake in Black Africa still bear the name of a ridiculous white racist European imperialist queen? It's a terrible insult to all Africans and all Black people everywhere."

Later, in a discussion of Joans's poetry, Jan Carew said: "He is the most impressive reader of poems I have ever heard in my life. His poems are very good on the page, but they are truly stunning when you hear him read them live."

At one point several of us—Joans, Brutus, Carew, Roediger, Franklin and I—went to lunch and discussed the anti-apartheid movement and the role of surrealism in revolutionary struggle. Quite unexpectedly Dennis Brutus told us that he had arrived in Chicago in 1976 just in time to attend the World Surrealist Exhibition, and that he considered that show to have been the high point of his years in Chicago.

We concluded with a rousing toast: "To our next reunion—in a free South Africa in a united continent of Africa!"

Ted Joans has always been a fanatic for the surrealist game of Exquisite Corpse, which he usually refers to by its French name, *cadavre exquis*. We have played it on every one of his Chicago visits, and even at Mandela Square.

One fine day in the late summer of 1993 he arrived at our doorstep in Chicago and introduced us to his companion, the surrealist painter Laura Corsiglia. On this trip Joans had brought one of his treasures. He calls it the World's Longest Exquisite Corpse, and he must be right. It was a giant, hefty roll, and when unrolled, its various sections (were they ten feet long? or twelve?) covered the floors of two large rooms in our house. Scores of surrealists and other friends in many lands had already taken part in this game, and now that he had at last brought it with him to Chicago, it was our turn.

Now the Chicago Surrealist Group had long discussed the desirability and possibility of arranging an exhibition of Exquisite Corpses, but thus far nothing had come of it. The situation changed when Ted Joans mentioned that a big bourgeois gallery in New York was threatening to put on its own show of Exquisite Corpses—not, however, by surrealists (except for a very few "historical" pieces), but by contemporary bourgeois artists! This news flash provided just the spark we needed. Although our earlier efforts to interest a gallery or café in such a show had been stymied, now a single telephone call resulted in an immediate agreement: the show would open at the Heartland Café on October 22 and run through November.

"Totems Without Taboos: The Exquisite Corpse Lives!" opened

on schedule, with fifty-seven Exquisite Corpses made between 1966 and 1993 by thirty-four surrealists from eleven countries. Several *cadavres exquis* made when Joans and Laura Corsiglia were in town were featured in the exhibition, including the one reproduced on the poster, titled "Thank You, Thelonious Monk." This was the first exhibition exclusively devoted to the Exquisite Corpse ever held in the United States. (We beat the New York gallery by two weeks.) Because the opening was so close to Halloween, our spur-of-the-moment show received considerable publicity in the local press.

Once again, a visit from Ted Joans seems to have "set things in motion," and once again there was a remarkable sequel. At the "Totems" opening, Louise Simons introduced a new Exquisite Corpse game: each player drew on a small square sheet, leaving connecting links on at least two sides; the actual connecting was done later, after all the individual sheets were gathered. The result was astounding, for the pieces could be arranged in countless ways.

Starting from the World's Longest Exquisite Corpse, we had arrived in a matter of weeks at the World's Most Rearrangeable Exquisite Corpse. We called it "The Exquisite Corpses' Wang Dang Doodle."

I have recounted only a few of our encounters with Ted Joans. I cannot think of anyone else we have met so often by chance.

His characteristically sudden arrivals have always been refreshing, and have often sparked a curious incident or a new collective activity. And this has been the case not only for those of us in the Surrealist Group in Chicago, but also for our surrealist friends in Paris, Amsterdam, Lisbon, Berlin, and other places. Ted Joans's adventurous nomadism, combined with the special gifts he had already brought to surrealism, appears to have made him a kind of spontaneous organizer of unpredictable liaisons, which have often proved to be lasting.

No blueprint, plan, or any sort of conscious intention is involved in these encounters, or even a flip of the coin. But what is involved?

Is it what Gellu Naum calls the "state of poetry"?

In the history of surrealism, certain other figures have been noted for their unexpected arrivals and departures, and for the very special influence they exerted: Arthur Cravan, Marcel Duchamp, and Nadja, to name only three. Simply by being themselves—that is, with no particular effort on their part—all were instigators of magical encounters, communicators of new impulses, catalytic agents of dialectical leaps, harbingers of wilder springtimes.

Charles Fourier, discoverer of the "butterfly" passion, would have understood the invaluable role such individuals play in the life of certain groups.

Since 1960, Ted Joans has played an analogous role. I say analogous because it has not been at all duplicative. Cravan, Duchamp and Nadja were quite dissimilar in background, attitude, temperament, the way they lived, and each of them influenced surrealism in unique, original ways. And so it is with Ted Joans. His influence on surrealist thought and action has been considerable, and distinctively his own. His approach to surrealism today emphasizes its emancipatory essence, its anti-ideological character, its open-endedness— and Africa. In the one-shot surrealist journal *Dies und Das* (This and That), which he co-edited with German surrealist poet Richard Anders in 1984, Joans pointed out that Breton's manifestoes "did not say everything because they were not dogmatic or ideological manifestations. . . We are not shadows of yesteryear's surrealists, although we have been nourished by 'them and those,' and their 'this and that' can be found engrained in the very marrow of our bones. . . Although André Breton is gone, his spirit is still contagious . . . Surrealists are committed to the cause of total emancipation . . . We have the power and that power's color is black"

Joans's influence on international surrealism is still growing, and will continue to grow because his contributions are concrete, based in the struggle for freedom, well adapted to the social needs of our time. But that's not all, for his contributions are not only quantitative but also qualitative. Indeed, Ted Joans is one of the few who, in recent years, can be said to have changed the molecular structure of the surrealist project in such a way that its revolutionary scope and actuality are now much greater than ever before.

Look at the record:

Surrealist love of jazz dates back to the twenties, but no one has expanded the jazz-consciousness of surrealists more than Ted Joans. For many younger surrealists, such great Black musicians as Charlie Parker, Thelonious Monk, John Coltrane and Cecil Taylor are as vitally important for surrealism as Rimbaud, Alfred Jarry, Jean-Pierre Brisset and Raymond Roussel. Ted Joans deserves a good share of the credit for this expanded consciousness.

Similarly, more than anyone else he has made the entire international surrealist movement familiar with Patrice Lumumba, Malcolm X, Walter Rodney, Black Power, revolutionary movements in Africa and the Caribbean, and the entire worldwide struggle for Black liberation.

"I confess my love for freedom now—not ten years from now."

Surrealists in Europe have had few illusions regarding "race relations" in the white supremacist U.S.A., but Ted Joans has done far more than any left paper, not to mention *Le Monde*, to keep them abreast of current hypocrisies and atrocities in the land of the dollar. A longtime student of the works of W. E. B. Du Bois and Frantz Fanon, Joans is himself a trenchant critic of the reactionary mystique of whiteness.

Joans has also done much "to update the true surrealist point of view of Africa," as he wrote in *Dies und Das*. In his view, Walter Rodney's *How Europe Underdeveloped Africa* should be high on every surrealist reading list. Joans's campaign to change the name of Lake Victoria to Lake Satchmo added something new to surrealist anti-imperialism. Largely thanks to Ted Joans, Africa today looms much larger on the Surrealist Map of the World than it did in the twenties, and the affinities between surrealism and African art, poetry and thought are now much clearer.

His love for rhinoceroses, his militant efforts to protect them (and other endangered species) from extinction, and more broadly to promote wider awareness of neocolonialist devastation of the natural world, have helped give surrealism's ecological dimension a new and urgent emphasis.

A poet first and last, but also a Black poet and a surrealist poet, Ted Joans has done more than anyone to bring the traditions of

African American poetry and surrealist poetry together. In this he has followed in the footsteps of other Black surrealists—Étienne Léro, René Ménil, Léon Damas, Suzanne and Aimé Césaire—all of whom insisted on the importance of African American poetry in shaping their own outlook. But Ted Joans has gone further. Guided by his insight that most Black poets in the U.S. have shared the essential surrealist priorities of revolt, freedom and love, he has made the surrealists of all countries much more aware than they were before of the richness and diversity of two and a half centuries of African American poetry.

Joans's passion for Outsider art is yet another facet of his many-sided influence. An outspoken champion of such great African American Outsiders as Bill Traylor from the Deep South, the Afro-Navajo Chicagoan Joseph Yoakum, and Detroit's Tyree Guyton, Joans has brought greater recognition to the immense but often overlooked African American contribution to one of the most vital currents of contemporary art. At the same time, by accenting the many forms of vernacular surrealism (a central theme of Chicago surrealism from the start), and in bringing Outsiders and surrealists into closer and mutually beneficial contact, Joans has helped give international surrealism a much firmer grounding in the revolutionary reality of the world today.

In short, a lot of what we take for granted as essentials of the contemporary surrealist project are to a large extent the result of the persistent influence of Ted Joans.

As a Black surrealist, with strong affective links to the Black Music scene, Joans is fully aware that surrealism and jazz have always been two-way streets. Just as he has celebrated the art, music and poetry of Africa and the African diaspora in numerous surrealist publications, so too he has affirmed his surrealist perspectives in such periodicals as *Black World, Coda*, and *Présence africaine*.

In emphasizing surrealism's African and other non-European roots, Ted Joans has made himself the messenger—within surrealism—of Other traditions, Other ways of hearing and seeing, Other ways of being surrealist and fomenting surrealist revolution. In a poem published in *Arsenal* 4 in 1989 he wrote:

Chicago there is a giant anteater installed invisibly everywhere
Rhinoceroses shall stampede someday soon throughout the city
All your automobiles will die of thirst
Pedestrians will inherit the streets . . .
The wind is whispering out loud
Ask any subversive cowrie shell

In one of its many *détournements*, surrealism long ago radical-ized the musty old notion that "the poet is the one who is inspired" by turning it around: The poet is the one who inspires. That's Ted Joans, the "Surrealist Griot." Always upbeat, never cynical, his enthu-siasm is always contagious, his humor never sours, and he is always ready to play. Few have succeeded more than Ted Joans in leading a truly surrealist life.

One does not have to agree with every line he has written to affirm that Ted Joans's intervention in the mythical life of our time has been salutary. He is one of the best-loved individuals in the in-ternational surrealist movement today. He is also one of surrealism's greatest "live acts." His knack for showing up just about anywhere at all, unexpected and unannounced, is part and parcel of his own very special "practice of poetry."

If I ever find myself in Timbuktu, I'll ask someone, "Is Ted Joans in town?" And I'm sure I'll run into him five minutes later.

Try it yourself if you don't believe me.

ten
Unexpected Paths:
Gustav Landauer, Munich 1919

The name Gustav Landauer is not well known in the English-speaking world. His flamboyant, courageous, tragic life, and his vital original thought have provoked relatively little discussion in the U.S. Only very recently has his work begun to attract serious attention here. Yet he is not a "minor" figure. For the expressionist author Ernst Toller he was "one of the finest men, the greatest spirits" of the German Revolution; the anarchist philosopher Rudolf Rocker called him "a spiritual giant"; and his biographer, Eugene Lunn, calls him "the most important German anarchist publicist and intellectual since Max Stirner." As revolutionist, critical theorist, agitator, novelist, teacher and editor, Gustav Landauer left impressive traces of his passage, from which we can still learn much today.

He was born April 7, 1870 to a middle-class Jewish family in Karlsruhe. As a student he joined the Social Democratic Party (SPD), and soon found himself in prison—the first of several substantial sentences he would serve, all for political activity. Because he was an ex-convict, he was refused admission to medical school. Eventually he became a teacher of literature, although social revolution always remained his chief interest. For many years he edited the important journal *Der Sozialist*; originally libertarian-Marxist in orientation, it grew increasingly anarchist. Indeed, by the mid-1890s Landauer had become a central figure of international anarchism.

In prison in 1899 he studied the great German mystics, most notably Meister Eckhart, about whom he wrote a major study. Throughout his life he wrote prodigiously on a wide range of subjects. He wrote on the sixteenth-century alchemist Paracelsus; on the contemporary American class-war prisoners, the McNamara brothers; and two full volumes on Shakespeare. He also translated works of Poe, Oscar Wilde, George Bernard Shaw and Walt Whitman into German. Perhaps his most important book on political

matters was *Die Revolution*, published in 1907 in a "psychosocial monograph series."

Landauer enthusiastically welcomed the overthrow of Czarism in Russia in 1917, and played a leading role in the abortive attempts at revolution in Germany during the next two years. Neither dogmatic nor sectarian, he stressed the urgent need for unity of all truly revolutionary forces—anarchists, left socialists, communists, poets—against the protofascist extreme rightists and their social democratic sides in the government. During the short-lived Bavarian Soviet Republic, he served as minister of education. Along with Rosa Luxemburg and Karl Liebknecht, he was among those most hated, feared and slandered by Germany's ruling class. At the onset of the counter-revolution, May 2, 1919, he was assassinated by an aristocrat-led military squad acting under authority of the SPD. A monument erected in his honor by the Munich Anarchosyndicalist Union in 1925 was torn down by the Nazis when Hitler came to power.

A flippant but sometimes vivid firsthand account of the Munich Revolution is given by Ben Hecht in his autobiography, *Child of the Century*. Hecht, who was there as foreign correspondent for the *Chicago Daily News*, portrays Landauer as a strange, romantic eccentric who had the habit of striding down the halls of the revolutionary government's headquarters—formerly a palace—announcing his own name over and over in a booming voice.

Strange, romantic and eccentric he undoubtedly was, though probably not in the way that Hecht meant. Outside all mainstream traditions, Landauer was influenced above all by extremely heterodox thinkers, mystics, poets and dreamers such as Eckhart, Spinoza, Shakespeare, Hölderlin, Achim von Arnim, Nietzsche, Ruskin, Whitman and his own contemporary, the philosopher Constantin Brunner, whose "fierce, prophetic voice" he echoed often in his works. More than anyone else Landauer developed the revolutionary social implications of the early German Romantics. Interestingly, his close friends included many leading figures of the expressionist movement, as well as the elusive anarchist novelist known to the world as B. Traven.

Even as an anarchist Landauer stood apart. He differed on major

points with all the classic libertarian theorists, and seems to have been more than casually drawn toward the work of such a tangential figure as Joseph Déjacque. In his later years he grew increasingly uncomfortable with the traditional "anarchist" label, and began to call himself an anarcho-socialist. Regarding anarchism as "merely the negative side of what is positively called socialism," he went on to explain that "anarchy is the expression for the liberation of man from the idols of the state, the church and capital; socialism is the expression of the true and genuine community among men, genuine because it grows out of the individual spirit."

Landauer sought a total revolution—a leap beyond conventional limits not only in politics and economics, but also in culture, in the individual's emotions, in the life of the mind. In his powerful, lyrical prose, he drew together the links between individual and collective transformation, as when he compared the processes of the individual's dreams and social revolution. He disagreed strongly with the notion of the "inevitability" of socialism, the fallacy that socialism would necessarily arise from the ruins of capitalism. He argued instead that socialism had to be desired before it could be realized. He had a profound sense that the proletarian revolution would take unexpected paths: "Where overwhelming change and renewal have occurred," he wrote, "it is precisely the impossible and the incredible that have brought them about."

For Landauer, socialism was nothing less than "an endeavor to create a new reality" and even "a new force against rottenness." He saw it as something "always just beginning, always something moving." As part of his revolutionary strategy, he called for the creation of alternative institutions, a program comparable to the IWW's "building the new society within the shell of the old," and long afterward taken up by the New Left in the 1960s. "The State," he observed, "is a condition, a certain relationship between human beings, a mode of human behavior; we destroy it by contracting other relationships, by behaving differently." And he argued further that "emancipation is possible only for those who prepare themselves internally and externally to step outside capitalism—only for those who stop playing a role and begin to be human beings."

His major emphasis, however, was on culture as a means of

subversion. He placed great hope in the revolutionary activity of "restless wanderers, hoboes and vagabonds" as well as painters, poets and musicians. "Our spirit must ignite, illuminate, entice and attract. We must give the example and lead the way." Ben Hecht reports that Landauer, as revolutionary minister of education, told him that "every Bavarian child at the age of ten is going to know Walt Whitman by heart. That is the cornerstone of my new educational program." Apocryphal though it may be, such a program would not have been uncharacteristic. The whole point of revolution, in his view, was "to realize materially . . . what the poets have awakened spiritually in their presentiments, visions, loves, longings and desires." No revolutionary socialist attributed more importance to poetry than Gustav Landauer.

One should not make too much of his unfortunate misreading of Marx, whom he seems to have regarded as—of all things—a vulgar, mechanical materialist! A thoroughgoing romantic himself, he sadly failed to perceive the romanticism of the young Marx. Landauer did not know Marx's *Economic and Philosophical Manuscripts* of 1844 (unpublished in any language before 1932), and probably had no idea that the author of *Capital* also wrote impassioned love poems. His criticism, in any case, is really directed not so much against Marx as against the reformist Marxism of the SPD.

In some of his writings Landauer anticipates certain notions later developed by Wilhelm Reich, the Frankfurt School, the surrealists. But at his best he conveys a revolutionary vision that is entirely unique. By turns he is lyrical, oneiric, polemical, critical, philosophical, poetic: but always thought-provoking. And at times he reveals a truly splendid humor. For him, the ordinary contradiction between objective and subjective revolution no longer counted. "The destruction of Charles the First and the storming of the Bastille," he wrote, "are examples of applied social psychology."

eleven

Mimi Parent: Luminous Laughter

Why are summer mornings so crystal clear? Sparkling, bright, still: Is it a quality of the air or of the light? Or of the mind in exhilarated expansion? I remember a summer morning, one of countless similarly delicious mornings when the brilliance of the sun brought out in glowing detail trees, boats, and houses across Fox Lake—more than five miles away—just as it searched through the transparent water revealing every ripple, every pattern of the golden sand on the bottom, every pebble, and fish, seemingly suspended and lighter than air, their dark shadows standing at their side. These mornings had a magical stillness about them and a sense of being delightfully becalmed, suspended in an ocean of fragrant air, motionless, stranded—but stranded precisely at the most glorious place in the world. What more could one wish for than this perfect delight, not timeless but time-free?

In such moments, far outside the hubbub and petty concerns of daily life, the imagination begins to dance, first slowly, then madly—like bugs skating on the water—until every molecule of oneself is alive, and that ability to see, as if forever, with unlimited vision, is the same as to live forever, in infinite extension.

Then, suddenly, from a branch overhanging the glistening water, a bright blue flash—a loud splash—as a kingfisher throws himself into the clear water as droplets of crystal like tiny glass magnets fall in showers of a shattering drama back into stillness.

In the art of Mimi Parent, among the most original and powerful of our time, I find the same magic transparence and delight of summer morning, along with the piercing audacity, the intense underlying passion of a kingfisher set to dive.

There are people we meet who, without realizing it at all, have a profound impact on us—an influence that does not diminish over time but lasts and grows. I first met Mimi Parent on a night like no other: New Year's Eve 1965 in Paris. Franklin and I had just arrived

there to look up André Breton and the younger generation of surrealists, and had been invited by the surrealist writer Robert Benayoun to their New Year's party, which was also in part a celebration of the International Surrealist Exhibition that had just opened at the Galerie L'Oeil. A marvelous, complex series of chances had conspired to get us to Paris at this particular moment; had we arrived sooner or later we might well have missed everything.

The party was held at the Théâtre Ranelagh near the Bois de Boulogne. One of the oldest theaters in Paris, the Ranelagh was quite a spectacular place in itself, but that night the marquee outside was dark: the party was strictly reserved for the group and its friends. The surrealists of Paris greeted us warmly, with special affection on the part of Mimi and her companion Jean Benoît, who kissed us on both cheeks and wished us a hearty *Bonne Année*!

Mimi Parent, who seemed to be in her twenties, was admirably flamboyant, splendid, brilliant. She was also patient with my rudimentary French, and kind enough to take the time to help me follow the boisterous conversations at surrealist gatherings, beginning that very night. We immediately became good friends. Mimi herself had come to Paris from Montreal in 1948, and spoke English and French perfectly. Since 1959 she had been a dynamic, exhilarating force in the Surrealist Group.

As we met I thought of her drawing, which I had just seen at the Galerie L'Oeil: Titled *En Veilleuse* (*A Lamp in the Night*), it reveals a woman with long flowing hair, dressed in carnival costume, standing on the saddle of a horse; on the ends of her balance-bar she carries the sun and moon. This exquisite and defiant picture serves notice that only poetry can rescue cosmology from positivism.

The exhibition also featured a large piece—large enough to walk through—titled the *Arch of Defeat*, a *détournement* of France's monument to militarism (and top tourist attraction), the *Arc de Triomphe*, now furnished—courtesy of Mimi Parent—with a wooden leg.

Clearly, Mimi's love of the Marvelous and her knack for subversion are but two sides of the same magic apple.

The International Surrealist Exhibition, *L'Écart absolu* (Absolute Divergence), was inspired by the visionary writings of Charles Fourier, the great utopian socialist and proponent of the theory of

Passional Attraction as a new means of understanding human beings and of discovering the true bases around which a new, non-exploitative society could crystallize. Mimi's art, following her own passional attractions, dazzlingly actualizes the poetry and humor of Fourier's revolutionary ideas, for her whole outlook is animated by a vital ethic of desire. Each of her works affirms Fourier's observation that "Attractions are proportional to destinies."

On another trip to Paris in 1970 I had the pleasure of seeing many of her paintings at her apartment on the avenue de l'Opéra. What a strange experience when we arrived there, for to reach Mimi's place we had to climb two stories of a tall, ancient, curving staircase. It was the staircase of dreams for me—the same as the one pictured in a childhood book of mine, *The Snow Queen*; in the story, a raven perched on the newelpost and the shadows of long dead ladies and gentlemen flitted up and down the stairs. Mimi's stairway seemed to me a harbinger of untold wonders, and I was not disappointed.

Mimi showed us her paintings, bringing them out one by one, and commenting on them playfully, with imaginative flair. At that time she did not show her work in galleries, and had no interest in exhibiting except in group shows organized by the surrealist movement itself. Her adamant refusal to be part of repressive society's official "art world"—in glaring contrast to the commercial ambition and greed of so many artists—seemed to me worthy of the greatest respect. But I protested, arguing that she should not deprive the world of the right to see these splendid works, that she must find ways to show them, because they were meant to inspire people and to change their lives, to counteract the rampant miserabilism of our time, and to help usher in the "New Amorous World" announced by Fourier.

Mimi's paintings cast their own unique glow—irresistible, and yet recalcitrant in the best sense of the word. In her art as in her life, she has always preferred the stronger passions. It has always been her pleasure to take risks that few painters today have been willing to take. In the painting she selected to be shown at the 1976 World Surrealist Exhibition in Chicago, a bird of fire emerges from a dark figure in a roadway lined with black trees and breaks through the green darkness—blazing wings about to soar, a flame-feathered athanor of desire, ready to swoop. Here again Mimi assures us that only

poetry, and the awareness that poetry ignites, can enable us to face the abyss. If the language of dreams did not exist, Mimi would have invented it for us!

The presence of birds in her paintings, which cannot be mistaken for a mere "motif," reminds us that in Fourier's Universal Analogy the bird is "the creature who rises above all others."

Another painting, aglow with four different kinds of radiance, portrays a gray sky filled by a gray eagle whose talons reach through the very walls of the Bastille to clutch two frilly female dolls. It is called *Les Très Riches Heures du Marquis de Sade*, a play on the famous *Very Rich Hours of the Duc de Berry*. It is Mimi's tribute to Sade's vision of freedom that defies convention and stretches the limits of the imagination.

I think of Mimi as a great magician, of the most elegant kind. It is easy to imagine her wearing a tuxedo, standing stage-center under a spotlight, pulling rabbits out of hats and making people disappear into cabinets. Is this because on that New Year's Eve night when we first met she was in fact wearing a top hat and tux with tails, exactly like a stage magician? No doubt—but she was also wearing black fishnet stockings on her long legs and dancing in a mad parody of a 1920s chorus line. A drawing of hers from the 1980s, titled *A Large Rabbit Frightens Madame Recamier*, shows a large white rabbit—just the kind that magicians pull out of hats—seated on Madame Recamier's famous couch, while Madame herself hides under it. Here we find Mimi merrily negating a museumified icon of fine art and a bourgeois ideal of womanly beauty, both of which have long been tiresome clichés. Overturning the platitudinous image and welcoming the intrusive rabbit, Mimi shows us that sometimes total upheaval is the best of all possible harmonies.

Humor, often black but sometimes rose or robin's-egg blue, is in fact central to Mimi's art. Her 1989 drawing, *Qui part? (Who's Leaving?)*, reproduced on the cover of my anthology, *Surrealist Women*, shows three female figures (the three fates, or graces?) sitting on a trapeze, and suspended just above a railroad track. Mimi's title imperiously recalls Gauguin's three questions "Where do we come from? Who are we? Where are we going?" and her demand is addressed to all three. Which one is about to leave? The one with skirt and legs for

a head? The one wearing a stern and anonymous black mask? Or the one whose upper body is the smoking engine of a railway train? Or is it all three? Or an interactive, dialectical blend of beings in constant motion, performing for her/their own pleasure (and, perhaps incidentally, everyone else's) on a circus trapeze bar?

Implicit in this drawing are other questions, no less provocative: Why can't one live more lives, have more identities? Why settle for conventional limits? Implicit too is the demand to resolve that dilemma of women and men in modern society, who find themselves trapped in the loneliness of narrow, stereotyped and ultimately ridiculous roles and patterns of behavior.

In any event, Mimi's baggage is packed, the rails lead into the future, and action is imminent!

The range of Mimi's work is impressive: In addition to the paintings and drawings for which she is best known, she has also made surrealist objects, collages, and fabrics, to say nothing of the important role she has played in the elaboration of surrealist group shows: her crypt devoted to fetishism, for example, at the 1959 International Surrealist Exhibition in Paris. In her most recent works, her tableaux-paintings, which are also among her finest, the restless activity of the imagery, like prime matter in the alchemist's cauldron, overflows the frame and leaps to our eyes. These perilous dramas, touched by the Gothic and even more by Umor, are stunningly confrontational: They pose the most urgent questions and refuse to take anything less than the viewer's own unfettered imagination for an answer.

Mimi's famous word of warning, "Knock hard, life is deaf," is indispensable advice for anyone who seeks to follow a nonconformist path, to venture into a different life. And it is a very special pleasure to follow the paths she herself has opened for us, to enter the worlds she has shown us, and to see them through the magic lucidity of Mimi's eyes.

Aeronaut of invisible spaces, explorer of the oneiric stratosphere, sorceress of luminous laughter, Mimi is a bird-woman who can travel equally well in the air, beneath the water, and even through fire. According to *Surrealist Intrusion in the Enchanters' Domain* (the catalog of the International Surrealist Exhibition in New York, 1960–61),

she herself lived "surrounded by birds." She knows their language and their secrets: especially the secret of freedom.

This is the art of Mimi Parent: a transcendental ornithology that illuminates the secret concealed in the old saying, free as a bird, and lets us be carried away with it.

twelve

The Life and Times of the Golden Goose

Everything is a fairy tale.
—Novalis

The paintings in the Medieval and Renaissance galleries exhibit themselves in careful rows, splendid in their gilt frames. Painting after painting shows off strange landscapes of endless pathways and serpentine rivers. Some also include stiff human figures and sometimes their own doubles and even doubles of their doubles, all performing gory religious acts in a sort of sinister comic strip without panels.

Religious painting is always stifled painting, and therefore stifling—like religion itself. How wonderful the art of the Middle Ages and early Renaissance would have been had it been able to escape the fatal calamity of religious oppression! This I know because I have heard the wonderful music of those days—its wild hurdy-gurdies, strident horns, rippling recorders and drums: the music Bosch's paintings danced to. But only a very few painters of the time succeeded in achieving even a fraction of the freedom from religion enjoyed by itinerant musicians.

No matter what anyone may say about the popularity of religion, one may have the galleries of religious painting all to one's self even on the Art Institute's busiest days. Wandering through these deserted halls one afternoon my attention was drawn to a painting of an enormous white bird with a long neck, poking its beak up the sleeve of a bishop standing resplendent in his golden robes and halo. I was amused, and suddenly carried along by a swift stream of associations—recalling, for example, that every tinhorn gambler in grade B westerns keeps his extra ace hidden in just such a convenient place. In the Bohemian language, moreover, the word goose is *hus*, and Jan Hus was the great Bohemian martyr who, a century before Luther, revealed the corruption of the Roman Church and inspired a revolution.

I had grown up in an extended family of Bohemian "Old Settlers" among whom Old Country traditions were still very much alive. Bohemian was still spoken by the older ones, although they did not teach it to me (and in fact insisted they were speaking French!). I learned about Jan Hus around the same time that I learned about George Washington, perhaps even earlier. Everyone regarded him as "our hero." When I asked what religion we were I was told we were freethinkers.

And so it was that a whole complex of childhood and later memories and reveries rushed through my mind as I stood there, alone, gazing at this strange image in the silent room. Was this painting, I could not help wondering secretly, an emblem of the Hussite heresy?

My inquiries revealed that the painting, attributed to the Master of Amiens and dated circa 1480, is supposed to represent St. Hugh of Lincoln (1140–1200), an unusual figure in Church history—unusual not only because he seems to have been a decent sort all in all, but because he was particularly noted for his love of animals. He is also known to have refused to pay a tax for war, and for this reason is regarded by some today as the "patron saint" of tax resisters. The bird turns out to have been his pet swan.

For my part, however, I have been unable to keep myself from seeing the bird as the central figure in the painting, or from seeing the bird as a goose and as the emblem of Jan Hus discovering what wickedness the Church had up its sleeve. Images are persistent and first impressions are strong. But what interests me especially is that my experience led me to see this painting so differently from the way most other people would see it. Is this not similar to the phenomenon noted long ago among the adherents of Voodoo in Haiti, for whom popular Catholic religious prints of St. Patrick, for example, are seen rather as images of the snake-god Damballah?

This practice of focusing on seemingly secondary or even "irrelevant" details is, in fact, common to so-called primitive people, the "mad," children and poets. And this fact already tells us a lot, for primal peoples, the "mad," children and poets are all notorious for having experiences and therefore perceptions that differ markedly from the ordinary.

One could say, then, that on encountering this work attributed

to the Master of Amiens, I was predisposed to see a goose, and Jan
Hus investigating Church corruption, where others would see only
a cleric and his pet. Such predisposition, however, has the density
of dream and revery—it is thick with temptations and discoveries,
the darkest subjective fantasies and the most dazzling revelations of
objective chance.

In any case, my associations when looking at this painting, or
thinking about it afterward, were not limited to Jan Hus: there were
also plenty of associations with geese, though, as we shall see, these
kept getting mixed up with Hus sooner or later and, indeed, with all
forms of heresy and rebellion.

I grew up in a large house surrounded by woods on Fox Lake, six-
ty-five miles northwest of Chicago. Vividly I recall the thrill I had
each fall, as a child, watching the wild geese, electric with joyfulness,
flying south in their marvelous, ever-changing formations—wave af-
ter wave of them, following no trails and leaving no tracks in that
ocean of azure that washes our planet, owning nothing but mastering
all, viewing the world from their heights in a way I could scarcely
imagine, off on wild adventures I knew not where, and that an earth-
bound creature such as I could only dream of.

A favorite puppet character of my childhood was Garfield
Goose, seen daily on afternoon television. In later years when visiting
relatives on their small farm I enjoyed watching their geese, listening
to their boisterous honking and admiring their boldness and bravery.

Above all, however, there was the favorite story of my child-
hood: *The Golden Goose.* It may well have been a family favorite, for
it was read to me hundreds of times before I could read it myself. I
still have the copy I had as a child, a small book of 44 pages, illustrat-
ed by a homegrown fauvist: anything in it could be any color except
the goose, which was always golden.

The Golden Goose tells the story of three brothers who live with
their parents on the edge of a wood. One day the eldest brother
packs up a delicious cake and a flask of wine and goes off to chop
wood in the forest, where he meets a curious little old man who

asks him for something to eat and drink. Selfishly refusing the old man's request, the eldest brother soon injures himself severely while chopping wood. Not long afterward the same fate befalls the second selfish brother.

Finally the youngest brother, called Simpleton, goes off into the forest as well, against his parents' objections, and furnished only with a poor cake made with water and a flask of sour beer. He too meets the little old man, who once again asks for food and drink. Unlike his selfish brothers, however, Simpleton shares what little he has with the mysterious stranger—whereupon, to his surprise, their humble fare is suddenly transformed into excellent raisin cake and wine.

Grateful to Simpleton for his kindness, the old man says he will give him good luck. He tells him to cut down a certain old tree, "and at the roots you'll find something." After felling this tree, Simpleton finds "a goose of feathers all of pure gold."

With the golden goose in his arms, Simpleton sets off. The selfish people he meets along the way, who try to take feathers for themselves, are stuck fast one to another and drawn along in a humorous parade in spite of themselves.

Eventually this assembly arrives at the king's court. It appears that the king has promised his serious daughter to whoever can make her laugh. At her first sight of Simpleton and his strange procession she bursts out laughing. The king, however, refuses to surrender his daughter until Simpleton performs three tasks: he must find someone to drink a cellarful of wine and to eat a mountain of bread, and he must produce a ship that can sail on land as well as on water. With the help of the little old man Simpleton accomplishes each of these apparently impossible feats. At last the king allows his daughter to marry Simpleton, and of course the two live happily ever after.

One of the tales collected by the brothers Grimm and published in their famous anthology in 1815, *The Golden Goose* has since been included in countless other compilations, and often issued as a separate volume for children. Beyond the facts that it is a European tale and

certainly several hundred years old, its origins and age are difficult to determine. Possibly, as has been argued of many a Mother Goose nursery rhyme, it was written for a specific social or political purpose at a particular historic moment. But certainly the tale as we know it today has undergone a long evolution, with succeeding generations of storytellers adding to it and changing it as they pleased. The reason that it has survived, however, is that—like other fairy tales and nursery rhymes—it is full of many different meanings on many different levels.

One does not have to search far for the psychoanalytic implications of such a tale. Freud suggested that the hero of all these tales is the ego, and that the adventure recounts the manner in which the pampered ego of early childhood learns to get along in a world full of other egos making the same demands.

In *The Golden Goose*, the youngest brother's ego suffers under the repressive domination both of his parents and his elder brothers, and it is on him that this fantasy of wish-fulfillment centers. Going into the forest to chop wood represents not only adult accomplishment for the ego but also, and above all, forbidden sexual activity. The forest itself represents hidden and dangerous female sexuality. The older brothers' self-injury symbolizes their castration. Simpleton's forest adventure concerns the male child's attempts to overcome his fears of his mother's female sexuality, to free his own sexuality, and to remove its cathexis from the mother so that it can find a new object and consequently effect his liberation from the stage of oral dependency. The large tree he cuts down is symbolic of the repressive father, and the golden goose a symbol of Simpleton's own penis (the first admirers of the goose are three girls who, desiring a piece for themselves, become inseparably attached to it). In psychoanalysis this stage is known as secondary narcissism.

The hero/ego challenges the king/father once more in Simpleton's demand for genital primacy and ego fulfillment. The king withholds his serious daughter—whose seriousness symbolizes her need for sexual emancipation—and sets requirements of sexual fulfillment that Simpleton meets by demonstrating his enormous sexual appetite (displaced to oral gratification or aggression). Finally, when the king/father is confronted with Simpleton's ship that can sail on land

or water—a potent symbol of male sexuality, which can accomplish the impossible—he surrenders his daughter.

Psychoanalytically, the female interpretation of this tale is more complex. Although the female child suffers the same sexual repression in the family and identifies with the hero of the tale, the goose itself may represent her own new-found female sexuality or a fantasy attainment of the male organ. With the appearance of the desirable daughter the young female reader might switch identifications and identify with the daughter as a passive sexual object judging the male sexual display—one who is satisfied that she has attained the longed-for male object through sexual union with the male, and whose ego finds gratification in being a highly desirable object rather than an active subject.

It is certain that the beginnings of sexual maturity cause the female child many doubts and hesitations which inhibit her accomplishments and her sexual fulfillment. The problem of the passive-object woman has been imposed through millennia of cultural and economic domination—religion, political traditions, folklore, psychiatry and language all contribute to it—and can be finally negated only by meeting the demands of life itself, for there is no passive life, and those who try to find one find only frustration, manipulation, depression and horrible pantomimes of despair.

A glance at the abundant annals of goose lore through the ages sheds light on many an elusive detail in the story of *The Golden Goose*.

We find, for example, that the goose appears in ancient Roman mythology as a discoverer of deceit and, as such, was esteemed for its vigilance. Indeed, it is thanks to geese that Rome was saved in 388 B.C. The besieged Romans in their last stronghold were warned of the enemy's approach just in time by geese cackling in the temple of Juno (the goose was sacred to Juno). Amazingly enough, each year on the anniversary of that momentous occasion a golden goose was carried at the head of a parade through the streets of Rome to the Capitol. (Later, we are told, Juno acquired snobbish pretensions and took the peacock for her sacred bird.)

Some ancient Greek vases represent geese pursued by Eros.

In India the goose has been a symbol of the soul and the sun. In the Hindu creation myth the Supreme Being laid a golden egg from which Brahma was hatched, and in Hindu art Brahma is often portrayed riding on gooseback. Hindus who achieve enlightenment and are thus freed from the torments of eternal rebirth are given the title *hamsa* (gander).

Striking similarities exist between Hindu and Egyptian myths. In ancient Egypt the goose was associated with the worship of Ra, the sun, and the sun is described as an egg laid by the primeval goose. Something of this notion survives even today in the fable of "The Goose That Laid the Golden Eggs."

English myth endowed the goose with the power of prophecy (the English words *goose* and *ghost* come from the same root, meaning "spirit") and a trace of this lingered on, perhaps, in the perception of Mother Goose as wise. The old "Royal Game of Goose"—a tabletop game in which markers are moved along squares on a spiral board—evidently had a Tarot-like divinatory character in its Continental beginnings, but by the time it reached England in the late eighteenth century it was simply a good guys/bad guys "chase" game.

During the Middle Ages it was believed that geese grew on willowlike trees that grew near the sea. (This notion may have had its origins in the so-called gooseneck barnacle that has a certain resemblance to long-necked birds.) It was also believed that witches rode geese.

In several languages, including French, the word for goose is a synonym for simpleton (cf. the English expression "silly goose").

At various times and places the goose has also been seen as a symbol of faithfulness (because of its loyalty to its mate), tenacity and toughness. "To shoe a goose" means to attempt the impossible.

Finally, and with an eye toward that bird peering up the bishop's sleeve, let us note that in the distillations of mythology and folklore, goose and swan often represent the same concept. The swan, of course, has acquired a more aristocratic connotation.

Much goose mythology and folklore is echoed in the literature of alchemy, in which the goose is often known as the "Bird of Hermes"

(after Hermes Trismegistus, "Thrice-Greatest Hermes," regarded by alchemists as the founder of their science, in Egypt, long before the Christian era). Alchemists themselves considered the *Argonautica*, the tale of the quest for the Golden Fleece, a textbook of hermetic philosophy, and their reading of the ancient Greek legend fits *The Golden Goose* as well.

Like the saga of Jason and the Argonauts and many specifically alchemical tales, *The Golden Goose* is the story of a quest, in which the protagonist has to overcome various challenges before reaching his goal. His unspoiled innocence and generous nature make Simpleton a perfect pupil for an adept; alchemists always insist that the ambitious and greedy—those who desire gold—will never find the Philosophers' Stone. He can also be regarded, on another level, as prime matter itself, for he is a "virgin," a "common thing," the "raw material" prerequisite for the stone's appearance. The little old man is the adept showing the way to "the highest that comes from the lowest"; he is the catalyst who, in simply letting Simpleton follow his own nature, allows him to find the stone.

The golden goose, of course, is the Philosophers' Stone, known in alchemy by innumerable poetic names, and the tree from which it emerges could only be the Tree of Knowledge. The three brothers may be regarded as Body, Mind and Spirit, and the seven persons who follow Simpleton to the king's palace represent, perhaps, the seven metals which, in turn, correspond to the hermeticists' seven planets.

The three tasks set for Simpleton by the king signify the three steps in the elaboration of the Great Work, identified in alchemy with the colors black, white and red, though not always in that order. The mountain of bread and the cellarful of wine clearly suggest white and red, and the ship that can sail on land and water is no less symbolic of the black phase, or Putrefaction, for the important thing about this stage of the process is, as Solomon Trismosin expressed it in his *Splendor Solis* (1582), that "moist and dry are joined together and not destroyed."

With the completion of these three tasks we are at last invited to the famous "Chemical Marriage," from whence Simpleton and his bride are able to continue the Great Work in their happy life together.

The Golden Goose can also be read as a parable of the Hussite heresy and the Bohemian Revolution. We have already seen that the Czech word *hus* means goose, and though the principal Hussite insignia was the cup (symbol of their heretical notion that the sacraments should be shared by all the faithful, and not confined to the clergy), the image of the goose also seems to have been used by the Hussite rebels on occasion.

Simpleton's sharing his food and drink with the old man relates to the Hussites' heretical conception of the communion (which was, in fact, one of their major differences with the Church of Rome), and also suggests the fundamentally communist values for which the Hussite movement—especially its Taborite wing—is also renowned.

The golden goose signifies the martyred Hus' teachings which, in the hands of faithful, good-hearted and true sons of the people, represented by Simpleton, irresistibly swept the masses along in their wake. Simpleton's seven followers on his march to the king's palace include three landlord's daughters, a parson, a sexton and two peasants—hinting at the broad union of social classes that supported the revolution. "The revolution of 1419," writes historian C.H. George, "began with assemblies of gentry working in close cooperation with committees of burghers. While the friends and disciples of Hus provided leadership, the working classes in towns around Prague, in southern and northeastern Bohemia, joined the poor of Prague and the peasants of all regions in an unexpected coalition of grievance and ideology."

The repressive forces, represented in the tale by the king, are finally overcome by someone who can drink a cellarful of wine and eat a mountain of bread. Who could this be but a people united into an army fighting for land and liberty?

And the wonderful ship that can sail on land or water? Could this be an allusion to the famed "Ark of the Covenant," in which God's word is protected and transported? (Against the monopolization of God's word by the Church hierarchy, the Hussites favored making the Bible available in the European languages so that the lowliest peasant could study its teachings.) Or perhaps the ship is meant to suggest the strange machine of war invented by the brave one-eyed Hussite general, Jan Ziska—that great military genius of the Bohemian Revolution who continued to lead his troops even

after he had become completely blind. (According to legend, at his death he asked that his skin be made into a drum so that he could go on leading troops against the invaders even after his death.) Ziska's invention, considered a marvel at the time, was a large fortified wagon that struck great fear in the hearts of the enemy.

The king's daughter, finally, can be seen as the symbol of Bohemia itself. Bohemia is a "feminine" country; indeed, its legendary founder was a woman. The daughter's seriousness signifies her sorrow at not being free (Bohemia at that time had a foreign ruler), and her laughter at the sight of Simpleton's parade reflects her joy in seeing the arrival of the army of liberation.

What can this ancient and incredibly adaptable story, with its bewildering multiplicity of possible interpretations—psychoanalytic dream-tale, hermetic allegory, revolutionary parable—mean for us today?

Now as always the forest is a symbol, a whole forest of symbols: source of the Marvelous, dwelling place of poetic inspiration, the unconscious mind, the promise of freedom. But today, when our forests and all wilderness areas throughout the world are being threatened and devastated as never before by commercial/industrial exploitation, we can appreciate how securely all this symbolism rests on very real foundations. The forest symbolizes everything wild and free because it truly is a place of wildness and freedom, and therefore fundamentally antagonistic to everything today's born-to-shop society stands for. Religious symbolism, and even many fairy tales, reek of neurosis, sexual frustration, servility, masochism, hostility to the life instincts, fear and hatred of the entire natural world. *The Golden Goose* is different: eros-affirmative, anti-authoritarian, utopian in the best sense, subversive of the dominant paradigm. It is a tale in harmony with the Earth, a tale in which Nature and human nature are not perceived as contradictory.

Looked at from this angle, the various symbolic interpretations of the tale may be seen to overlap, and their interconnections suggest new implications for today.

Psychoanalytically, for example, according to Géza Róheim, an

individual's relation to the environment is "conditioned ontogenetically by the attitude of the mother toward her child." The forest has a sinister, evil aspect only when it is the projection of neurotic sexual attitudes. In the society we live in, which is so devoted to the destruction of wilderness—a destruction rationalized in the name of "Progress"—we must seek out the social and psychological mechanisms that are at the root of this hostility and free ourselves of them.

Significantly, the golden goose itself—in which we can recognize the Philosophers' Stone, a magical being, a surrealist object, a talisman enabling us to change life—is first of all an animal. This reminds us that in dreams, and in unconscious life generally, as well as in the myths and poems of all times and places, animals have symbolized the fulfillment of desire and a liberated sexuality (puritans have always bemoaned sex as man's "animal nature"). Psychoanalysis has shown that capitalist/Christian society's repressive attitude toward animals corresponds to its attitude toward sexuality. For any truly radical alternative to today's social system, a new attitude toward animals is of the utmost importance. Human beings will not be free until they affirm their own animalness and their kinship with other species. *The Golden Goose* supports the surrealist view that individual human emancipation requires social emancipation, that both are unthinkable without sexual emancipation, and that all three are inseparable from the emancipation of nature.

Psychoanalysis is, in a sense, one of the heirs of alchemy, and it is only natural that a Freudian reading of the tale should be confirmed by hermetic inquiry, and vice versa. Our wonderful "wild goose chase" in pursuit of the hermetic/totemic object reminds us that, in Róheim's words, "we grow up through magic and in magic . . . Without this belief in ourselves, in our own specific ability or magic, we cannot hold our own against the environment and against the super-ego." Psychoanalytically and alchemically the golden goose, as André Breton said of the Philosophers' Stone, is that which "enables the human imagination to take a stunning revenge on all things."

The Hussite reading of the tale specifically poses the question of revolution and thus complements the others. Simpleton's sharing his food is a simple lesson that humankind must learn again in our time when inequality, exploitation, the difference between rich and poor are greater than they have ever been in history. The tale's

demonstration of the power and virtue of solidarity and mutual aid reflects the communist ideal of the most radical wing of the Hussites, which is still our best hope for a better world.

As modern technology and its side effects are fast becoming their own worst enemy, Simpleton's ship that can sail on land and water (using wind power) charmingly exemplifies what has been called an "appropriate technology"—a human inventiveness that is not hostile to the natural world.

Viewed as a revolutionary fable, some aspects of *The Golden Goose* seem absolutely modern, which only shows to what extent our most advanced notions tend to be a relearning of primordial wisdom long ago suppressed. It is important that our hero attains the highest happiness and love not through slaying dragons or hard work or arduous, heroic journeys, but rather through innocence, naturalness, simplicity and chance. The tale is a systematic repudiation of what everyone recognizes as bourgeois values. It is utterly devoid of the "work ethic" (aside from chopping down one old tree Simpleton labors not at all), or respect for one's parents (he is so irresponsible that once he leaves home he never returns), or deference to any authority (he fulfills the king's "impossible" demands so effortlessly that the king appears ridiculous). Moreover, Simpleton not only talks to strangers but shares his food with them! There is nothing Christian, capitalist, repressive or conformist about *The Golden Goose*. The "moral" it teaches is erotic, generous, adventurous and pleasure-oriented. Evangelists would find the story Satanic, and from their point of view they would be right, for it is a celebration of dream, chance, imagination and desire, which always have been enemies of God and the State.

Centuries after its author and original purpose have been forgotten, *The Golden Goose* has continued to be passed on from generation to generation, living a mysterious life of its own in the "underground" of folklore and children's literature. Exemplifying the spirit of poetry and magic that makes us affirm the Marvelous as the very center of a life worth living, the tale recalls the dreamtime that is not only behind us in the past but still with us, if we only know where to look for it. Each and every one of us needs only to find his or her own golden goose in the forest of indigo evenings for this dreamtime to be with us, ahead of us, and all around us always.

thirteen
Nancy Cunard and Surrealism: Thinking Sympathetically Black

Who could have imagined that Nancy Cunard, white, blue-eyed, pampered and privileged daughter of the British ruling class (her grandfather founded the Cunard Steamship Lines), would come to identify herself with surrealist revolution, communism and Black liberation?

All three causes are embodied in her justly famous anthology, *Negro*, published in 1934. The volume's 850 lavishly illustrated pages in large format (10" x 12") contain essays, poems and polemics by 150 contributors from Africa, the Americas, the West Indies and Europe. Its authors include Zora Neale Hurston, W. E. B. Du Bois, Sterling Brown, Alain Locke, Langston Hughes, George Padmore, Jomo Kenyatta, Arthur Schomburg, Arna Bontemps, Jacques Roumain, Nicolás Guillén, and, among non-Black writers, Theodore Dreiser, Lawrence Gellert, William Carlos Williams, Josephine Herbst, V. F. Calverton, Walter Lowenfels and George Antheil, as well as several of Nancy's surrealist comrades.

Substantial sections are devoted to Slavery, Negro History and Literature, Education, Racial Injustice, Communism, Scottsboro, Music, Poetry, and Sculpture. There are some 250 articles, including ones on "Three Great Black Women" (Phillis Wheatley, Sojourner Truth, Harriet Tubman), folklore, "white superiority," imperialism, lynching, chain-gangs Pushkin, Louis Armstrong, Sterling Brown, "'Clicking' in the Zulu Tongue," theater, dancing, boxing, Ethiopia, "Congo Masks," and the conjure doctor "Uncle Monday."

As Hugh Ford notes in his introduction to the current paperback abridgement, the anthology's purpose was simply "to combat racial prejudice," and to celebrate the richness, creativity, dreams and vitality of the world's Black population. Long since recognized as a classic, no publisher at the time would touch it. The book was so good that it was banned in the British colonies.

One of the best-known race traitors of her time (her name was on Hitler's "enemy list"), Nancy Cunard was a traitor to her social class as well, and although she was not exactly a feminist she violated gender taboos and accepted nothing less than complete equality with men.

She was born in 1896 and brought up in the rarefied milieu of the British aristocracy and imperialist bourgeoisie; her U.S.-born mother aspired to be "Mistress of the Robes" when Wallace Simpson became queen. Even as a child Nancy found that life empty and loathsome, and imagined a totally different world: a world alive with poetry. Isolated as a child, and an avid reader, she dreamed dreams of "Africans dancing and drumming around me, and I one of them."

There seems to be something in the intelligence of children that enables them to see through the phoniness of adults and to reject the lies of conventional life—a truth detector of sorts, which most people somehow lose as they grow older and more confused. Evidently Nancy Cunard's truth detector remained in good working order, and prevented her from being dazzled by the fabulous but deadly illusions that wealth can supply.

She married young—anything to get out of the house!—but soon left her husband and moved to Paris in 1920. There, having escaped her family for good, she discovered surrealism. Man Ray and Tristan Tzara were early friends. For the first time in her life she found herself in a milieu in which she felt comfortable, and even exhilarated. She frequented the Bureau of Surrealist Research and later the Surrealist Gallery, attended the daily Surrealist Group meetings, and for a time lived in the raucous surrealist commune on the rue du Château, where André Thirion years later recalled that she was "always ready for serious discussion." She and Louis Aragon became lovers and traveled together all over Europe together listening to African American jazz and going to junkstores where, in those days, one could often find exquisite examples of African art. Interestingly, Aragon's best works, including *Paris Peasant* (1926) and *Treatise on Style* (1928), were written during his life with Nancy. She herself wrote some of the first articles on surrealism in English (for *Vogue* and *The*

Outlook), and when the Buñuel/Dali surrealist film *L'Âge d'Or* was banned in France, she showed it for the first time in London.

For Nancy Cunard, the experience of surrealism was a determining one. It encouraged her own rebellion, strengthened it and gave it direction. In surrealism she felt the kinship, even the oneness, of poetry and revolution. Although her active involvement in the movement lasted only a few years, its impact on her sensibility and outlook lasted all through her life. (She died in dire poverty in Paris in 1965.)

Meanwhile, she was widely recognized as the epitome of the "New Woman" of the Jazz Age: fiercely independent and daredevilishly nonconformist in everything. She turned up as a character in novels by Aldous Huxley (*Point Counter Point*) and Michael Arlen (*The Green Hat*), where she is described as "a woman for all times." Many soon-to-be-famous artists painted her portrait. Several volumes of her poems appeared (critics found them "delirious"). She also learned to set type and run a press, and her Hours Press became one of the leading "small presses" of the time.

In Venice, 1928, Nancy met Henry Crowder, the Georgia-born African American jazz pianist who was then playing with Eddie South and the Alabamians. They became lovers as well as co-workers at the Hours Press. In 1931 the Press published a collection of Crowder's musical compositions, with poems by Samuel Beckett and others, and a cover by Man Ray.

Meeting Crowder was a decisive encounter for Nancy, who up till then had known little about African Americans beyond what she gleaned from *Uncle Tom's Cabin* and her love for jazz and African art. From Crowder she learned about African American history, politics, literature, and racial conditions in the U.S. He told her about W.E.B. Du Bois and other Black Americans, and sent for copies of *The Crisis* and *The Liberator* for her to read. Soon she was studying everything she could find in the way of Black literature and history. As Crowder made plain in his posthumously published memoir, *As Wonderful as All That?*, their relationship had its tensions and troubles—as did all of Nancy's relationships with her lovers—but she always warmly acknowledged Crowder as the man who introduced her to the Black world, and hence as a major influence in her life.

A trip to London with Crowder gave Nancy her first personal

experience of racial discrimination. When word got out that the daughter of Lady Cunard was in town with a Negro, they were subjected to the snubs and stings of racist abuse. Newspapers ran sensational stories about them; hotels denied them rooms; they received threatening letters and phone calls. The famous conductor, Sir Thomas Beecham, said Nancy should be "tarred and feathered." Predictably, Nancy's white supremacist mother (whom she sarcastically called "Her Ladyship") was horrified by the scandal; she hired detectives to spy on the couple, and not long afterward slashed Nancy's allowance. In response to this hypocrisy and pettiness, Nancy wrote and published *Black Man and White Ladyship*, a polemic in the grand style of surrealist invective. She was the first woman involved in surrealism to write such a text—a bitter denunciation of her own racist, imperialist mother!

From Cunard's endless discussions with Crowder the *Negro* anthology began to take shape. The project advanced like a surrealist game: improvisation was the only rule, and new players were always welcome. "Whatever organization *Negro* had," Hugh Ford points out, "came about more or less spontaneously," with "no strict plan." The result was a special blend of desire and necessity. As Nancy put it in the opening words of her foreword, "It was necessary to make this book," and to do so "in this manner"—that is, first of all to let these voices of the Black world (along with a few of their non-Black friends) be heard at last, and all together, but also to make a book of such magnitude, scope and beauty, and so full of compelling and wonderful material, that it simply could not be ignored.

Nancy solicited the articles, edited the book, assembled the hundreds of illustrations, proofread the galleys, and in the end, paid for the printing—which wasn't easy, because when the time came to pay, she was broke. Her Ladyship had severed her allowance (later she was completely disinherited), and she had spent whatever money she had putting together the book. But now surrealist "objective chance" intervened to save the day. In the wake of the racist press distortion of her and Crowder's London trip in 1931, Nancy had sued several papers for libel. The case dragged on, but suddenly and by chance in 1933 an out-of-court settlement provided her with £1,500—the exact amount needed to pay the printer!

Although critics seem to have ignored the surrealist dimension of the book, *Negro* is in a very real sense a surrealist anthology, or, more precisely, an anthology in which surrealist inspirations are evident from cover to cover. No less than seven participants in surrealism (including Cunard herself) were actively involved in the project. The French contributors included two of the most prominent figures in the movement, René Crevel and Benjamin Péret, as well as the little-known Raymond Michelet, who was perhaps still in his teens when the project began, but nonetheless was Cunard's "chief collaborator," and author of the powerful concluding text, "The White Man Is Killing Africa." The English painter John Banting was one of Cunard's close friends; he accompanied her on her second trip to Harlem, wrote "The Dancing of Harlem" for *Negro*, and a few years later became a key figure in the Surrealist Group in England. And from Belgium there was surrealist poet Ernst Moerman, who contributed a poem titled "Louis Armstrong," as well as Rolf Ubach, credited with taking many of the photos in the book, and better known as the great surrealist photographer Raoul Ubac. In addition to these individual contributions, Negro was also the original place of publication of the French Surrealist Group's major anti-imperialist declaration, "Murderous Humanitarianism." This was the first surrealist tract co-signed by Black surrealists: newcomers Jules Monnerot and Pierre Yoyotte, students from Martinique living in Paris.

Bringing together the world of Africa and the African diaspora and surrealism, *Negro* is a mix of great diversity which nonetheless reveals an underlying unity. This was Nancy Cunard's most important contribution to surrealism: to expand it by situating it, for the first time, within the worldwide movement for Black liberation. The Surrealist Group always had strong "elective affinities" in this direction, especially since the Riffians' uprising in 1925. But it was Cunard's anthology which highlighted these affinities in a specifically revolutionary and Pan-African context.

Like some of her surrealist friends, Nancy still had hopes for the Third International as a force for world revolution. She never joined the Communist Party, however, and always considered herself an

anarchist. Significantly, *Negro* received no notice in the communist press outside England. Mike Gold promised to review it in the *New York Daily Worker*, but never did. One of the longest reviews, in *The New Statesman*, was by English anarchist Herbert Read, who, two years later, helped organize the Surrealist Group in London.

Full of deep passion for freedom and an exalted life for all, the anthology continues to resonate today. In contrast to so many of today's "anti-racists" who pretend that white supremacy can be overcome without radical social change, Nancy Cunard boldly recognized the revolutionary implications of the struggle against whiteness. In our time of global imperialist escalation and other exacerbations of the "white problem," her vision of liberation is still up-to-the-minute, as exemplified in her ringing challenge: "How come, white man, is the rest of the world to be re-formed in your dreary and decadent manner?"

Marcus Garvey was not a man noted for bestowing praise on white folks, but he hailed Nancy Cunard as a person who "thinks sympathetically black." For Nancy Cunard, as for us, to do anything less would be unthinkable.

fourteen

Lee Godie, Queen of the Outsiders

Last time I saw Lee Godie we had tea together in her private castle overlooking the Chicago River. We were seated in a vast marble and limestone hall, a hundred feet long with ceilings thirty feet high. The weather outside was as chilly as November, but a warm sun streamed in through the giant arched twenty-five-foot-tall windows, with their many panes, casting long golden swatches of sunlight in detailed patterns across the floor. People were coming and going, their footsteps echoing on the highly polished marble floors as their long shadows danced along next to them, hurrying to keep up.

Lee commented on how delightful and hot the tea was. She was relaxed and at home—her personal confidence spread round her, casually annexing the vast space of the hall, asserting her ownership with a subtle but sure authority. We watched the soberly dressed people come and go, off on their many missions, busy, busy, busy—but with what? Surely something of the utmost importance . . .

This memorable visit with one of Chicago's great artists actually took place in the Wrigley Building, a large stone office building on Michigan Avenue, built by chewing-gum magnate Philip K. Wrigley, who was also the owner of the Chicago Cubs. Lee and Franklin and I sat together on a stone bench in the lobby. No one else had thought of appropriating this grand room as her/his own personal space—at least no one else had managed to achieve it: no one, that is, except the indomitable though virtually homeless Lee Godie.

Franklin and I had recognized her while walking on Michigan Avenue. It was 1986, during the *Tribune* strike; we had come to join the strikers' picket line as well as an anti-Apartheid picket line across the street. We invited Lee to join us for tea at a nearby restaurant, but she said no and instead invited us to the luxurious space she commandeered in the Wrigley Building lobby. I then went for tea "to go," and returned with steaming styrofoam cups; Lee protested this extravagance, suggesting that I should simply get hot water, for she always carried her own supply of teabags.

She was quieter that day than usual, and I noticed that she did not appear to be carrying any paintings. She explained that she had no canvases with her at the moment for she had sold all that she made. In the preceding three or four years, "Artist Godie," as she often signed her works, had become Chicago's best-known and certainly best-loved painter. It is largely thanks to her—and to the African American artist known as Mr. Imagination (Gregory Warmack)—that "outsider art" began to attract such a large audience in the city.

It was a cold day, but I had not worn gloves. Lee tried to give me hers, but I said, "I can't take your only pair of gloves!" She smiled and produced a second pair of gloves from her pocket.

The first time I met Lee Godie was ten years earlier, a few months after the 1976 World Surrealist Exhibition. That initial meeting was a classic example of a surrealist objective chance encounter—desire precipitating reality. Our friend Clarence John Laughlin, the surrealist photographer from New Orleans, had come to visit us. As we drove him all over the city he regaled us with endless stories of marvelous places he had photographed and amazing "characters" he had met. Among others he told us about Lee Godie and her work, which he ardently admired. (On this same visit he also told us about another Chicago artist, the late Henry Darger, and arranged for us to see some of his works at Nathan Lerner's place on Webster Street, where Darger had lived. It was always a wonder to us how Clarence, who spent almost all of his time in New Orleans, managed to be such an encyclopedia of esoteric information about present-day Chicago.) Clarence told us that Lee Godie was one of the very best self-taught so-called "naive" painters in the country, and that she often sold her works on the steps of the Art Institute during the summer. He described her as a "tall, pale, older woman who wore exaggerated makeup," and said she was easily recognized, for she almost always wore several overcoats, and a big hat.

The following weekend Franklin and I happened to have a car and were driving out to the western suburbs. At some point I made a wrong turn, ended up on Michigan Avenue, and soon we were passing the Art Institute. There on the steps we saw a tall, middle-aged

woman with shoulder-length hair wearing a broad-brimmed pink hat of fine organza. It was actually a bit early in the year for that kind of hat, and I noticed that this tall, thin figure was layered in coats and sweaters over a long wrapped dress. She was also carrying what at a distance appeared to be rolls of wallpaper. It could only be Lee Godie.

I pulled over and managed to park—illegally, of course, for there are few legal parking places near the Art Institute on a week-end afternoon—and we walked toward the museum steps; as we approached her, she introduced herself, in a strong, clear voice: "I'm Lee Godie, French Impressionist, better than Cézanne." I told her we had heard of her work and were very pleased to meet her. Franklin and I introduced ourselves, and she smiled warmly and said, "I could tell just from looking at you that you're artists, both of you." And she added: "True artists always recognize each other."

When I asked if she would show us the works she had brought along, she readily agreed and began unrolling her canvases, spreading them out, and commenting on them, pointing out various details. One was the portrait of a woman with a modest, captivating smile, simple and beautiful, radiant with a certain 1920s-ish quality. How-ever, there was something disquieting about this woman, an effect increased by the fact that her dark left hand (in a glove, perhaps, but then why were her pink fingernails visible?) was raised, holding a sprig of pussywillow. It was titled "The Unfinished Muriel."

For me, this immediately set off a reverie of free associations, for when I was growing up we had a neighbor named Muriel, and I have never since known anyone else of that name. I recall her on her wedding day—astonishingly beautiful in her elaborate white dress and a veil that set off her black hair. Delicately formed and light of step was Muriel, and more beautiful than any movie actress. She was eighteen. Her wedding day was probably the happiest moment in her life, for it was downhill from then on. In five years Muriel had six children—a half dozen squalling, fighting children (she fed them all Sugar Frosted Flakes for breakfast, lunch and dinner). Her husband was interested only in beer and sex, but poor Muriel was a Catholic who could neither use birth control nor seek a divorce without pro-voking the wrath of God. After five years her husband grew tired of marriage and divorced her.

*Painting by
Lee Godie in the
collection of Penelope
Rosemont.*

I remember, too, that my mother saved Muriel's life one day. Called by the desperate children, she and I ran over to find Muriel writhing purple-faced on the floor, gasping, unable to talk. Without a moment's hesitation my mother reached into Muriel's throat and removed a bone that had lodged there. Muriel hugged my mother and cried and cried.

Now that I think of it, it was chiefly because of Muriel that as a teenager I resolved never to be a wife, never to have children, never to let my life be stolen from me. Said I to myself: "If this could happen to someone as beautiful as Muriel, it could certainly happen to me."

It was good to meet Muriel again in Lee Godie's portrait—"un-finished," perhaps, but glowing, eighteen again, and free.

Years later I learned that the name Muriel also had wide-ranging significations for Lee Godie, for she called her portfolio her "Muriel Case," seemingly a blend of the word "mural" and the woman's name.

The other painting she showed us was a profile of a dark-haired woman, her hair cut squarely, her teeth also very square, with bright red lips and fuzzy caterpillar eyes (Lee often did fine, excessive lashes). This was clearly the portrait of a self-confident woman, who some have said resembled the original Barbara of Barbara's Bookstore. Sewn to this painting was yet another painting portraying a branch of leaves in golden/reddish brown against a gray background.

I was charmed by the visual strength, humor and verve of these paintings, and wished we could buy one, but I did not think we had enough money. Clarence had told us that it was possible to acquire one of Lee Godie's works "for as little as fifty or seventy-five dollars," but that was not so little for us in those days. To another person who had stopped briefly and inquired about prices Lee asked a hundred dollars each for the paintings she was showing us, but then—before this individual had a chance to reply—she asked us if we were interested in them. Of course we said yes, we'd love to buy both of them, but we only had thirty dollars with us. "Thirty dollars will be fine!" said Lee, rolling up both canvases. At this the other inquirer objected, but Lee explained, rather heatedly, "These are friends of mine, and fellow artists!"

So we bought both (or all three, if the diptych counts as two) but to me she asked: "Are you sure you'll want the picture of another woman on your wall? Won't you be jealous?"

I laughed and said, "No, I love her; you can't be jealous of someone you love." Lee smiled.

Meanwhile, a young art student had pushed herself forward. "How much do you want for that one?" she asked, rather crassly, without so much as a hello, pointing to another unrolled canvas. "For you," Lee replied, "a hundred and twenty-five dollars." The student responded angrily: "But you just sold two to them [pointing to Franklin and me] for only thirty! And I don't have that much with me!"

"That's okay, sweetie," said Lee, condescendingly, "I'm sure you can get it." And she turned away from the officious student to resume her conversation with us, with a big smile. Lee evidently had

instantaneous likes and dislikes; the criteria she used to size people up was all her own. "A lot of these people talk big," she said, nodding toward the obnoxious student, "but they don't know anything about art—they're just fourflushers."

As we left, I said I hoped we would see each other again. "I'm sure we will," said Lee. So we waved goodbye and returned to the car with our paintings. To our surprise, we didn't even get a parking ticket! *Quelle chance!*

Where Lee Godie came from no one seemed to know. The salient points of her biography seem to be few: She was born Emily Godie on September 1, 1908, and at a crucial moment in her life a red bird told her (in a dream?) to take up painting. (Many of her works portray birds holding signs in their beaks bearing such messages as "Alive—Yes!") Early in life she also wanted to be a singer. Although details are lacking, unquestionably she knew many hardships, and her life was a constant struggle. In the early 1960s she became a "street person." And then one day, in 1968, she turned up on the steps of the Art Institute, with paintings for sale.

By '68 those wide steps between the stone lions were a gathering place for the sixties generation of dropouts. The Art Institute was free then, its excellent library open to the public, its unpretentious cafeteria better-than-average and cheap, its gardens and fountains green and inviting. A colorful array of counterculture types, dissident artists and radicals adopted its front steps on a part-time basis, as a kind of summer headquarters. We surrealists often went there to distribute leaflets and harangue the crowd. Our first group show at the Gallery Bugs Bunny in 1968 was promoted largely by leafleting a big Art Institute surrealist retrospective on loan from New York's Museum of Modern Art. Although this anarchic free-for-all use of the front steps did not please the Institute's directors and trustees, it was several years before they came up with a plan to rid this so-called public institution of such "riff-raff."

Lee was some forty-odd years older than most of the sixties youths

who assembled there; already gray-haired, she nonetheless fit right in, with her sari-type dresses fitted with safety pins, her makeup painted on with poster paint, and rolls of homemade art under her arm.

Lee Godie had no permanent address, did not pay taxes, had no insurance, received no social security. She slept on benches in the summer and lived in pay-by-the-night flophouse rooms during winter. She kept her possessions in bus station lockers—many bus station lockers—and made regular daily rounds keeping them paid up.

To promote her paintings, she sometimes gave away, as "special incentives," cameo pins, cans of sardines, teabags, and snapshots of herself taken in photo booths. Once when she had accumulated enough money, she held a pool party for art collectors at a posh Lake Shore Drive hotel. Another time she held an open-air exhibition of her work at dawn in Grant Park.

We ran into her several times over the years—always on the Art Institute steps or in the street. She always seemed to remember us, and greeted us enthusiastically whenever we met, sometimes referring to the pleasure of meeting "fellow artists."

Her piercing wit was reserved for critics, journalists and others she regarded as "phonies." In 1985 a *Wall Street Journal* writer came to interview her and to buy one of her paintings. As soon as she learned he was from New York she raised her price to $1,000 per picture, and explained that "a thousand dollars is nothing to people in New York because they steal $6,000 in Chicago."

In these days of boring minimalist and conceptualist "installations" and other repulsive state-supported fads of a thoroughly uninspired, commercialized and conformist "Art World," Lee Godie and her work remind us of what art is really all about. Throughout her exceptionally difficult life she never forgot to put poetry first. In spite of everything, her marginal existence always had something magical about it. Amidst the cold barren cliffs of the city she managed to live a defiant life of freedom, following the path of her own desire.

Lee Godie: one of Chicago's uncompromising rebels, a beautiful and courageous example of the imagination set free: "Alive—Yes!"

fifteen
Dada: Emmy Hennings, Kandinsky, and the Theory of Relativity

One hundred years, since the opening of the Cabaret Voltaire—it lasted less than six months—in February 1916 in Zürich. Who would have guessed that this obscure beginning would herald a world-rocking negativity that was at the same time an ardent demand for renewal? The Movement that it created, Dada, itself didn't last very long but quickly mutated into surrealism and somehow made its presence known worldwide.

Zürich, at that time an island of peace, surrounded by ice, surrounded by war, attracted anarchists, revolutionaries, war resisters, bohemians who were fleeing the waves of patriotism and war-fever rampant in Europe—it was even home for a time to V.I. Lenin. Albert Einstein lived there, taught there, was there in 1916. Bakunin lived there a few years earlier.

Emmy Hennings arrived with Hugo Ball in May 1915. They performed throughout Switzerland and then decided to establish a cabaret in Zürich named for Voltaire, to them: "the anti-poet, the king of Jacanapes, the prince of the Superficial, anti-artist, preacher of the gate-keepers, the Papa Gigogne of newspaper editors . . . " Plans were hatched with Marcel Slodky, Hans Arp, and Max Oppenheimer. On Cabaret Voltaire's first evening Tristan Tzara and the Janco brothers showed up and joined the group.

Emmy Hennings, herself, a singer, was the star performer. Ball played piano. Others acts included a balalaika band, a Dutch banjo group, dancers who performed to the mandolin, passionate poets and pianist Artur Rubenstein who played Ravel, Saint-Saëns, and Debussy. Art by Picasso, Slodky, Janco, Arp, and others hung on the walls. Dances created by Sophie Tauber Arp and puppet skits performed by Hennings. They were joined by Richard Huelsenbeck playing drums and reading his poems. Plays, poems, dances, songs, Negro chants, puppet theater; it was open to all; all were encouraged;

all were celebrated raucously . . . Ball wrote, it was, "a race against audiences' expectations that called up all our powers of invention . . . an indefinable intoxication."

According to painter Christian Schad, in the spring of 1916 Dada gave birth to itself from this atmosphere of "spontaneous incongruities, formulated anti-meaning, ebullient collisions of opinions." The name Dada itself was found by chance while searching for a title for their journal in a French dictionary.

When Dada or the avant-garde movements of this time are discussed, the women are most often completely left out; they might have been sensational performers like Emmy, but nothing is left of their performances or it is entirely possible their absence could be assigned to the male-centered cultural sieve that strains women out of history. Some of my favorite women Dadas: Hannah Höch, Emmy Hennings, Sophie Tauber Arp, Beatrice Wood and Elsa von Freytag-Loringhoven participated in Dada and produced first-class work and yet. . . .

Emmy Hennings was born in Flensburg on the coast of Germany, the daughter of a seaman. In 1906 her child died and she was deserted by her husband; she took to the road, joining a traveling theater company. She had another child that she left with her mother and continued as a vagabond performer appearing in road shows, light opera and nightclubs in Cologne, Budapest, Moscow . . . A poet and writer, she wrote for *Pan* and *Die Aktion*, these were left and anarchist journals. She and participated in the magazine *Revolution* which was founded by Hugo Ball and Hans Leybold. A star performer in Munich where she met Hugo Ball while singing at Cafe Simplicissimus. Hugo Ball knew the gentle and elderly anarchist Gustav Landauer, active there. Landauer, a fine writer is especially notable for his theory of play was later killed in the Munich uprising.

In 1914 she spent time in prison, charged with forging passports for those wishing to escape the war. She identified with the pacifists, unlike some of the avant-gardists who supported the war. John Elderfield, editor of *Flight Out of Time* by Hugo Ball, claims she was implicated in a murder. She and Ball left for Zürich in 1915 to escape the madness of the collapsing social fabric.

According to Huelsenbeck, Hennings sang "Hugo Ball's aggres-

*Chicago Surrealists
celebrate the 100th anniversary
of Dada, 2016.*

sive songs with an anger we had to give her credit for, though we scarcely thought her capable of it," referring to the passionate voice of the frail Emmy. *The Zürcher Post* called her the "star of the cabaret" and described her as "exuberant as a flowering shrub, she presents a bold front and performs with a body that has only been slightly ravaged by grief."

In her poem "Prison," read at the first Dada event, she voiced her hatred of war and the prison system, her continuing despair: "There lies outside the world, there roars life, there men may go where they will, once we belonged to them, and now we are forgotten, sucked into oblivion, at night we dream of miracles on narrow beds, by day we go around like frightened animals, we peep out sadly through the iron grating, and have nothing more to lose. . . ."

Dada represented the beginning of a revolution in culture and consciousness but Einstein's work was the revolution in science.

November 1915 Albert Einstein triumphantly revised Newton's universe and began calling it the General Theory of Relativity. "Not merely the interpretation of some experimental data or the discovery of a more accurate set of laws. It was a whole new way of regarding reality," said his biographer Walter Isaacson. Einstein was ecstatic.

In 1917 Hennings and Ball had broken with Dada and left Zürich. The Russian Revolution was in full swing and Lenin was sent there in a sealed train. The Isaacson biography mentions the German Revolution of 1918 that began with a revolt of the sailors, became a general strike and then a popular uprising. On November 9, Einstein noted, "Class cancelled because of Revolution." Protestors occupied the *Reichstag* and the Kaiser resigned. Students took over the university and jailed the deans and the rector. Einstein and two friends, physicist Max Born and psychologist Max Wertheimer, asked the students to release the prisoners. But the students didn't have the power to do so, so Einstein and friends went to find the new German President, who did then sign the release order. That day also, Einstein addressed a crowd on the dangers of tyranny, both right and left.

Emmy published an autobiographical novel *Gefängnis* (1918), which described her prison confinement, her talks with other prisoners and the feeling prison provoked in her of being trapped always— whether in prison trapped by bars or outside the walls trapped by society. Ball, who had written an entire book on Bakunin, now claimed anarchists were innocents (perhaps he did not always feel this way) while Emmy seemed to have turned to religion. Most of her work, including two novels which may have a religious turn, and information on her life is available only in German.

Einstein's theory was not known to the broad world until 1919, when it was confirmed by the Eddington observations. The *New York Times* then published a huge six-part headline "Lights All Askew in the Heavens, Men of Science More or less Agog over Results of Eclipse Observations, Einstein's Theory Triumphs, Stars Not Where They Seemed or Were Calculated to Be. But Nobody Need Worry. . . ."

Wassily Kandinsky, sympathetic to anarchism, too passed through Zürich. He was a friend and a major influence on Hugo Ball, he was in touch with Tzara and his work was included in the first Dada journal (1916). It is notable that Kandinsky's Moscow exhibition of 1920 showed a change in his work—forms floating in space,

perfect circles, geometric designs, the spectrum of color, bent forms and waves, cosmological considerations. He seems to have been translating Einstein's theory of relativity into exhilarating paintings.

A time of high hopes and many defeats, a Munich Soviet was established in 1920 and the gentle Gustav Landauer became minister of education. But it was soon put down, massacred by the army and Landauer was murdered.

And Emmy Hennings: one wonders what would have happened to her if she had moved to France as other Dadas—Tristan Tzara, Max Ernst and Jean Arp and Sophie Tauber Arp. Perhaps then her demons would not have taken over her life.

Thinking about Dada from the perspective of today, it is astonishing that such a small, obscure group should have become the major influence it did . . . a laboratory for new ideas, and unrestrained, uninhibited, playful activity, their work still delights us. Groupings like this still exist; one finds them around small publishers, small magazines, small bookstores, small cafes: they are poets, artists, writers, socialists, anarchists and environmentalists. They are City Lights, AK Press, PM Press, Red Emmas Bookstore, *Oystercatcher, Fifth Estate, Rag Blog*, etc. They are determined to create new ideas, new worlds, and most of all, a new future.

The Chicago Surrealists celebrated the 100th Anniversary of Dada with days of poetry, rants, improv, paintings, collage, sculpture and punk rock music by the Steve Smith Band.

Postscript: A Dada Chicago Manifesto in the form of quotes from our Dada friends

Dada is movement, you can't be stationary in your attitude toward Dada.

—Henrietta Cartier-Bresson

Dada is always exciting. Speak it. Dada it. Life is boring without it.

—John Pearl Buck

Dada is a magical orange grove in a nightmare.

—Roberta Lowell

Dada first, think later.

—Tristana Tzara

If you want to Dada, go to where it's played and find a
way to get in. Dada happens when you get in the game.

—Christine Matthews

If anybody laughs at your Dada, view it as a sign of
Dada success.

—Jimella Rogers

If you can't dazzle them with brilliance, baffle them with
Dada.

—W. C. Fields

If your Dada is under control you are going too slow.

—Marian Andrette

If you wish to be a Dada, do Dada.

—Epicurus

Whereever you go, go with all your Dada.

—Confucius

Wipe the dust from your Dada, see its brilliance.

—Paul Garon

Whatever you are, be a good Dada.

—Abra Lincoln

Once you can accept Dada as Dada expanded into
nothing that is something, wearing stripes with plaid
comes easy.

—Alberta Einstein

If at first you don't succeed at Dada, Dada again. Then
quit. No use being a damn fool about it.

—W. C. Fields

Do your own Dada stunts. Don't commandeer a Dada
double to do them for you.

—Charlene Chaplin

Never go out to meet Dada. If you just sit still, in nine cases out of ten, some bird will Dada for you.

—Calvina Coolidge

I've learned the glories of Dada. Don't take things too seriously. Celebrate Dada.

—Louisa Haza

The best Dada comes as a joke. Make your thinking as Dada as possible.

—Davida Ogelsvey

You were born with Dada wings. Why crawl though life.

—Patricia Rumi

Dada loves to be grabbed by the shirt and told "I'm with you, kid. Let's Dada."

—Marvin Angelou

Absolute Dada is not being hindered by anything.

—Tershuawa

Life attracts life, Dada attracts Dada.

—Elaine Levi

Don't save your Dada for tomorrow. Tomorrow it may rain.

—Leah Durocher

sixteen

Surrealism and Situationism: King Kong vs. Godzilla

an attempt at a comparison and critique by an Admirer and Participant, including a brief look at a seemingly faraway place in space and time, or How New Thoughts are let loose in the World.

> *"Young people everywhere have been allowed to choose between love and a garbage disposal unit. Everywhere they have chosen the garbage disposal unit. . . ."*
>
> —Gilles Ivain (Ivan Chtcheglov) *IS* 1, 1958.

> *"In matters of revolt one needs no ancestors."*
>
> —André Breton

> *"Without contraries there is no progression."*
>
> —William Blake

This is an attempt at the impossible, that is, to sum up briefly, the interactions, the concepts, and the importance of two of the most significant radical movements of the 20th Century. Movements that not only have shaped the thoughts and actions of radical minds and the alternative media, but have found their way into the mainstream for better or for worse and changed in major ways how we see our world. The Chicago Surrealist Group which I helped found with Franklin Rosemont, Bernard Marszalek, and others from an outpost of the IWW, the Solidarity Bookshop, had contact with the Situationists and their writings. Red and Black, Fredy and Lorraine Perlman in Detroit, kept in touch. André Breton and the French Surrealist Group wrote a few letters; our main contact with the group was Robert Benayoun. There were significant points of rupture between the surrealists and the situationists, but they shared a narrative

history and an analysis of both is needed so that we may determine what has been surpassed. There is a need to make new decisions about the nature of the society we live in and create the possibilities for the emergence of another, hopefully improved version.

In 1965, I arrived in Paris by accident. I was with Franklin Rosemont and we had just been deported from England as undesirables.

Not far from the hotel where we stayed at Rue Dauphine and rue de Buci, we found that an international surrealist exhibition had just opened. It was called *L'Écart absolu*, absolute divergence, and it was dedicated to and being held in celebration of the utopian socialist thinker Charles Fourier, inventor of the Phalanstery and the Butterfly Passion.

At the very center of the exhibition was a "Monster" fifteen feet tall—made up of a gigantic pink mattress, with mattress head and mattress arms extended. It had one eye—a television set; from its head sprouted the sirens of a police van, its stomach consisted of an automatic washer with a window, its contents, the wash (daily newspapers) tumbled over each other hypnotically. And then on a label we found its name, it was called *The Consumer* and exemplified that great bloated monster of contemporary society. This fit into a situationist critique. . . .

Across the Seine, near the Sorbonne, was a small bookstore La Vieille Taupe, the old mole. (It reminded me of our Solidarity Bookshop in Chicago.) That is where I found the Situationist International (SI) literature, probably in March 1966. Prominently displayed was the flashy journal *Internationale situationniste* and the *Address to Revolutionaries of Algeria and All Countries*, the SI statement on the Algerian war. I brought the statement back to our hotel and both Franklin and I read it and thought it excellent.

Later at La Vieille Taupe we bought more SI literature, and talked with the person who ran the store. He inquired, "Would you like to meet the situationists?" And indeed we did want to meet them, in part because calling yourself a revolutionary then when we were living the "best of all possible lives" in the "best of all possible worlds" seemed totally out of place, impossible, crazy. And what we wanted the most was to meet people who besides ourselves were intransigent insurrectionists, implacable enemies of the stale social order.

A few days later, we met at a small cafe on a second floor, plain white walls, nobody there but us four—Guy Debord, Alice Becker-Ho, Franklin Rosemont, and myself. Our meeting with Debord went well, we liked him very much, he smiled often, had a lively intelligence, good sense of humor, and was well acquainted with surrealism and its ideas. He admitted a fondness for surrealism and said, "If this were the 1930s, I'd be a surrealist!" But considered that "surrealism was absorbed now, they teach it in the grade schools, now one must be a Situationist!"

We commented that we thought conditions were different in the U.S., that people there really didn't know what surrealism was since so very little was available in translation—the images had moved with the speed of light compared to the theory and politics. And we thought a better understanding of surrealism could create a possibility and a necessity that would get beyond stale and rigid Marxism and that our group, making a specifically surrealist intervention in the U.S., would add a new dynamic to the growing consciousness. This was a more difficult task than we imagined, but surrealism never aspired to be a mass political movement in itself; it didn't plan to issue membership cards. The same was true with the SI—they were after a fashion what could be called "influencing machines" or "viruses of the mind," using one of today's modern expressions from the computer world and the popular writer Richard Brodie. Surrealism has always considered itself a choice, a way of life. Both of these groups, admirers of Rimbaud and Lautréamont, would be well pleased to be considered "viruses of the mind."

What is still "in the air" today, imprinted in our consciousness from the 1960s, are the few words, the slogans that were put together to fit on buttons or be quickly painted on walls. One can't remember May '68 or situationists without remembering "Be Realistic, Demand the Impossible" or "All power to the Imagination!"—very surrealist-inspired slogans. And when we remember the antiwar movement, a slogan that comes to mind is the phrase our Solidarity Bookshop group invented in 1965 for a spring demonstration, "Make Love, Not War!" (Recently seen at a San Francisco bakery, transformed yet again to "Make Loaves, Not War!") These compact and closely fitted together words unfold into entire worlds. Worlds that are still in the making. I recall when we put the phrase together,

giving a new twist to the old War. Resisters League slogan, "Make Peace, Not War!" Too dull we thought; the '60s were all about love and sexual freedom. We wanted to celebrate it.

We were able to understand Debord's French and he could understand our English. So our conversation ranged far and wide at that meeting; we told about our IWW Solidarity Bookshop in Chicago and our mimeoed journal *Rebel Worker*. We had a lot in common with the SI including the importance of workers councils; also we made a point to recommend that people read Paul Cardan's *Modern Capitalism*. We planned to visit the London Solidarity group in the coming weeks.

We asked if we could bring some SI literature with us back to the bookshop in Chicago. This meeting was near the end of our sojourn in Paris so this had to be arranged quickly. Debord was glad to supply us with literature. He liked us, otherwise why would he have spent so long with two kids. He was ten years older, in his 30s, with quite a few accomplishments behind him. (We were 22 and when I look at our photos I'm surprised anybody took us seriously.) Not eager to leave, he seemed a bit disappointed that we didn't want to follow up on joining the SI . . . so, for better or for worse, we missed our chance to be the American section.

A couple of days later Mustapha Khayati brought the SI publications Debord had promised. He didn't seem very familiar with surrealism or especially friendly. We did ask him about how one went about joining the SI and what the requirements were. But were told abruptly that we couldn't dabble in surrealism too—dual memberships were not tolerated. We brought up Benjamin Péret, probably a mistake. Péret had written an attack on the SI published in *Le Surréalisme même*. Khayati gave us a stack of assorted pamphlets for our bookshop, at least 300 copies of the *Decline and Fall of the "Spectacular" Commodity Economy*. These we sold in Chicago at Solidarity Bookshop and across the country though our journal *Rebel Worker* and later through our mail order catalog and at Barbara's Bookstore, then on Wells Street. It is an honor to have had a role in spreading these ideas and to have been part of that network of new thought.

For us to whom history was important it was frustrating when we brought up the situationists to the surrealists. We got a scowl from Radovan Ivsic and simply, "They are not our friends." Nothing

further. Breton was not present at that meeting. This response was not unusual; they didn't like to talk about splits and it was hard to pry this information out of any of them.

Before we left I felt we needed to write an essay or a manifesto, something to give to the Surrealist Group to explain at least in part why we had come, what we were doing there and what our future intentions were. Our piece, "The Situation of Surrealism in the United States," was translated and published in *L'Archibras* 2, October 1967.

There is a considerably tangled and knotted web of history behind the relationship between the Surrealist Group and the SI group. Quite a few of the characters who played important roles in one were also linked to the other, or were among the important players in surrealist groups or SI precursor groups or knew one another from those groups or other groups or were in contact with each other on some level. Our friend Édouard Jaguer in Paris, who was a great help on my book *Surrealist Women*, was part of a small group of young people who established a group *Le Surréalisme révolutionnare* towards the end of WWII. He was a member of Cobra and also later part of the Paris Surrealist Group. After that, he established the surrealist-related journal *Phases*. Important Cobra members were Asger Jorn, and also, Pierre Alechinsky whose beautiful print "Central Park" was prominently displayed at the surrealist exhibition *L'Écart absolu* right next to the giant pink mattress of *the Consumer*. Both Jorn and Alechinsky were significant characters in the SI.

One of today's major theorists of surrealism, Michael Löwy, writes in *Morning Star, Surrealism, Marxism, Anarchism, Situationism, Utopia*: (p116) that surrealism is "the human spirit in revolt and an eminently subversive attempt to re-enchant the world . . . to reestablish the 'enchanted' dimensions at the core of human existence—poetry, passion, mad love, imagination, magic, myth, the marvelous, dreams, revolt, utopian ideals—which have been eradicated by this

civilization and its values. . . . surrealism is an adventure that is at once intellectual and passionate, political and magical, poetic and dreamlike." Löwy's book also contains an essential article assessing the significance of Guy Debord and his thought, "Consumed by Night's Fire: The Dark Romanticism of Guy Debord."

Löwy evaluates the subversive implications of the concept of *dérive* and quotes Debord, "the future will speed up irreversible changes in behavior and the structure of society. One day, we'll build cities to practice *dérive* in." (*Morning Star*, 2009) Löwy considers Debord and the SI if not belonging directly to surrealism to have drawn a considerable part of their subversive force from it and certainly to be linked by "elective affinity."

At the beginning of *Arsenal* 4 (1989), Franklin Rosemont wrote, "Surrealism began, point blank, with life-and-death questions that everyone else ignored or pretended to ignore: questions of everyday life, suicide, madness, nature, poetry, love, language and absolute revolt. The most audacious dreams of centuries suddenly were dreamed anew and brought to fruition in this new and unexpected 'communism of genius' that plunged its roots deep in the manifold forms of outlawed subjectivity. Here was a dialectical leap of world-historical implications, transforming once and for all the conditions of thought, art, poetry and life itself."

"The situationist encounter with surrealism," Ron Sakolsky has commented, "in spite of the Oedipal denial of the many connections between the two on the part of the situationists, can better be seen as a dialogue between 'specialists in revolt.'" Sakolsky's essay "Surrealist Desire, Anarchy & the Poetry of Revolt" is the best discussion of surrealism and its political evolution in the English language. It contains a lengthy discussion of politics of surrealism and situationism and is included in his book *Creating Anarchy*.

Chicago anarchist, *Rebel Worker* writer and part of our Solidarity Bookshop staff Bernard Marszalek considering our days working together in the '60s says, "The SI and Surrealism are complimentary. Where the surrealists lacked a political program in the narrow sense the SI supplied one, generalized self-management, not simply worker-councils though that was the core of the historic thrust for a world based on popular desire. But the SI lacked the wider vision that the

Surrealists provided, encapsulated by the concept of the marvelous in everyday life. These two elements really need each other. And lastly, the anarchist example of melding these two aspects into a practical utopianism informs both while lacking their depth. We anarchists did live differently (proto-surrealism) and had a generalized critique of power on all levels (the SI's contribution). I think this is the real contribution of Chicago's *Rebel Worker* group, connecting these all together" (Email, 2012).

Surrealists and situationists do have significant differences—an especially basic one is on the importance of the unconscious mind. The situationists tended to side with bourgeois rationalists and dismiss the importance of the Unconscious. The surrealists found in the Unconscious the essential font of creativity—the uncensored mental processes found in dreams, thoughts and desires that are beyond our control that advertising, religion and many aspects of the Society of the Spectacle try to either exploit or condition, to use for their own ends, basically to sell a product or to sell an ideology or a bankrupt social system. The SI attacked the making of art but for a while at least promoted thinking about city design and architecture . . . some was of an ultramodern, stripped-down form that we in Chicago and most other surrealists found completely miseriblist and inhuman, though I'm tempted to look at it as an SI joke.

Both the surrealists and the SI venerated the liberated sexuality of de Sade but the SI criticized surrealism for a bourgeois attitude towards love. On the other hand, Simone de Beauvoir didn't like the surrealist attitude either. Those involved in surrealism have championed the feminine, the idea of love, and encouraged women. There have been many women theorists and creative artists. Surrealist sex rebel Claude Cahun is finally getting a share of the attention her work deserves. Annie Le Brun, Nancy Joyce Peters, and Nora Mitrani are important among surrealist theorists. Leonora Carrington, Mimi Parent, and Toyen have contributed masterpieces as surrealist painters. Suzanne Césaire, Jayne Cortez, Carmen Bruna are startling and wonderful surrealist poets. Surrealists have often called attention

to the idea that the progress of a civilization could be judged by the way it treats its women and they upheld a belief in Mad Love and sexual experimentation, considered also concepts such as the androgyne and the Egregore. Women and sexuality is a major area in which SI thinking should have been developed.

Though the SI was interested in *dérive*, something one might consider applicable to a stroll through the forest, their conception of wandering is divorced from the natural world. Like the old-line Marxists they oriented toward work and technology; one is hard-pressed to find even a passing reference to, much less any concern for, the Earth or its creatures. Surrealists as poets influenced by Lautréamont with thinking influenced by Darwin were sensitive to the natural world and the wild and were exalted by the wonders of the shark, the octopus, the Luna Moth. . . . But perhaps the first militant statement concerning animals and the environment was ours in Chicago with our often quoted and reprinted anti-zoo leaflet originally issued in 1971, the "Ant-Eater's Umbrella" and later involvement with other defenders of nature, especially Earth First! Though even before that in 1966 our "Theses on Vision, X-Ray and Otherwise" ended with "the forest is deep and the night is long, but now we know the wolves are on our side" (Rosemont, *Forecast* p. 9).

Truth is we didn't have time to translate SI works or criticize them in any detail at the time; we assimilated them by a sort of osmosis as we discussed them at Solidarity Bookshop with friends attempting to translate unitary urbanism, *détournement*, psychogeography, etc. Inspired by what the SI wrote we considered whether the world needed a psychozoology, too. But after all, in 1967, things were heating up fast, our statement "The Forecast is Hot!" was indeed timely.

Historian Robin D.G. Kelley writing in *Freedom Dreams* comments, "Surrealism may have originated in the West, but it is rooted in a conspiracy against Western Civilization. Surrealists frequently looked

outside Europe for ideas and inspiration . . . in tracts like 'Revolution Now and Forever!' the surrealists actively called for the overthrow of French Colonial rule" (*Freedom Dreams*, p. 159).

One of the very significant developments of surrealism that the SI did not consider in its various critiques was the influence of surrealism on Pan-Africanism, especially through Martinique, Aimé Césaire in particular. In *Freedom Dreams* Robin D.G. Kelley writes, "Aimé Césaire, after all, has never denied his surrealist leanings. As he explains: 'surrealism provided me what I had been confusingly searching for. I have accepted it joyfully because in it I have found more of a confirmation than a revelation'" (*Freedom Dreams*, p. 169). Kelley explains that Césaire's *Discourse on Colonialism* (1950) "was indisputably one of the key texts in a tidal wave of anti-colonial literature produced during the post war period—works that include . . . Frantz Fanon's *Black Skin, White Mask* (1952), George Padmore's *Pan-Africanism or Communism? The Coming Struggle for Africa* (1956). . . ." (Freedom Dreams, p174).

The SI and the 1968 uprisings may have saved surrealism from occultation and increasing mysticism, but what will save the SI's ideas from increasing abstraction and cooptation? The Occupy Movement came along at a fortunate time to pin radical theory back to practice at the same time it raises the stakes and also the question, what next?

Chicago Surrealists considered it necessary that a major focus of surrealist work should be poetry and with it, the restoration to language of the real power of our own thought. Franklin Rosemont wrote with passion of the history of the neglected, forgotten, repressed—the history of revolt, that urge for liberation that persists always in the human spirit. Among his writings are a book on Joe Hill, another on Jacques Vaché and an often reprinted pamphlet *Karl Marx and the Iroquois*. He pointed out that Debord incorrectly considered surrealism as irrational. But surrealism is not irrational, it is anti-rational.

According to Rosemont, "the fact remains that the central elements of the situationist project—rejection of the pseudo-world of the spectacle; support for workers' self-emancipation, the passion for

freedom and true community, revolt against work and affirmation of play, *détournement*, revolution as festival, "consciousness of desire and desire for consciousness"—were all essentials of surrealism's project long before the SI existed. . . . I recall Guy Debord: In spite of himself—and above all in spite of the myth of himself—the most surrealist of anti-surrealists!"

Debord's *Society of the Spectacle* (1967), like Marx's *Communist Manifesto*, may prove to be one of the most influential and enduring documents of our time. It has provoked, and continues to provoke, critical thinking on how our world is structured, how it functions, its values, what is important . . . and in this it surpasses any other theoretical work of the time. Of course, it was part of that time and "the developments of capitalism have speeded up." Now thanks to computers, the internet and YouTube everybody can be part of the spectacle, for better or for worse, as we see.

My own interests these days lead me toward a critique of everyday life, the deconditioning necessary for us to accomplish a liberated future, what is work and what is play and what could they be? And how can we transform our relationship to the natural world and to each other . . . how will our acts influence events. For that matter, I also like to play with "What is history?" And to play with "What is identity?" Who do we think we are anyway, what validates our idea of self and gives it a social value? Especially in these days of no jobs and uncertain futures.

Part of our work as surrealists is the attempt to understand and put together a critique of the new myths, myths in formation: Advertising, Science, Pop Culture. We see as important new mythological figures that harbor the seeds of liberation such as Bugs Bunny (especially Bugs Bunny), as Groucho Marx, as King Kong, as Godzilla. Sometimes my brain entertaining itself visualizes King Kong or Godzilla confronting the gigantic pink mattress of *The Consumer*. Who will be the winner in this colossal confrontation?

And speaking of King Kong and Godzilla, surrealism and situationism, these two heros/anti-heroes, creations of born of dream/nightmare, filling our ears with cries/roars, these two enraged escapees from cultural conditioning—still today—these two Monsters of Consciousness remain most certainly . . . "At Large!"

seventeen
Toyen: Surrealist Sex Rebel and the Phantom Object

At sixteen, I decided that my life would not be what others intended it to be. This idea . . . and perhaps good luck . . . allowed me to escape most of the misfortunes inherent in woman's condition. . . . In this time when everyone claims that one is not "born a woman" but one "becomes a woman," hardly anyone seems to trouble herself not to become one.

Indeed it is just the opposite. . . . Disdaining the masters who act like slaves, as well as slaves eager to slip into the skins of masters, I confess the ordinary conflicts between men and women have been of very little concern to me. Rather my sympathy goes to those who desert the roles society assigns them. . . .

Above, I am quoting Annie Le Brun's introduction to *Lâchez tout* (Drop Everything)." I do this because I was surprised to find so little on Toyen while exploring the internet. I was looking forward to learning more about my enigmatic friend, more information than I had when I wrote about her in my books *Surrealist Experiences* and *Surrealist Women*.

I quote Annie because Toyen wrote that she considered surrealism "a community of ethical values." It was her community, her values. As a young woman she broke with her family and took the gender neutral name Toyen. She frequented the anarchist milieu. A sex rebel, she dressed in male and female attire on alternating days. She was a founder of the Czech Surrealist Group and never left surrealism. So I feel that Annie, who was a surrealist and a good friend of hers, can speak for her.

In October 1970 I remember sitting on the couch with Annie

in Toyen's studio located on Île de St-Louis while Toyen brought out her magnificent paintings, one by one, laughing. There was one especially we laughed at heartily. . . . quite large, it featured Dalmatians dogs opposed by their shadows on a red and black chess board and apparitions of cheetahs . . . it was dated 1968.

This was not the first time Toyen, Annie, and I had met, I was in Paris in 1965–66 and met Toyen and the entire Surrealist Group including André Breton. We first met at a Surrealist Group New Year's Eve party held at the Théâtre Raneleigh, one of the oldest theaters in Paris and a truly impressive place. I wrote that "I felt a great affinity for Toyen from the moment I met her . . . like meeting an old friend after a long separation." The party was also celebrating the surrealist exhibition *L'Écart absolu* (absolute divergence) devoted to Charles Fourier. I was 23. Born in 1902, Toyen was 63.

We saw each other at the Surrealist Group's meetings which happened almost every day around 6:30. The group was talking about cartoons one day. There was a small theater in Paris Théâtre Universel that showed cartoons only and every single day. I went there quite often. Toyen insisted that her favorite cartoon character was Bugs Bunny . . . those films shown were *What's Opera, Doc?, One Froggy Evening*, etc. Back then Bugs Bunny was a crazy anarchist who always got the best of the obsessive homeowner Elmer Fudd.

The 1970s trip began unusually; Franklin and I had trouble at the airport in Chicago before even getting off the ground, but were allowed to board the plane after being searched and questioned. When we landed in Paris we were shocked. The Left Bank was a militarized zone. Every block had busloads of armed police parked on it. The bridges across the Seine had machine gun posts on both sides. It seemed like they were expecting a total uprising. What we didn't know but finally found out was that the trial of Alain Geismar, one of the student revolutionaries from 1968, was about to begin. They expected riots, but none materialized. Jean-Paul Sartre and Simone de Beauvoir made the news by coming out in support of Geismar, who got 18 months in prison.

We knew there had been big changes in the group but there too we were surprised. By this time the Surrealist Group had broken up into several parts, due largely to the questions of what direction to

take after '68. It was drastically different for our surrealist friends and hardly any of them wanted to talk about it. They no longer met at the cafe. Some were in despair. In '68 they had done their best to inspire the student-lead uprising. They put out manifestoes and calls to action (and were indicted for this), their cafe was overwhelmed with people wanting to join them, they camped out on the barricades, were tear-gassed, even Elisa Breton.

The group split several ways: Jean Schuster and Gérard Legrand decided surrealism was over but their duty was to carefully document it (this has been very useful). Most of the surrealists gravitated to a group organized by Vincent Bounoure; kind-hearted, patient, and inspired, he and his friends began a *Bulletin* to publish some works and keep in touch internationally. In Prague, the Czechs found that their magazine *Analogon* that come out with a first issue in '69 and mentioned our Chicago Surrealist Group, was suppressed. But the Czechs stubbornly continued to do their surrealist work and are still doing it today. They just published a new issue of *Analogon*.

Toyen's life was a remarkable one. Europe was in great turmoil; the rise of fascism and war made life itself precarious. She was in surrealism since 1934 when the Czech group was founded; surrealism was in a category considerably lower on the scale than the so-called "Degenerate Art" banned by the Nazis.

Before surrealism she and her companion Jindich Styrsky had been active in avant-garde movements including one they invented themselves in Paris, 1927 named Artificialism, it was similar to but preceded abstract expressionism. She also was a founder of the group Czech group Devetsil. She translated Lautréamont into Czech. Placed on a blacklist of forbidden intellectuals during war she continued to produce works. According to Sidra Stich, Toyen hid fellow surrealist Jindrich Heisler in her apartment for four years; he was on a wanted list.

In 1947, after the liberation by Soviet troops, on the eve of her first show since before the war they both fled to France. You might think this paranoid on their part but three years later in 1950, her friend Zavis Kalandra, a staunch supporter of surrealism who had smuggled Jews out of the country on foot, strongly fought the Nazis and been arrested by the Gestapo in 1939 and sent to a prison camp

by them was given a show trial, accused of being a follower of Trotsky and executed along with some of his friends by the ruling communist government.

How can we know Toyen? The surrealists loved games and inquiries. One involved the question: Would you open the door? And here is what Toyen answered.

> *Baudelaire? Yes, with Affection.*
> *Chateaubriand? No, devoid of interest.*
> *Freud? Yes, to make him psychoanalyze me.*
> *Goya? With joy.*
> *Marx? Yes, in the friendliest way.*
> *DeQuincey? Yes, to dream with him.*

Toyen's often erotic work changed after Breton's visit in 1935. The major influence on her work and on the development of her work is found in surrealist theory, especially that of André Breton. Breton, Jacqueline Lamba and Paul Éluard visited Prague in 1935, and were given a warm welcome; this was thanks especially to Zavis Kalandra, editor of the communist political periodical *Rudé Právo* who was to meet such a tragic end. Kalandra made sure that Breton got excellent publicity for his speech entitled the "Crisis of the Object." Czechoslovakia was still independent and had not yet been invaded by Germany. Its Communist Party was not yet completely totalitarian and even though Breton had been expelled from the CP, denounced socialist realism, demanded free expression and denounced the French CP, still they were given a warm welcome in Prague.

"The Object" has gained some interest recently . . . Bestselling book by Neil MacGregor, *A History of the World in 100 Objects*, applies a historical method for the most part, and also considers: the poetry of objects, the survival of objects, the biographies of objects, the limits of objects, objects across time and space . . . very

interesting indeed. MacGregor reflecting on an early stone tool says that brain patterns indicate that "if you can shape a stone you can shape a sentence" and later that "objects are both a love affair and a dependency." He quotes David Attenborough, poet of Earth: "The object sits at the base of a process which has become almost obsessive among human beings."

Though poetry comes up for MacGregor he doesn't mention Breton's speech, the "Crisis of the Object." One of Breton's points was that current thinking was now "dominated by an unprecedented desire to objectify." He did not mean that objectification was necessarily a good thing. He thought that "Surrealist Objects" should be created as an oppositional force. Breton had already suggested that "objects seen in dreams should be assembled and put into circulation in the world." Duchamp led the way when he displayed his famous urinal re-titled *Fountain* in 1916. This piece was actually suggested to him by a Dada woman Elsa von Freytag-Loringhoven.

Surrealism, itself, is an attempt to get beyond false contradictions, such as waking and sleep, reason and madness, objective and subjective; surrealism hopes to find that point in the mind beyond dualities. Breton, in his Prague speech, urged his listeners and surrealists, to consider that "our vital task is to pursue our experiments unceasingly, reason will tag along behind, blind-folded by its phosphorescent bandage."

And further that "our primary objective must be to oppose by all and every means, the invasion of our sensual world by things that humankind makes use of only by habit . . . the mad beast of conventionality must be hunted down . . . "

"To actualize objects concretely no matter how bizarre they might be . . . as more of a means than an end" . . . "to unleash the powers of invention that would then be revitalized by these dream-engineered objects representing desire in its most concrete form possible."

Further than just the creation of such objects, he hoped for "nothing less than the objectification of the very act of dreaming . . . its transformation into reality."

Breton went into considerable detail on different kinds of surrealist Objects. He pointed out that "Objects can achieve a new

identity "simply through a change in role." Or "Attaching a new label," or being a "Found Object, either, natural or manufactured," or through the "bringing together divergent elements," or else being an "Object Poem," symbolically functioning almost like a rebus. Or later the possibility of Phantom Objects.

Breton was aware of Marx's idea of the Commodity—an Object that is bought and sold in the marketplace—of the changes of mass production and mass consumption. The surrealist object (and the surrealist collage, the creation of an object on paper) should be considered Anti-Commodities—not mass-produced, not mass-consumed, totally unique and of absolutely no "use-value." Subversive to rational thought, these anti-commodities exalt only the desire to create and the desire to play. Desire as a motivating force and play are among essential ideas of surrealism.

As for the character of the surrealist object, I think it is not only an Anti-Commodity but seeks to go further: it is an "Object in Revolt." An object that has become an individual, one with a uniqueness and an individuality that is determined to affect you, to provoke you, to change you, that one demands recognition. It is determined to be no longer passive, like the woman rebel who would be her own hero and rescue herself, like the sex rebel Toyen herself, the surrealist object stands before us with a beauty that is convulsive . . . dangerous.

But where did this concern for the Object come from? Before Marx and Breton "the Object" was of concern to Hegel. Breton attended some of the lectures beginning in 1933 by French Hegel scholar Alexandre Kojève, who explained Hegel's thought on the Object thusly:

"The knowing subject loses himself in the Object that is known . . . desire is what transforms being into an Object revealed to a subject by an Object different from the Object and opposed to it. . . . It is through work, that one recognizes oneself objectively as a person." (Surrealists might insist not just on work, but on play, also.) In any case, Hegel was concerned about the Object. And he never encountered either Facebook or a Whole Foods store. (Here I am funning a bit at Hegel's expense.)

Other influences on Toyen and surrealist thinking: the Paranoiac Critical method by Dalí (1930), of which Breton wrote, "This

method is a first class instrument"; the film *L'Âge d'Or* (1930); the idea of "symbolically functioning objects" (1931); Lacan's two articles in *Minotaure*, "Paranoid Form of Expression" and "Paranoid Criminal Motivation" on the Papan sisters (1933); and beloved by all surrealists "mad love" story, the film. . . . *King Kong* (1933).

In 1936 Toyen painted *The Sleeping Girl* a charming blonde girl, an *Alice in Wonderland* apparition, but an empty cone that looks out on a bleak horizon, in her hand a butterfly net. But there are no butterflies to be seen anywhere. Around the same time Styrsky painted the *Trauma of Birth* its title from the psychoanalyst Otto Rank after talking with Breton about the expression of objects. Toyen represents her thoughts on life, on her identity, on woman's identity with unparalleled power: unique, strange, unforgettable, they do not lose their power of enchantment. So how can we know Toyen . . . we know her most intimately through her art, her work . . . her surrealist desire at play.

A magnificent book has come out by Derek Sayer, *Prague, Capital of the Twentieth Century, A Surrealist History*. My main criticism is that there is not more on Toyen. Malynne Sternstein has published fine work on Toyen that should not be neglected. And one of the few things I did find on the internet was some fine writing by Karla Huebner, including an article on Toyen and Queer Theory. Toyen would not have thought of herself in those terms but as a surrealist and a sex rebel she would most likely be glad to be counted in that number.

Earthly Visions: From Grant's Tomb to the Emerald Tablet, San Francisco

From Grant's Tomb to the Emerald Tablet may seem a long way. But it is just a couple of blocks. In San Francisco, that is. For me, San Francisco was a surprise. As I left Chicago the first spikes of green were poking up through Chicago whiteness. . . Suddenly it was spring. That's how I think of San Francisco. Spring! San Francisco is City Lights Bookstore and the Pied Piper Bar & Grill; 24th Street and Bernal Heights; Mechanics' Institute Chess Room and the waterfront. Countless other oddball places. It is more beautiful than the French Riviera. Lawrence Ferlinghetti is there and has made it the "Poetry Capital of the World," and Nancy Joyce Peters who came to the World Surrealist Exhibition in 1976 and wrote a great piece on "Women and Surrealism." Diane di Prima reads her powerful poems. A series of pictures in my mind. . .

Friends put together an exhibition. *Insect Music* is what Winston Smith, Dennis Cunningham, and I called our show of surrealist collage and found-object sculpture at Grant's Tomb in 2012. It was a festival of collage! Each of us embodied creative energy in our own way. That is the incredible power of collage. How to describe the brilliance of Winston Smith's collages? One of the greatest collagists ever, his works embody, without effort, warm humor and yet black humor, *détournement* and plastic fantasy. Collages of the "happy people" of the 1950s combine with images and titles that shock one's sensibility. Winston hardly needs to be celebrated, since his collages have graced the covers of Dead Kennedys albums. Perhaps the most magnificent of his works so far is the piece entitled *Happy Birthday, Christ*. This is Winston's *détournement* of Da Vinci's *Last Supper*. A birthday cake sits in front of Christ; Eskimos, giraffes, monkeys cavort as guests. . . I can only compare it to Picasso's *Guernica* . . . but it is not a work of pain; it is a work of joy at play.

Dennis Cunningham, more famous for his work as an attorney,

defender of Black Panthers, Judi Bari, and Attica prisoners, brought his assemblages of Found Objects. His creatures are not intellectual abstractions, not cold and remote, as much sculpture is; his creatures are personal, humorous, beautiful. Like life, they have plenty of rough edges, like living beings they long for each other's company. To be with them is to be possessed by good demons . . . *eudaemonia*. Their presence inspires, protects, and brings good fortune.

My work consisted of insects with music. Perhaps it has something to do with my fondness for cicadas. Lighthearted adventure provokes thoughts on "sizeism," that is, relative scale and the different worlds that exist all around us. A Pluriverse. These characters seldom have a chance to meet or interact except in collage, and certainly not as equals. A salamander and Marilyn Monroe, a praying mantis and the Empire State Building. Inspired in part by the trance music of insects on a hot summer's day, distractedly playing with fragments of images from magazines—most of them leftover pieces from other collages—I pasted some bug parts on a page of old sheet music. I was immediately surprised by the curiously choreographic interaction of the color cut-outs and their new environment: the silent-sound of printed musical notation. The sheet music I used was simply "found music," with no relationship to the work. But a relationship developed. The abundance of notes, so static when viewed by themselves, began vibrating as soon as figures were set on them. Radiant black beauty, these notes reminded me of ants, and appealed to my love for the formidable civilizations of the social insects. These bits and scraps—parts of insects, fish, fungi, feathers—formed a branched chain of essences, snake-dancing their way through the musical maze.

Around the corner from City Lights Bookstore, I found the Emerald Tablet, celebrated by alchemists. I had been searching for it for decades. I expected to find it in Egypt, buried in the shifting sands of time. But here it was in a San Francisco alley. A modest door opened onto a large room. What a place for a surrealist show! It had to be. We called the show *Surrealism's Earthly Visions: Carnivorous Flowers of Volcanic Thought*. The title was from Philip Lamantia's *Meadowlark West*. Philip knew the secret of hermetic transformations. He used it in his language.

Beth Garon joined us in this show. Beth, part of the Chicago

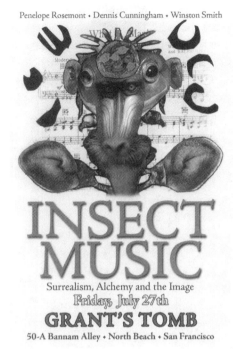

Penelope Rosemont • Dennis Cunningham • Winston Smith

INSECT MUSIC

Surrealism, Alchemy and the Image

Friday, July 27th

GRANT'S TOMB

50-A Bannam Alley • North Beach • San Francisco

*Exhibition in
San Francisco including
Penelope Rosemont,
Winston Smith, and
Dennis Cunningham, 2016*

Surrealist Group, has long practiced, and been inspired by, collage. There is a wildness to her work, running horses, flying flamingoes, gliding squirrels. She has written a manifesto in defense of squirrels. And co-authored a book with Paul Garon, *Woman with Guitar: Memphis Minnie's Blues.*

Marvels can be created with the materials at hand, those objects and images manufactured and rejected by the society of the spectacle in its never-ending cycle. Collage restores the sense of wonder, the connection with the marvelous. By creating a new balance, we refresh our minds. Not only can we liberate these images and objects, we must imagine, and we must create a liberated future. Giving new life to what is cast aside.

We were also joined by Marian Wallace, known for her dreamy, ethereal underwater scenes. Marian has made a wide variety of experimental films. She is part of RE/Search and the producer of San Francisco's Counter Culture Hour. Collage is evident in Marian's films.

Collage lends itself to group activity; doing collages with a group of surrealist friends and a stack of old magazines can be so much fun nobody wants to go home. I remember our friend Robert Green always getting lost in the articles on animals and occasionally announcing, "Did you know that Octopi can turn colors or that male seahorses carry the young in a pouch?" Sometimes I wish I had written down each animal and the origin of each piece. A taste of Proust . . . the complex layers of pieces, their past lives. Moments intersect in the collage and give it a layered history.

Some are pieces are recognizable, Chevrolet and Satan; Marilyn Monroe, and Charlie McCarthy; Tiger and pitch-fork; skull and salad bowl . . . but usually these elements are overcome by the personality of the resulting being or image. Arcimboldo's embrace! In Paris surrealists invented a game of Parallel Collage. The group was working with the identical materials, yet everyone's collage came out differently.

In a collage, the created image provokes a story, a mystery, a history that we recreate in our own mind as we view it.

Just as photography destroyed realistic painting, collage will surpass photography. Disquieting. We search for mental clues to the secrets of these images.

Somehow I seem to suffer from an insatiable hunger for images. Is that me, is it a symptom of the Times? Or is it all of us?

Leonora Carrington, and the Lion and the Unicorn in the Theater of Analogy: Chicago

"It is the task of the right eye peer into the telescope, while the left eye peers into the microscope."

—Leonora Carrington

"Art is the imagery of the potential appearing in the established universe of existence."

—Herbert Marcuse

Smoke in the air. Sirens howling. Fire engines careening around corners. Ambulances arriving. Fire hoses lying in the street. (This is the block I'm looking for.) Access is blocked by barricades. I drive around and approach from the south. Cordoned off. I have an appointment to meet Leonora Carrington; it will be the first time I have seen her since 1970. Is she in a burning building? I park the car and push my way through gawkers and police . . . Her building is across the street from the fire . . . Relief.

Vintage 1930s with a once very fashionable lobby. Now, though lovely, there is no longer water in the fountain. Up a staircase, I hear a conversation in English, Spanish and French . . . it has to be Leonora.

And it is, talking with a woman who has come over to help arrange things. Leonora is always arranging and re-arranging, the small apartment neat as a pin. Light-colored walls with nothing on them. A couch. An easel. A fireplace. There, standing in the middle of the room, with a stately presence is Leonora saying goodbye to her helper and hello to Franklin and me. She apparently has not noticed the chaos out in front.

In a small bright kitchen we settle down for some tea. There is a period of catching up: Leonora is here because her son Pablo,

his wife Wendy and their two sons are currently living in Oak Park. Pablo Weiss-Carrington is a research scientist (and also is a surrealist painter). Leonora quickly dismisses his scientific career and makes it known that he has a wonderful potential, "if only he would stick to the important things in life: surrealist painting and writing." That's what's truly important: imagination and creation. Not the typical practically oriented Mother.

Leonora has been living in New York and has a gallery there, the Brewster Gallery. She fled New York on the eve of an exhibition that a gallery was doing of her work. She did not want to attend. She is an odd combination of bold and withdrawn. She tells us outright, "Don't ask me about Max Ernst!"

Twenty-some years ago, I showed up at her house in Mexico City with Franklin Rosemont and a copy of *Arsenal: Surrealist Subversion*. We were there on a quest to meet Leonora and visit the magnificent Mayan cities, lost in the Yucatán. This is the same year that the solution to reading the Mayan glyphs was suggested at a meeting in Palenque. In 1972 we published with Leonora's permission her autobiographical *Down Below*; since then we put together a World Surrealist Exhibition; a section of *City Lights Journal*; and, published by City Lights, *Free Spirits*. We are now working with Charles H. Kerr Publishing Company. We've kept busy. We've sent her books, letters and surrealist postcards signed by our Chicago group.

I ask Leonora if she has been painting and she seats us in the living room facing the easel and goes to a side room, brings out a painting and sets it on the easel in front of us. It is quite wonderful, it is done in shades of gold and brown. Leonora announces that this is the under-painting and explains she works in a classic method that gives the colors special depth and luminosity. She mentions she often mixes egg tempera. And says Wendy is photographing the painting in its progress. One I remember well is a lone skater she painted in the winter. Asked why there were none of her paintings on the wall, she answers, "It's better that way, I get lonesome and feel the need for company." So you see she lives with creatures she creates. A very remarkable and surrealist way of living. A reordering of the world akin to Bosch but uniquely Leonora.

We come out to Oak Park every Tuesday and occasionally on

Penelope Rosemont & Leonora Carrington, "No Blood for Oil" demonstration. Chicago, 1992

the weekend to do our typesetting for the Charles H. Kerr Publishing Co. At this point in history, the new typesetting equipment cost over $100,000 so we are sharing with the *Wednesday Journal*, an Oak Park weekly newspaper edited by Dan Haley. It's just a couple of blocks north of Leonora's apartment. We would often dine together at a deli near there. Leonora would always buy cigarettes on the way and smoke at the restaurant, but her home never smelled of smoke. I got the impression she did it only when she went to a restaurant, perhaps to project a sophisticated image. She would wear a short purple coat stuffed with down. And she took driving lessons from a driving school. Her photo was published in the local newspaper as one of the oldest persons to take up diving for the first time and pass the test. She said, "What if I just feel like driving off someday and never coming back!"

Oak Park is one of Chicago's western suburbs—famous for

Frank Lloyd Wright, Ernest Hemingway, Percy Julian, and Edgar Rice Burroughs. I especially like Burroughs because of his far-reaching imagination, he wrote his planet Mars novels while working in his office at Sears, Roebuck and Company in Chicago. (In these novels he humorously mocked religion, another plus.) The Chicago Metra actually has a stop called Mars, so it is one of the few places where you can easily commute to Mars and hear "Next stop, Mars!" (Mars Candy is located there.)

On the way out to Oak Park we often stopped to see our 80-year-old friend Jenny Velsek. Jenny also an odd combination of withdrawn and bold was a staunch "One Big Union" supporter. An IWW militant, she was Finnish from Minnesota and had gone to the IWW's Work Peoples College. She'd often say, "I wish I'd been a man!" Then we'd visit Leonora. Who also felt confined by the role of "woman." It was a treat to see them both. Two women who had chosen their own paths. But then getting to work typesetting required much coffee from the all-night White Hen Pantry. And either a late-night drive home down North Avenue or the CTA Green Line transfer to Red Line.

Leonora often told me, "If you want to meet people you must travel alone." She told us about a trip she took by herself, mind you she is around 75, from New York to Mexico City by bus. She didn't like to fly very much. "You arrive too quickly." There was a stop in Texas, maybe Amarillo. She said the place was surrounded by parked motorcycles and when she walked inside there were men in black leather jackets. But also, at the same time, a convention of bagpipe players going on wearing plaids and kilts with their knees showing. Bagpipes screaming. I had to laugh, not what you would expect in Texas. Somehow it seemed only Leonora could find such a place.

Leonora made a feminist out of me. She made it a point to ask Debra Taub, Gina Litherland, Beth Garon and me if we were feminists? We all hedged, said that we considered ourselves surrealists not feminists. Leonora defended feminism, "One doesn't always think of oneself as a woman, one thinks of oneself as a human being among other

human beings but when a man sees you, he says: 'There goes that woman!' So realize you're a woman, whether you like it or not." She affirmed the need for autonomous women's organizations, and defended women's direct action against sexism (she herself has engaged in such activity).

I thought about it, she was right. One of my very favorite surrealist texts, one I read in public whenever I get the chance is her piece, "What is a woman?" Brilliant. It always gives me a feeling of exhilaration.

We talked about the 1968 massacre of students in Mexico City. She had left then. Friends said it was not safe. Got on the first plane she and her children could get on. It was headed for Chicago. Unrest there also. What was going on? But she met friends and stayed until things calmed down. Her friend Octavio Paz, who was a diplomat for the Mexican government, resigned because of his government's repressive action.

Leonora had an interesting circle of friends in Mexico City: Octavio Paz, great poet and diplomat; Edward James, supposed-royal eccentric; Benjamin Péret, friend of André Breton and Trotskyist; Remedios Varo, wonderful painter who she dearly loved, missed and talked about quite often.

Busy describing Péret, and talking about him and his Trotskyist friends, she said, "Péret would get together with his two or three friends and plot to overthrow the entire world!"

Then, she stopped suddenly and hesitated for a moment, "Hmmm, that's sort of what we all do, isn't it!" And it truly is, especially for surrealists—"Transform the World, Change Life."

Leonora liked popular science magazines and always bought the new issues. Sometimes we talked about the exploration of the planets, which interested us both. But she was also interested in Carl Jung and his version of psychoanalysis. Most of the members of the Chicago Surrealist Group did not care for Jung. We read Edward Glover's book *Freud or Jung* and thought Jung was a step backwards toward an unscientific approach and a return of religion. But Leonora asked

me to accompany her to a meeting of a Jung group in Oak Park. I did. Largely because I enjoyed her company.

A young woman got up at the meeting and said somewhat hysterically, that she was having trouble concentrating: finishing college and taking care of her three-year-old. (To me, this looked like a problem that could be solved by a babysitter.) But the Jungian expert announced, "This is a conflict between your Hera and your Athena! Between the goddess of the hearth and the goddess of knowledge, a serious problem, the two goddesses are at war!" "Oh, yes! Cried the young woman, "that's exactly it!" She was advised to find a way to make peace between the goddesses. (Or, perhaps, she could have just sacrificed the three-year-old to the Gods.)

I laughed. Leonora was not amused. Thinking about it, I realized she loved the stories of the old Greek gods and was happy to hear their names. She was not religious. As far as whether it helped the young woman . . . perhaps just a little attention and recognition helped.

Leonora also liked the Jungian idea that our sexual persona is the opposite of our actual manifested sex. Thus, women are really masculine thinkers and men really feminine thinkers. And this was a key to dealing with men, especially. I wasn't sure I agreed here but it is certain that we contain both masculine and feminine. In fact, it is crowded in the mind. We contain multitudes.

Leonora had grown up with brothers. She considered that they were greatly favored over her. She loved to ride horses and was competitive with her brothers. Leonora and Pablo, Wendy and the boys drove to my house in Rogers Park. We were all sitting in the living room when one of the boys pointed a green toy gun at the other and said, "Bang! I shoot you!" Leonora looked at him and strictly said, "Never point a gun at anyone! I know. I shot my brother once!"

"Oh," I said, "that's too bad, it was an accident of course. Was he badly hurt?" Leonora replied, "I shot him on purpose. I shot him in the ass and he couldn't get up for a week."

A bit of stunned silence. No comment from anyone. . . . As Beth Garon has put it, "Leonora was not your usual grandmother!" Though she did dearly love the boys and loved being with them. Could be this got her sent to boarding school.

During that time we put out an issue of *Cultural Correspondence*

with Paul Buhle; an Anti-Columbus 1492–1992 manifesto; a "Rivers Revenge" leaflet; a newspaper, "What are you going to do about it?"; a Gulf War flier, "War is the Happy Hour of Those Drunk on Power." The Gulf War had begun; it was a sub-zero winter day and some of the Surrealist Group, including Leonora Carrington, decided to go to downtown Chicago for a big "No blood for oil!" demonstration. We didn't have our own banners but took what was there and marched . . . until we turned blue. Beth Garon wore earmuffs. It was bitterly cold. Then we went to a café to warm up. Robert Green and Debra Taub picked up Leonora and took her home. We had high hopes. Who would think an endless war would follow.

Our magazine/anthology *Arsenal* had been a long time coming. In February, Pablo brought Leonora and his family to our party for *Arsenal* (1989) at Powell's Bookstore in Lincoln Park. We celebrated with music by AACM jazz greats Hamid Drake, Douglas Ewart and Light Henry Huff. Carole Travis, an old friend from Lake Forest College, showed up and was photographed with us, Carole, avant-garde and intellectual, always found her way to unusual places and things; she could talk about surrealism or Chaos theory or the Brotherhood of Locomotive Engineers of which she was President. Leonora took the opportunity to urge Paul Garon to talk with Pablo, "Can't you do something to get him to realize that he should forget his scientific career and take up painting . . . "

I wrote about the folk tale of the Golden Goose for *Arsenal* and a piece entitled "Revolution by Chance." We finally published our 1971 correspondence with Herbert Marcuse on surrealism. Marcuse seemed to be describing Leonora and her concerns when he said, "Surrealism invokes an infinitely richer, denser universe, where people, things, nature are stripped of their false familiar appearance. It is an uncanny universe, for what could be more disturbing than to discover that we live under the law of another, unfamiliar, repressed causality. . . ."

And Nancy Joyce Peters describes Leonora's work with a keen insight in her wonderful essay "Surrealism and Women" (*Arsenal* 1989). She writes, "Leonora Carrington raises the curtain of an analogical theater, on whose stage wondrous beings enact dramas that expose psychic realities behind physical ones. They have a great

range, some evoking a sort of gnawing domestic anxiety, and others, the terrible beauties of theophany. Flames consume Giordano Bruno watched over by a unicorn and lion bearing alchemical symbols on their brows." With insight Peters continues, "We witness, in a pre-Christian world celebrations of mysteries, feasts that suggest rebirth and spiritual metamorphosis. Masks which hide the face, and sometimes the entire body, imply a synesthesia of the senses; and a visionary eye gazes at realities that lie behind experiences."

In Leonora's essay also in *Arsenal*, the "Cabbage is a Rose," she wrote, "Most of us, I hope are now aware that a woman should not have to demand Rights. The Rights were there from the beginning: they must be taken back again, including the Mysteries which were ours and which were violated, stolen or destroyed, leaving us with the thankless hope of pleasing a male animal, probably one of our own species." Her profound and allegorical painting the *Naked Truth* was included.

Asked what she thought of *Arsenal*, Leonora said she didn't agree with everything in *Arsenal*, but agreed with most of it. Basically, she said, "it made her happy to feel that she was with friends again for the first time in a long while." She was there celebrating with us and we were joyful that she was there. It made our event very special.

1963, Franklin Rosemont and Lawrence DeCoster had hitchhiked to Mexico City to search for Leonora Carrington and surrealists. They found Benjamin Péret was dead; Octavio Paz was in New Delhi, but they did find Leonora. They charmed me with a picture drawn in words, of Leonora multitasking, at the same time carrying on multilingually. The friends in Mexico mentioned Claude Tarnaud and Nicolas Calas in New York; so they soon headed east and made it a point to meet them. Tarnaud was in touch with Breton and the Paris surrealists and this is how we found the group. The letter that Tarnaud wrote to Robert Benayoun was published in *La Brèche* of the visit of the two young surrealists.

In 1970, I traveled to Mexico City to meet Leonora. We arrived at her house and she was there in the kitchen at work on at least three projects at once and speaking three languages. She greeted us and called Pablo and Gabriel to meet us. They knew of our magazine *Arsenal/Surrealist Subversion* but they had trouble believing it

was us who had produced it . . . we were way too young. Leonora told us we could wander through the house to look at her paintings and we did. It was arranged on three floors with rooms that opened onto an internal court in the Spanish style. The rooms sparsely furnished looked cool in the Mexico City heat. In fact, the internal court cooled the house quite efficiently.

The pale walls were bare except for the large paintings by Leonora. Paintings featuring images, colors, rituals that drew you in. So that finally you noticed that you had been standing there for quite a long time trying to fit yourself into that world the painting had created, that mood, that moment. If there is magic that is it! Time is stopped. Attention riveted.

We bid Leonora goodbye, feeling we knew her very well and at the same time we realized she too had looked into us and knew us. She commented on how "special it was for surrealists to meet surrealists . . . always like finding again an old friend. Even if you have never met before."

We headed next to see the ruins of the great Mayan Civilization. Not long ago I wrote about it in my essay *Lost Worlds, Forgotten Futures, Undreamed Ecstasies: Some Thoughts on the Relationship of Surrealism to the Mayan Millennium & to each his own Pluriverse.* I stopped to meet a deadline, otherwise I might still be writing, researching and exploring that alternate world.

"I never read anything anyone writes about me. I can't stand it."

Leonora was visited by British TV; in their documentary, they said Leonora Carrington, daughter of richest man in the world, was living in a slum. Oak Park, Leonora's building, was not slum . . . In many ways it was an ideal place, a suburban paradise with small shops and good restaurants, summer festivals, not too far from downtown Chicago. It housed surrealist art collector Joseph Shapiro who founded and funded the Museum of Contemporary Art and who also was a friend of Leonora. He sometimes gave things to a small bookshop there and I got a few surrealist items.

Leonora was one of the first surrealists I read when I was coming to surrealism. A few of her stories and *Down Below* were available in English. In 1964 there was not very much surrealist material available in English; one of the tasks I set myself was to make more

available. Thus we started the Surrealist monograph series (my idea with Paul Garon to call it the "Surrealist Research & Development Monograph Series") and published Carrington's *Down Below*, Paul Nougé's *Music is Dangerous*, Toyen's *Specters of the Desert* in small editions. We sold them at our bookshop on Armitage Avenue and Barbara's Bookstore, the best independent bookstore in the Midwest, on Wells Street, the avant-garde City Lights in San Francisco and even Gotham Bookstore in New York a fortress of surrealist books that Franklin and Larry visited with Claude Tarnaud—he bought surrealist books for them, actually loaded them down with surrealist books including *La Brèche*.

I have mentioned the *Down Below*, but it is so very important in the field of exploration of the mind. Here is a young woman in a time of crisis subjected to what amounts to torture in the name of curing her. But thanks to her imagination and the strength of will she finds in herself, she manages to escape "the cure" aimed at making her into a normal boring person and becomes a great painter and writer.

Later in life Carrington confronted the problem of aging and came out with a book that had a wide influence, *The Hearing Trumpet*, and she has also written a play *Penelope* that brought us closer as that is my name.

On several occasions she expressed a nostalgia for the 1960s. "What an amazing decade! All of a sudden there was a completely different spirit in the air—a spirit of hopefulness and enthusiasm—and people felt it everywhere, all over the world!" Sixties politics were "a very different kind of politics, accenting generosity, spontaneity, humor, and having fun."

"But where are all the sixties radicals now!" she asked, rhetorically, and answered: "They've all joined the IRS!"

Discussing the sixties often made her reflect on her own youth. "When I was young," she told us, "my friends and I were sure we were going to change the world."

"And to a great extent," I said, "you did." I was thinking of the profound effect of surrealism on everything visual and more. . . .

"You're very generous," said Leonora, obviously skeptical. But a little later she added: "I do believe small groups can have an impact all out of proportion to their numbers."

At that point we showed her some of the Chicago Surrealist Group leaflets. She had lent illustrations to our zoo leaflet *The Anteater's Umbrella* and was pleased with it. She also enjoyed the recent tracts—especially "A River's Revenge" (on Chicago's 1992 "flood"). And responded, "Every action, even the smallest, has an effect."

A radical environmentalist, during her stay in the Chicago area, she was a supporter of Chicago Earth First! (in which the entire Surrealist Group was quite active). She particularly liked not only to preserve existing wilderness, but also to expand wilderness, by dismantling highways, malls and other cement-blighted areas and letting the wild take over.

A happy moment in Oak Park was encountering a foraging raccoon at night in an alley. Leonora considered this a privileged encounter, with magical significance, and the raccoon soon found its way into one of her paintings. A dog with a black spot over his eye, she said, "You know him?" "How would we know him?" I replied. "He's on TV, he's Spuds MacKenzie!" and so Spuds was rescued from the world of advertising, from the world of commodities, and installed proudly in our imaginations. Surrealism steals from the real and finds the imaginative core.

Farley Mowat's *Never Cry Wolf* is a favorite book we all shared. She expressed an interest in the "special knowledge" possessed by birds and other wild creatures, and wondered how we might learn to share that knowledge. She said the Earth is a living being, and that until people realize this basic truth, and act accordingly, they will continue to destroy the planet and their own lives. She denounced the mining industry for maiming the Earth's flesh, the electric utility for plundering the Earth's nervous system and the oil industry for draining the Earth's blood. Oil is the blood of Earth.

Leonora admired the Gnostics for their acute awareness of being "alien," misfits in the social regime. Leonora always regarded herself as an "alien"—outside and against the existing order. One day when she received her Green Card from the Immigration and Naturalization Service, she announced with astonishment that she was pleased to be informed that she was now a "registered alien."

Over the years Leonora "dabbled" (her word) in several other religions and cults. Said she: "Most mothers worry about their children joining some "cult," but with me, it has always been just the opposite; my sons are always worried about which crackpot group their mother is going to join next." She doesn't join as a "believer"— though sometimes she has tried, in the spirit of "let's pretend," but she joins rather as an explorer and seeker of images. In any event, her experiences as an experimental religious devotee have not been pleasant. She denounced gurus she encountered as "hideously sexist," in spite of their vegetarianism and avowed compassion for all sentient beings. She felt they had nothing but contempt for animals, especially those with six or more legs. Staying with a Buddhist order she found her room full of cockroaches. She complained. In reply she was told, "You may buy, poison and kill them if you wish, but I cannot." Her comment, "He didn't care one bit if my soul went to Hell for killing the bugs, after all I was just a woman."

According to Carrington, a hateful aspect of religions (all religions) is that "they try to monopolize the world of the imagination, the marvelous." (One of her best friends Benjamin Péret is well-known for the photo of him insulting a priest. He also wrote an essay, "Magic: The Flesh and Blood of Poetry.") As Carrington sees it, mental blockades erected by religions are self-defeating, cutting people off from the deepest part of their being; religion exacerbates the fragmentation of human life and society.

Exploration of the world of imagination and the expansion of our awareness of that world and its relation to what we call reality has long been pursued by true poets and artists, and are among the tasks the surrealists assigned themselves from the start. "To make discoveries," she once put it, "it is necessary to establish friendly relations with the sordid part of oneself."

In the 1950s and early '60s, her good friend was the Spanish-born painter Remedios Varo, who had joined the surrealist movement in 1937 (the same year as Leonora), and who, like Leonora, settled in Mexico during the war. As she explained, "Remedios and I were very close, as you know. We did many things together. We discussed everything, told each other our dreams, conspired together in all kinds of ways. The two of us were practically a whole movement!

But after Remedios died [in 1963], I felt that surrealism was over, at least for me. I didn't know anyone else who shared any of the concerns Remedios and I shared. I felt terribly alone. I must say that meeting you and your friends has forced me to rethink a lot of things, and especially to rethink surrealism, and what surrealism could be today."

We discussed this topic ("surrealism today") over many weeks and months, with Leonora often assuming the role of devil's advocate. Once she said: "I hope I disagreed with you enough to make our discussion interesting." Eventually we agreed that what is alive in surrealism today, and will live a long time, is its radical questioning of all ideologies; refusal to conformism; exploration of the dark corners of the mind; expanding knowledge; ideas of discovering and developing new human relationships; play and danger; visions and dreams, and the pursuit of the image; love and laughter; and the scattered bones of chance.

One day as we arrived, she surprised us by announcing loudly: "I'm planning to start a great revolution"—and here she hesitated a moment to enjoy our surprise before completing the sentence: "in the way we think and feel."

One day when Leonora and I were talking about our childhood, I brought up that I had assembled a sort of survival kit of my favorite things and included some of what I considered necessities and kept it in a little suitcase; I think this was supposed to be a doll trunk but instead I deposited fossil coral that resembled a beehive filled with honey (found by me in Fox Lake); my favorite marble (resembled a small crystal ball and could be used as one); a post card of Crater Lake; a blue jay feather; some practical things like three safety pins, my swimsuit, a pencil, some colored pencils, small notebook, and a green-plastic pencil sharpener shaped like a dog; a pearl-handled pocket knife; an old key for I knew not what (maybe it was for a pirate's treasure chest); the comic book *Scrooge McDuck and the Seven Cities of Cibola*; etc. In case of emergency, or if I needed to run away from home, I could just put in a peanut butter sandwich and go.

Well, Leonora laughed and said, "Yes, I did that too. But what we really need now is a Surrealist Survival Kit," and we had much fun deciding what would go into our Surrealist Survival Kit.

She spoke frequently of the urgent need for this special piece of equipment, the "Surrealist Survival Kit"—which is described by Kenneth Cox in the wonderful book *What Will Be* (2014) as a "collection of poetic, magical, talismanic objects, images, and other 'favorite things.' A kit could include, for example: a pebble, a feather, a bird's egg, a piece of wood, a chunk of coral, a bead, a shell, a bit of colored glass, a painting the size of a postage-stamp, a poem by Benjamin Péret, a 'Let There Be Wolves!' sticker). Every item small enough to keep in a cloth sack children kept marbles in.

"Its purpose: to offset the destructive effects of daily-life, to pull us through the hardest times, to reawaken our sense of wonder and to renew our capacity for dream and action. Designed to function symbolically; each would be different, for no two people are exactly alike.

"Overcome by demoralization and defeat, depressed or suicidal, then is the time to open one's "Surrealist Survival Kit" and enjoy a breath of magical fresh air. To lay out its marvelous contents carefully before oneself, one by one, and let the objects and images play together, arrange them, rearrange them, enter the play with them. Relaxing and soothing as well as exhilarating and reinvigorating. In other words, just what every surrealist needs."

"I don't have opinions," Leonora said one day, "I have questions."

A beautiful example of her questioning method is the text "What Is a Woman?" that we published in *Cultural Correspondence* (1981) and later in *Surrealist Women*. Here is a short excerpt:

> Fifty-three years ago I was born a female human animal. This, I was told, meant that I was a "Woman."
> But I never knew what they meant.
> Fall in love with a man and you will see. . . . I fell (several times), but saw not.
> Give birth and you will see. . . . I gave birth and did not know, who am I? Am I? Who?
> Am I that which I observe or that which observes me?

I am that I am, God the Father told Moses on the Mountain. This means nothing to me. *I am* may have been a dishonest invention meaning multitude. *Je pense donc je suis* [I think, therefore I am], but why? Some kind of pretension of Monsieur Descartes? If I am my thoughts, then I could be anything from chicken soup to a pair of scissors, a crocodile, a corpse, a leopard or a pint of beer.

Always wish our time together had been longer; Leonora had a profound effect on me. But I visit with her often through her painting and writings, her love of hyenas and horses, strange hybrid beings and the high hopes she had for us women.

twenty

Restless, Reckless Rendezvous
of Women Surrealists (A Fantasy)

This essay was written in reply to the SURREALIST ENQUIRY 2016.

Grandmother Moorhead's Aromatic Kitchen
(named after a painting by Leonora Carrington)

THE QUESTIONS

This enquiry has been devised by women for women in the international Surrealist movement. (The category "women" includes anyone who identifies as female.) Please forward it to any women in the movement you think we might have missed.

1. Imagine that there is a Surrealist meeting attended exclusively by women. There is no particular reason why—it just happened that way. Describe the meeting as vividly as you can.

2. Imagine that there is a Surrealist group that is made up entirely of women. There is no particular reason why—it just happened that way. Describe what the group will be like: what will we do, what games will we play, what discussions will we have, what adventures will we go on?

Your responses to these questions can take the form of texts, images or anything you like. There is one stipulation: in written responses, please refer to the women as "we," not as "they." This is to foster a consideration of women as subjects, at both individual and collective levels.

The results of the enquiry will be collated and distributed to all of the participants. It will of course be your choice whether to share them with your other Surrealist friends and comrades too. [The results were published on the Internet.]

Merl Fluin & Emma Lundenmark, Stockholm, November 2015

Very difficult to think in the abstract, my mind rushes to fill vacancy with surrealist women I know and love. First, I think of meeting at the home of Leonora Carrington on Oak Park Avenue which often happened in the clear, cold white Chicago winter, winter like living inside a crystal. Leonora, with always a warm welcome and hot soup ready . . . pokes around in her kitchen in a purple sweater, making food or art or both at the same time. We just about get settled when Mary Low strides boldly in, in cowboy boots, and gives big hugs all around. In the cozy room with fireplace, Beth Garon, Gale Ahrens, Debra Taub, Nancy Joyce Peters, Kate Khatib and Jayne Cortez . . . (some never will meet, but we know and recognize each other through our works, our choice: surrealism).

The group is lively with plans. We want to hold a Surrealist Women's gathering. Some of us resist a bit, saying that we don't actually think of ourselves as women, that is for "bourgeois feminism." But Leonora laughs and says, "Oh, you think of yourself as a human being just like a man . . . that's just an illusion. When a man sees you go by, he says to himself, 'There goes that woman!'"

There are mild protests but we all realize it is true, that we are not just like men; we defer to men, out of habit, out of love. We like to watch them show off for us. Here together though, we feel freer to express ourselves, even if men are sometimes on our minds.

Mary Low who was organizer of the Women's Militia in Spain says, "The transformation of the young women who joined the militia was amazing; they were meek and frightened and isolated in their homes. Then, every day we met and practiced and every day they grew stronger and happier. It gave them self-confidence and hope. They found friends. They discovered themselves."

Thinking of war, Leonora says, "You have to be careful with guns, where you point them, I shot my brother in the ass with a rifle . . . "

I quickly said, "Oh, but it was an accident!" She replied, "No, I meant to shoot him, I didn't like him. . . . He survived, of course, but he couldn't sit down for quite a while." This incident probably got Leonora sent to boarding school.

Leonora had several brothers so she probably understood and experienced the unequal treatment more than I, an only child.

She calls technology "man's brainy toys" and says "we are passively allowing ourselves to be devoured by our own teddy bears . . .

it's time to take away the teddy bears and other obnoxious toys that threaten to turn the nursery into a tomb."

Jayne is here from New York and brings her book of poems *Mouth on Paper*. Jayne tells you what you don't want to hear, about the sorrows of Black Americans and the violence of the world, but she says it so beautifully it transforms into the Marvelous. She recites a few lines from a poem she is working on, "Sacred Trees." (As far as I'm concerned this is the most beautiful poem ever written in the U.S.)

Leonora shows us a painting she is working on of a lone skater. I remember when her canvases were crowded and I know she misses her friend Remedios Varo and the surrealists she was always close to. She says she has signed up for driving lessons. This actually makes the newspaper.

Nancy Joyce Peters, our philosopher, adds that "Women's emancipation requires a massive transformation of erotic dynamics, a psychic and social revolution scarcely yet imagined, essential if we are to survive."

Debra says, "We could try to express it with dance . . . with dance comes freedom and erotic joy. We could put together some dances."

Gale Ahrens who initiated our "Defense of the Moon" and wrote the draft of our Gulf Oil Spill manifesto insists we be militant in our defense of the planet. Send our manifestoes out to the news media. Beth Garon mentions squirrels, small animals most of us take for granted, yet have important roles, "I will write a manifesto defending them: 'Hail squirrels, generous, forgiving reforesters of the city, the town, the wilds'. . . . Let our voices be heard."

Kate Khatib has taken time off from her writing and Red Emmas Bookstore in Baltimore. Kate is passionate about surrealism and an amazing organizer.

We plan a special outing to get together and celebrate our wonderful planet and her creatures. We decide on Denman Island in western Canada and let Sheila Nopper be our organizer. Sheila does a great collage poster. We spend the day outside, swim early in the morning in Chickadee Lake. Tinglet women greet us, opening our gathering with song, drum and dance. We join them in dancing.

We talk about collage, painting, photography sculpture and experiments, about movement, dance, memory and an end to

*Penelope
Rosemont at an
exhibition Chicago
Surrealism organized
to celebrate the 100th
Anniversary of Dada.
Photo: Dan Godson*

religion. We write fiery manifestoes on behalf of the human and natural world.

Rikki Ducornet has come and she takes us on a tour of the forest; ferns, flowers, and plants seem to wave to her and part to let her pass. She calls them by name. Diane di Prima sends her best greetings.

In the evening we dine, read poems, dance, play. Jayne reads, "Every time I think about us women I think about the trees, escaping from an epidemic of lightening, the raped trees flashing signals through the toxic acid of sucking insects. . . ."

The late hours are filled with trance music, we recline with our friends and lovers . . . male, female or other . . . whatever gives pleasure. We wait eagerly for the arrival of our surrealist friends from England, Sweden, Prague, Tokyo, Moscow, Cairo, Quito, Veracruz, Terra del Fuego, Dar es Salaam; we know they will be here, but we just don't know when. It will be beautiful.

Flier for the exhibition Revolution Imagination: Chicago Surrealism from Object to Activism *(2018).*

The Magnetic Fields, Cinema, and the Penetrating Light of the Total Eclipse

The translations from André Breton and Philippe Soupault's *Les Champs magnétiques* (*The Magnetic Fields*) (1920) and other texts are by Penelope Rosemont.

My Days in the Mimeo Revolution

This text was written for the international conference at the University of Westminster *The Art of the Mimeograph* (February 8–9, 2019) and the Bruce Castle Museum show *The Art of the Gestetner* (September 29, 2018–January 31, 2019), staged by the Scots art group Alt Går Bra.

Paris Days – Winter to Spring

This text appeared in Penelope Rosemont's memoir *Dreams & Everyday Life: André Breton, Surrealism, Rebel Worker, SDS & the Seven Cities of Cibola* (Chicago: Charles H. Kerr, 2008), pages 47–119, 146–147.

Chicago: Maxwell Street in the Sixties

This text appeared as "Maxwell Street in the Sixties" in Penelope Rosemont's essay collection *Surrealist Experiences: 1001 Dawns, 221 Midnights* (Chicago: Black Swan, 2000), pages 41–46.

For a film about Maxwell Street in the 1960s, see *And This Is Free*, directed by Mike Shea (1965; Newton, NJ: Shanachie Entertainment, 2008), DVD.

Toyen and *The Sleeping Girl*

This text appeared as "Toyen" in *Surrealist Experiences: 1001 Dawns, 221 Midnights*, pages 51–57.

André Breton. "Introduction to the Work of Toyen," *Surrealism and Painting*. New York: Harper & Row, 1975.
André Breton, Jindrich Heisler, and Benjamin Péret. *Toyen*. Paris: Editions Sokolova, 1953.
Radovan Ivsic. *Toyen*. Paris: Filipacchi, 1974.
Penelope Rosemont, ed. *Surrealist Women: An International Anthology*. Austin, TX: University of Texas Press, 1998.
Toyen. *Specters of the Desert* (1939). Surrealist Research & Development Monograph Series. Chicago: Black Swan Press, 1974.
Ragnar von Holten. *Toyen*. Koping: Lindfors Verlag, 1984.

The Hermetic Windows of Joseph Cornell

This text appeared in *Surrealist Experiences: 1001 Dawns, 221 Midnights*, pages 62–65.

Joseph Cornell. "Enchanted Wanderer: Excerpt from a Journey Album for Hedy Lamarr," in *View*, 1st series, No. 9–10, December 1941/January 1942.

Joseph Cornell. "Story Without a Name—For Max Ernst," in *View*, 2nd series, No. 1, April 1942.

Joseph Cornell. Various contributions to the "American Fantastica" issue, in *View*, 2nd series, No. 4, January 1943.

Joseph Cornell. "Monsieur Phot," in Julien Levy, *Surrealism*. New York: Black Sun Press, 1936.

John Maxson Stillman. *The History of Alchemy and Early Chemistry* (1924). New York: Dover, 1960.

Citizen Train Defends the Haymarket Anarchists

This text appeared in *Surrealist Experiences: 1001 Dawns, 221 Midnights*, pages 68–71.

Paul Avrich. *The Haymarket Tragedy*. Princeton, NJ: Princeton University Press, 1984.

Henry David. *The History of the Haymarket Affair*. New York: Russell & Russell, 1958.

Edward P. Mitchell. *Memoirs of an Editor*. New York: Scribner's, 1924.

Daniel E. and Annette Potts. *A Yankee Merchant in Goldrush Australia*. Melbourne: Heinemann, 1970.

Robert Riegel. *American Feminists*. Lawrence, KS: University of Kansas Press, 1968.

David R. Roediger and Franklin Rosemont, eds. *Haymarket Scrapbook*. Chicago: Charles H. Kerr, 1986.

Don C. Seitz. *Uncommon Americans*. Indianapolis, IN: Bobbs-Merrill, 1925.

Willis Thornton. *The Nine Lives of Citizen Train*. New York: Greenberg, 1948.

George Francis Train. *My Life in Many States and in Foreign Lands*. New York: Appleton, 1902.

Irving Wallace. *The Square Pegs*. New York: Knopf, 1957.

Mary MacLane, A Daughter of Butte, MT

This text appeared as "Marvelous Mary MacLane" in *Surrealist Experiences: 1001 Dawns, 221 Midnights*, pages 74–80.

Sherwood Anderson. *Memoirs*. New York: Harcourt, Brace, 1942.

Gertrude Atherton. *Adventures of a Novelist*. New York: Liveright, 1932.

Tiffany Blake. "Sidelights on Case of Mary MacLane." *Chicago Evening Post*, May 17, 1902.

André Breton and Paul Éluard. "Notes sur la poésie," in Breton, *Oeuvres complètes* I. Paris: Gallimard, 1988.

Clarence Darrow. "*Story of Mary MacLane* Little Short of a Miracle, Says Darrow," *Chicago American*, May 4, 1902.

Lawrence Ferlinghetti and Nancy Joyce Peters. *Literary San Francisco*. San Francisco: City Lights Books and Harper & Row, 1980.

Henry Blake Fuller. "An Extraordinary Book," *Chicago Evening Post*, April 26, 1902.

Henry Blake Fuller. "Unquenchable Fires," *The Dial*, May 3, 1917.

Hamlin Garland. *Companions on the Trail*. New York: Macmillan, 1931.

Thomas J. Hagerty. "Socialism vs. Fads," *International Socialist Review*. Chicago: Charles H. Kerr, February 1903.

"Have You Read the Story of Mary MacLane?" Advertisement in *Chicago Evening Post*, May 24, 1902.

Mary MacLane. *The Story of Mary MacLane*. Chicago: Herbert S. Stone, 1902.

Mary MacLane. *My Friend Annabel Lee*. Chicago: Herbert S. Stone, 1903.

Mary MacLane. *I, Mary MacLane*. New York: Frederick A. Stokes, 1917.

Carolyn J. Mattern. "Mary MacLane: A Feminist Opinion," *Montana: The Magazine of Western History*, XXVII:4, Autumn 1977.

James McQuade. Review of *Men Who Have Made Love to Me* in *Motion Picture World*, January 28, 1918.

H.L. Mencken. "The Cult of Dunsany," *Smart Set*, July 1917.

Harriet Monroe. "More About Mary MacLane's Book," *Chicago American*, May 10, 1902.

Harriet Monroe. "Mary MacLane: Fire of Youth," *Poetry*, June 1917.

Louella Parsons. "On Movies [review of *Men Who Have Made Love to Me*]," *Chicago Herald*, January 25, 1918.

Peggy Pascoe. Untitled research paper on Mary MacLane, 1978. Copy in possession of the Butte-Silver Bow Public Library.

Elisabeth Pruitt, ed. *Tender Darkness: A Mary MacLane Anthology*. Belmont, CA: Abernathy and Brown, 1993.

"Remarkable Book from Out of the West," *Chicago American*, April 26, 1902.

Penelope Rosemont. Introduction to a selection of MacLane's writings in *Free Spirits: Annals of the Insurgent Imagination*. San Francisco: City Lights Books, 1983.

Penelope Rosemont, ed. *The Story of Mary MacLane & Other Writings*. Chicago: Charles H. Kerr, 1997.

Patricia Meyer Spacks. *The Female Imagination*. New York: Avon, 1975.

Mae Tinee. Review of *Men Who Have Made Love to Me* in *Chicago Tribune*, January 25, 1918.

Oscar Lovell Triggs. *The Changing Order*. Chicago: Charles H. Kerr, 1906.

Leslie Wheeler. "Montana's Shocking Lit'ry Lady," *Montana: The Magazine of Western History*, XXVII:3, Summer 1977.

Gideon Wurdz. *The Foolish Dictionary*. New York: Grosset & Dunlap, 1904.

Surrealist Encounters, Ted Joans, Jayne Cortez, Black Power

This text appeared as "Surrealism, Encounters, Ted Joans" in *Surrealist Experiences: 1001 Dawns, 221 Midnights*, pages 83–95.

Robert Benayoun. *Le Rire des surréalistes*. Paris: Le Bougie du Sapeur, 1988.

André Breton. *Nadja*. New York: Grove Press, 1960.

André Breton. *What Is Surrealism? Selected Writings*. Ed. Franklin Rosemont. New York: Monad Press, 1978.

Paul Buhle, ed. *Popular Culture in America*. Minneapolis, MN: University of Minnesota Press, 1987.

Michel Fabre. "Ted Joans, the 'Surrealist Griot,'" *From Harlem to Paris: Black American Writers in France, 1840–1980*. Urbana, IL: University of Illinois Press, 1991.

Paul Garon. *Blues and the Poetic Spirit* (1975). New edition. San Francisco: City Lights Books, 1996.

Paul and Beth Garon. *Woman with Guitar: Memphis Minnie's Blues*. New York: Da Capo, 1992.

Ted Joans. *A Black Manifesto in Jazz Poetry and Prose*. London: Calder & Boyars, 1971.

Ted Joans. *Afrodisia*. New York: Hill & Wang, 1970.

Ted Joans. *All of Ted Joans and No More*. New York: Excelsior, 1961.

Ted Joans. "Am Gone, Am in Chicago," *Arsenal: Surrealist Subversion* 4. Chicago: Black Swan Press, 1989.

Ted Joans. "Bird and the Beats," *Coda* 181, June 1981.

Ted Joans. "Black Flower," *L'Archibras* 3. Paris, March 1968.

Ted Joans. "I, Black Surrealist," *Opus International: André Breton et le surréalisme internationale*. April–May, 1991.

Ted Joans. "Ted Joans parle," *La Brèche: Action surréaliste* 5. October 1963.

Ted Joans. *The Hipsters*. New York: Citadel, 1961.

Ted Joans. *Wow: Poems*. Mukilteo, WA: Quartermoon Press, 1999.

Ted Joans and Hart Leroy Bibbs. *Double Trouble: Poems*. Paris: Éditions Bleu Outremer, 1992.

Ted Joans and Joyce Mansour. *Flying Piranha*. New York: Bola Press, 1978.

Walter Rodney. *How Europe Underdeveloped Africa*. Washington, D.C.: Howard University Press, 1982.

David R. Roediger. "Plotting Against Eurocentrism: The 1929 Surrealist Map of the World," *Surrealism: Revolution Against Whiteness*, special issue of *Race Traitor*, 1998.

Franklin Rosemont. "Black Music & Surrealist Revolution," *Arsenal/Surrealist Subversion* 3. Chicago: Black Swan Press, 1976.

Franklin Rosemont. "Jospeh Jarman," *Arsenal/Surrealist Subversion* 3. Chicago: Black Swan Press, 1976.

James G. Spady. "Surrealism and the Marvelous Black Plunge in Search of Yemanga and the Human Condition," *Cultural Correspondence* 12–14, Summer 1981.

Tyler Stovall. *Paris Noir: African Americans in the City of Lights*. Boston: Houghton Mifflin, 1996.

Totems Without Taboos: The Exquisite Corpse Lives! Exhibition catalog. Chicago: Heartland Gallery, 1993.

Unexpected Paths: Gustav Landauer, Munich 1919

This text appeared as "Unexpected Paths: Gustav Landauer" in *Surrealist Experiences: 1001 Dawns, 221 Midnights*, pages 96–99.

Paul Avrich, "Gustav Landauer," *The Match*. Tucson, AZ: December 1974.

Ben Hecht, *Child of the Century*. New York: Simon and Schuster, 1954.

Joseph Déjacque. *A bas les chefs!* Paris: Éditions Champ Libre, 1971.

Gustav Landauer. *For Socialism*. St. Louis, MO: Telos Press, 1978.

Gustav Landauer. "On Constantin Brunner," in Walter Bernard, *The Philosophy of Spinoza and Brunner*. New York: Spinoza Institute of America, 1934.

Eugene Lunn. *Prophet of Community: The Romantic Socialism of Gustav Landauer*. Berkeley, CA: University of California Press, 1973.

Colin Ward. "Gustav Landauer," in *Anarchy* 54. London: Freedom Press, 1965.

Mimi Parent: Luminous Laughter

This text appeared as "Mimi Parent" in *Surrealist Experiences: 1001 Dawns, 221 Midnights,* pages 119–124.

André Breton. "Mimi Parent," *Surrealism and Painting.* New York: Harper & Row, 1975.

Petr Kral. "Mimi Parent," *Dictionnaire Général du Surréalisme et de ses environs.* Eds. Adam Brio and René Passeron. Paris: Presses Universitaires de France, 1982.

Mimi Parent. Exhibition catalog. Texts by Peter Spielman, José Pierre, Pierre Cadare, Milan Napravnik, Annie Le Brun, Radovan Ivsic, and Heribert Becker. Bochum: Museum Bochum, 1984.

The Life and Times of the Golden Goose

This text appeared in *Surrealist Experiences: 1001 Dawns, 221 Midnights,* pages 129–141.

The Golden Goose. Pictures by Mary Lott Seaman. New York: The Happy Hours Books, Macmillan, 1928. Slightly different translations may be found in numerous fairy-tale collections, for example: Andrew Lang, ed., *The Red Fairy Book* (1890). New York: Dover, 1966. 340–45.

Edward A. Armstrong. *The Folklore of Birds.* New York: Dover, 1970.

C.H. George. *Revolution: European Radicals from Hus to Lenin.* Glenview: Scott, Foresman, 1971.

Michel Leiris. "On the Use of Catholic Religious Prints by the Practitioners of Voodoo in Haiti," *Evergreen Review* 13 (special 'Pataphysics issue), May–June 1960, 84–94.

Joseph Macek. *Jan Hus et les traditions hussites.* Paris: Plon, 1973.

Géza Róheim. *Magic and Schizophrenia.* Bloomington: Indiana University Press, 1955.

Beryl Rowland. *Birds with Human Souls.* Knoxville, TN: University of Tennessee Press, 1978.

Nancy Cunard and Surrealism: Thinking Sympathetically Black

This text appeared in *Surrealist Experiences: 1001 Dawns, 221 Midnights,* pages 147–152.

Anne Chisholm. *Nancy Cunard.* New York: Knopf, 1979.

John Henrik Clarke, ed. *Marcus Garvey and the Vision of Africa.* New York: Vintage, 1974.

Henry Crowder. *As Wonderful as All That?* Navarro, CA: Wild Trees Press, 1987.

Nancy Cunard, ed. *Negro*. London: Wishart & Co., 1934.

Hugh Ford. "Introduction," *Negro*, abridged paperback ed. New York: Ungar, 1970.

Hugh Ford. *Nancy Cunard: Brave Poet, Indomitable Rebel*. Philadelphia: Chilton, 1968.

Penelope Rosemont, ed. *Surrealist Women: An International Anthology*. Austin, TX: University of Texas Press, 1998.

André Thirion. *Revolutionaries Without Revolution*. New York: Macmillan, 1975.

Lee Godie, Queen of the Outsiders

This text appeared as "Lee Godie" in *Surrealist Experiences: 1001 Dawns, 221 Midnights*, pages 155–162.

Artist Lee Godie: A 20-Year Retrospective. Chicago: Department of Cultural Affairs, 1993.

Dada: Emmy Hennings, Kandinsky, and the Theory of Relativity

This text was written for and presented at the DADAChicago 2016 conference, October 21–November 6, 2016, 760 N. Milwaukee, Chicago, IL.

Surrealism and Situationism: King Kong vs. Godzilla

A much longer version of this essay appears in *No Gods, No Masters, No Peripheries: Global Anarchisms*, Eds. Barry Maxwell and Raymond Craib (Oakland, CA: PM Press, 2015), pages 244–262.

Michael Löwy. *Morning Star: Surrealism, Marxism, Anarchism, Situationism, Utopia*. Austin, TX: University of Texas, 2009.

Leonora Carrington, and the Lion and the Unicorn in the Theater of Analogy: Chicago

Her de Vries and Laurens Vancrevel. *What Will Be: Almanac of the International Surrealist Movement*. Amsterdam: Brumes Blondes, 2014.

Ron Sakolsky. *Surrealist Subversions: Rants, Writings & Images by the Surrealist Movement in the United States*. Brooklyn: Autonomedia, 2002.

Forecast is Hot! Tracts and Other Declarations of the Surrealist Movement in the United States. Editor, with Franklin Rosemont and Paul Garon. Chicago: Black Swan Press, 1997.

Surrealist Women: An International Anthology. Editor and author of introductions. Austin, TX: University of Texas, 1998.

Surrealist Experiences: 1001 Dawns, 221 Midnights. Foreword by Rikki Ducornet. Chicago: Black Swan Press, 2000.

Dreams & Everyday Life: André Breton, Surrealism, Rebel Worker, SDS, & the Seven Cities of Cibola. Chicago: Charles H. Kerr Publishing Co., 2008.

"My Life in SDS," in *Students for a Democratic Society: A Graphic History.* Edited by Paul Buhle. New York: Hill & Wang, 2008.

Armitage Avenue Transcendentalists: Collected Stories. Editor, with Janina Ciezadlo. Chicago: Charles H. Kerr Publishing Co., 2010.

Lost Worlds, Forgotten Futures, Undreamed Ecstasies: Some thoughts on the relationship of Surrealism to the Mayan Millennium & to each his own Pluriverse. Surrealist Research & Development Monograph Series. Chicago: Black Swan Press, 2012.

"Liberating Desire from the Confines of Time," in *La Chasse à l'objet du désir.* Author, with Bernard Marszalek. Montreal: Sonámbula, 2014.

"Surrealism and Situationism," in *What Will Be: Almanac of the International Surrealist Movement.* Edited by Her de Vries and Laurens Vancrevel. Amsterdam: Brumes Blondes, 2014.

"Surrealism in the U.S.," in *Il Surrealismo, Ieri e oggi: Storia, filosfia, politica.* Edited by Arturo Schwarz. Author, with Paul Garon & Connie Rosemont. Geneva: Skira, 2014.

Make Love, Not War: Surrealism in 1968! Author, with Don LaCoss and Michael Löwy. Chicago: Charles H. Kerr Publishing Co., 2018.

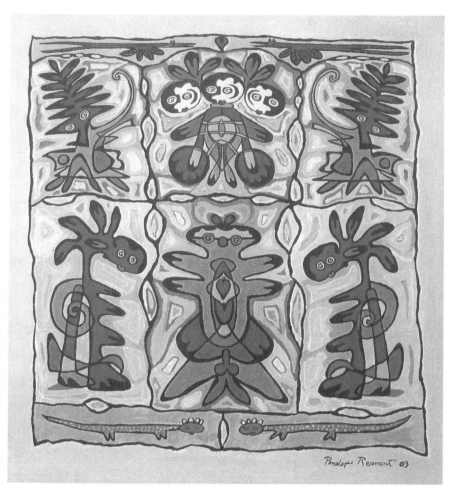

Penelope Reamont 03

Writer and painter, Penelope Rosemont went to Paris and attended surrealist group meetings with André Breton and his group for five months in 1966. Mimi Parent, Toyen, Joyce Mansour were active members of this group and friends. She spent an afternoon in discussion with Guy Debord, was introduced to Aimé Césaire at Présence Africaine Bookstore and visited CLR James in Brixton. She co-organized a surrealist group in the U.S. with Franklin Rosemont. Her painting the *Marriage of Heaven and Hell* was in the Venice Biennale, 1986 chosen by Arturo Schwarz.

An advocate for the recognizing the importance of women surrealists, she edited *Surrealist Women: An International Anthology* (University of Texas Press, Austin, 1998), also published by Athalone, London. In her research she found over a hundred women who had been active participants in Surrealism.

Her paintings appeared recently in the exhibitions *Revolutionary Imagination: Chicago Surrealism from Object to Activism* (2018) and *Dada Chicago* (2016). She presented a paper on "Pan-Africanism, Négritude: Ted Joans and Jayne Cortez" at the ISSS (International Society for the Study of Surrealism) 2018 Conference. She continues to be active in the surrealist movement and is in touch with surrealist groups in Madrid, London, Prague, etc.